mary frank

hayden herrera

mary frank

harry n. abrams, inc.

publishers | new york

ENDPAPERS:
Mary Frank's studio,
West 19th Street,
New York, c. 1978

PAGE ONE:
Kneeling Woman. 1976
Ceramic, height 13″
Private Collection

TITLE PAGE:
Passage. 1986
Oil on plaster, 18½ × 28″
Collection the artist

for margot and john

Project Director: Robert Morton
Editor: Harriet Whelchel
Designer: Judith Michael
Photo Research: Johanna Cypis

library of congress cataloging-in-publication data

Herrera, Hayden.
Mary Frank / by Hayden Herrera.
p. cm.
Includes bibliographical references
ISBN 0–8109–3301–2
1. Frank, Mary, 1933– . 2. Artists—United States—Biography.
I. Title.
N6537.F735A4 1990
709′.2—dc20 90–212
[B] CIP

printed and bound in japan

contents

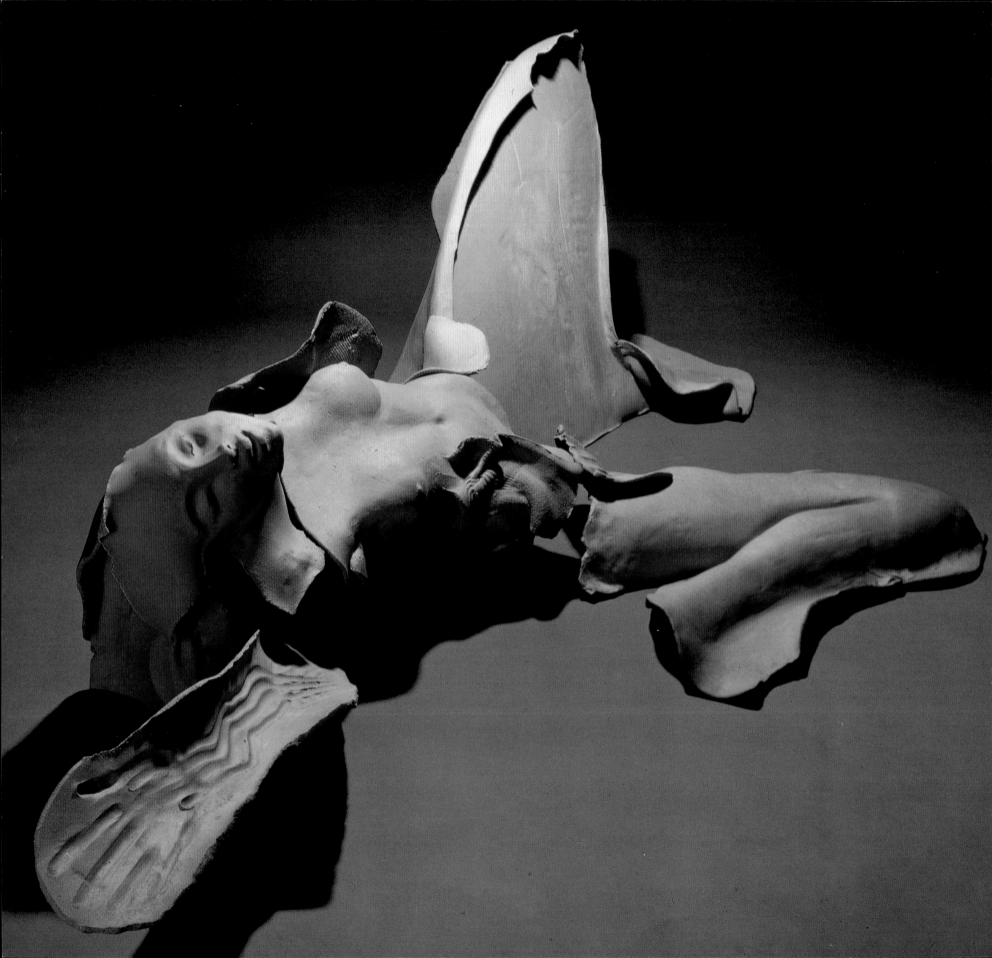

With her parted lips, her lightly closed eyes, her limbs reaching from a recumbent torso, Mary Frank's *Persephone*, 1985, celebrates an openness that is at once visceral and spiritual. Warm terra-cotta flesh swells with plenitude, yet her body is nothing but a fragile shell. A thigh curves up to become a mountain, then drops away into a perpendicular chasm. An arm flung back invites embrace, but it is concave, not convex, and the sculptor's fingers have already dug into wet clay leaving four wavering lines that end in the skeletal imprint of a hand. *Persephone* draws us into a realm where extremes unite and opposites mingle. She is earthbound and transcendent, momentary and timeless. So high pitched is the feeling she embodies that her meaning is both fiercely direct and utterly ambiguous. Is that ecstasy or pain we see in her upturned face, life or death in her receiving and relinquishing limbs?

Like so many of Mary Frank's sculptures, *Persephone* sustains a perfect balance

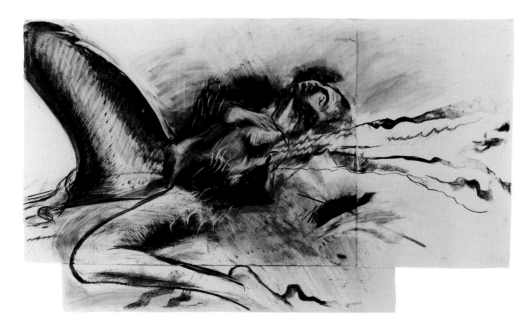

Persephone. 1985
Charcoal and brown Conté crayon,
35⅝ × 60¾″
Collection Rima Ayas and Ronald W. Moore,
New York, New York

OPPOSITE:
Persephone. 1985
Ceramic in five parts, 25 × 74 × 38″ overall
Collection Mr. and Mrs. Sidney Singer

between the absorptive and the projective. She pulls the viewer into her sensuality, thereby returning us to our bodies, to earth, to clay. But *Persephone* is also radiant. Her limbs send forth energy as she arches her back to deliver herself to the elements. From her belly and breasts, legs and an arm fan out like the sun's rays. In one of many drawings that Mary Frank made of the finished sculpture, the goddess's left arm dissolves into a series of outflowing lines that suggest dissolution in transport: solid flesh melting into air. Shorter lines spring from her torso as if her body radiates heat.

This simultaneous pulling in and giving out of energy comes from Mary Frank's desire to capture what she calls a "state of being" that is outside of history and common to all living creatures. One aspect of this state is ecstasy. An ecstasy quivering on the edge of anguish sinks into, moves out from, and transcends the body. Another aspect is longing. A mood of loss and longing pervades her work and is expressed as an urge to connect with something outside the self. This need propels the leap into space of Mary Frank's running men, the windblown gait of her walking women, the transformation into branches of Daphne's fleeing arms. Longing, like ecstasy, simultaneously pulls life in and moves outward toward that which is desired. Either way, the urgency of Mary Frank's work draws us into a realm that we recognize as primal.

In her sculpture, pastoral imagery combines with evocations of myth, glimpses of dreams, and—what keeps both imagination and the artist's hand fresh and true— immediate perceptions of nature. Images are clearly impelled by emotion—love, loss, rage, a pantheistic joy in nature—but, while her work is powerfully affected by her life, it is not specifically autobiographical, and Mary (she dislikes being called Frank) is reluctant to reveal the links between her personal experience and particular works of art.

She has populated her world with nudes, earth goddesses, sylvan spirits, and a vast bestiary that does not always conform to the fauna found in zoology books. There are chimera, bird-women, centaurs, women that are part fish, part snake, or part lion. Once the viewer becomes familiar with Mary's cast of characters, they look as natural as figures drawn from life. For all its Arcadian poetry, her sculpture is too urgent to be coy, too earthy to be sentimental or sweet. Because she conveys such a strong sense of life's interconnectedness, and because her figures are one with nature and exist in all time, the aura of longing in her work is distinct from the romantic's insatiable yearning to connect with nature or to recapture the past. Her urgency is more primitive. It is the exquisite longing that comes at the peak of satisfaction when oneness is almost too full to bear.

To enter Mary's art we must let go of mundane utility and participate in a fantasy that has all the power and concreteness of myth. Here the specific touches the universal, the instant includes eternity, and place becomes infinite space. A binding of flesh and spirit that is almost baroque in its extravagance directs us to our own sensuousness and vulnerability. It is perhaps because her work roots us in the deep sedimentary layers of our being, that Mary Frank is one of the most loved of contemporary sculptors. Yet for some the work's psychic intensity and eroticism are a threat. They shrink back from her invitation to a more intimate contact with the self.

Woman in Wave. 1967
Monoprint, approx. 20 × 16″
Private Collection

Although many of Mary Frank's titles are mythological, she does not illustrate myths; rather, she makes figures that embody the myth-making urge by seizing on the elemental constants in everyday life. The mythic aura of Mary's imagery, the suggestion that something momentous and magical, yet inevitable and natural, is happening, is not drawn from books. It comes from a vast reservoir of images absorbed from art history and from an ability to imbue immediate sensation with Olympian grandeur. A nude cradled by a breaking wave, for example, is not the birth of Venus. Nor is she simply a summer vacationer going for a swim. "The image," says Mary, "comes from being in waves, from seeing people in waves on Cape Cod and drawing them."[1]

A woman holding her breasts might look like an ancient fertility symbol but is in fact another example of Mary's attraction to postures that are spontaneous while at the same time they carry some larger meaning. "The woman with her hands on her breasts shows an intimate gesture that women do," says Mary. "I once saw a model take that posture in my studio, and I remember thinking she looked like certain Greek statues."

Like most of her images, the Daphne that appears so often in Mary's work derives from a composite source. More or less at the same time that Mary was moved by the posture of the fleeing nymph in Antonio del Pollaiuolo's small painting of *Apollo and Daphne*, she was struck by a pose taken by a male model whose rear leg stretched into a strong diagonal that hid his front leg from view. The Daphne theme was also prompted by "a feeling about trees in movement and the whole sense of what it is to be human or what I think it might be like to be a tree. It's about becoming nature, and leaving nature, too." Most of Mary's Daphnes have, like the 1975 Daphne entitled *Woman with Outstretched Arms*, one long leg and no foot, suggesting defiance of gravity and the idea of transcendence through transformation.

"All myths," Mary says, "deal with transformations," and it is the metamorphic potential of her figures that make them mythic. But Mary insists that her metamorphoses are not derived from classical mythology. "I could have a drawing of a woman on a page, and then maybe draw a swan, and everybody would say, 'Oh, Leda and the Swan.' . . . I don't mind; it's just that often it's not what I've been thinking or feeling. If I have a drawing of a man with a ram's head, it's a feeling I have about some connectedness."[2]

When she made *Persephone*, Mary was not telling the story of Demeter's daughter stolen by Pluto, made Queen of the underworld and allowed to return yearly to the earth's surface to create the miracle of spring. Nor was she making a symbol of nature; rather, *Persephone* is nature. She is continuous with earth, water, and air. "I made the large clay figure of a woman," Mary recalled. "She arches and turns and reaches back thru water and forth thru season. She survived many changes and later I called her Persephone. . . . I'm not sure that she is mythological but I do know that, at best, working is."[3]

Seen for the first time, Mary Frank's ceramic sculptures look ancient, as if they had been unearthed in an archaeological dig. Figures evoke molds or fossils taken from long-departed beings. Spare, ceremonial spaces recall excavated temples. Often the sculptures are intentionally fragmented, but they appear to have been fractured by the earth's subtle shifts. Their variety of color and texture—mostly warm tan brushed with

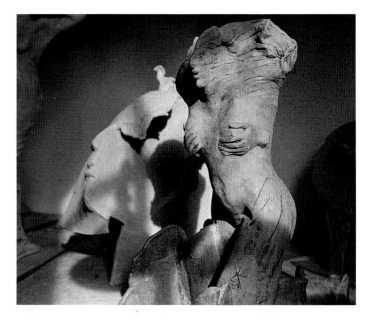

Woman in Waves. 1972
Ceramic, $22 \times 12 \times 18''$
Courtesy Zabriskie Gallery

Disappearance. 1976
Monoprint in three sheets,
$53 \times 45''$ overall
Private Collection

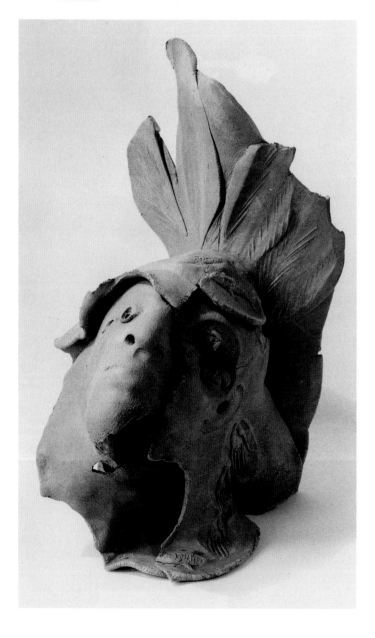

Head with Leaves, Fish, and Baby. 1982
Ceramic, height approx. 30″
Private Collection

reddish browns, sometimes imprinted with leaves and seals—suggest the patina of age. This aura of the archaic is enhanced by the fact that although Mary works in a variety of mediums—she has used plaster, glass, sticks, wax, bronze, papier-mâché, just about anything she can lay her hands on to make sculpture—her chosen medium is clay. The oldest material for art and an emphatically primitive substance, clay is the "dust of the ground," from which God molded Adam.

It is for her ceramic sculpture that Mary is best known. Sensuous and earthy, clay responds to the lightest touch of her fingers, and it adapts to the elusive nuances of her imagination. "It is," she says, "the most impressionistic material I know." She loves clay also because it is "cheap and common," available to everybody.

Nothing is static in Mary's work. As cheek flows into shoulder, arm into wing, foot into water or air, there is always the feeling that her creatures are just coming into being, just taking form in clay. As the sculptor reenacts the creation, the shapes she makes result from a spontaneous give-and-take between the movements of her body and the body of her clay. Form does not seem imposed, but, of course, to a great extent it is. Truth to materials is all very well, Mary points out, but clay is gravity-seeking, and if left to its own devices it is apt to slouch. "There is," she says, "a fine line between giving in to the medium so that clay is nothing but clay, and letting the medium have its own life. I want to articulate sculptural form, but art that denies nature seems very arrogant to me." It is Mary Frank's genius that she can let clay look like clay while at the same time transforming it. Thus, handling her materials with a mixture of humility and authority, she molds the human figure in the image of clay rather than clay in the image of the human figure.

She views reality as open, ambiguous, changing; clay allows her to give form to flux. Her figures are alive with many different kinds of movement: there are the movements of walking, running, dancing limbs and the movement of imputed emotions; there are the slow, unfolding, curling rhythms inherent to clay itself, plus the sweep of space in and out of form. Line, shape, light, and shadow move constantly as the spectator circles around the sculpture. In addition, traces of the artist's gestures are left clearly visible: fingers dragged though wet clay, edges swiftly torn or gently folded. There is also the movement of figures transforming themselves into fantastic hybrids—part animal, part architecture, part plant, water, air, and earth. Finally, Mary sees an equivalence between motion and emotion: "The impulse to work comes from being moved, a word I take literally. Maybe that's why I draw moving animals or people. Their movement gives an image to my own. I mean, when we say we are moved, something is actually changing in us."

While her sculptures elicit a strong emotional and physical response, their exact meaning and form remain difficult to grasp. They change radically when viewed from different angles. The back of a walking woman, for example, may turn out to be a sheared-off surface upon which a nude is profiled in iron oxide. Or if you walk around a ceramic head you may find a horse and rider in a mountain landscape on the other side. Mary wants the spectator to have an intimate encounter with her sculptures. They are to be looked at up close and from a distance as well. Her work demands that we walk slowly around it. "A sculpture," she says, "should not be predicted at your first

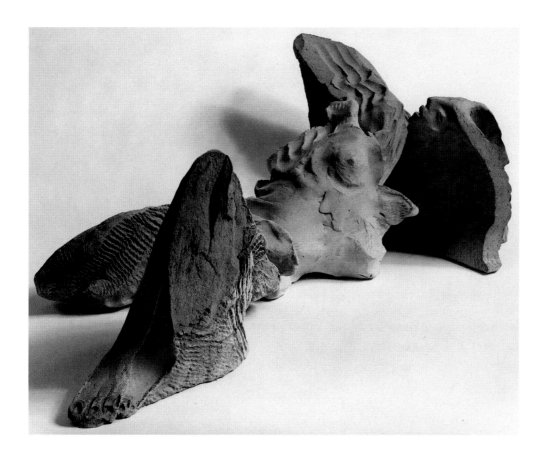

Nike-Persephone. 1987
Ceramic in five parts,
9½ × 25 × 13″ overall
Courtesy Zabriskie Gallery

glance. I like the sculptures to change abruptly in a way that is startling."

In its complexity and subtlety, her art is the opposite of the kind that she referred to when she said, "Much contemporary sculpture looks to me as if it's to be seen from a fast-moving car." On a trip to the vast sculpture park at Storm King, near the Hudson in New York, she was horrified by the "macho" blatancy of many of the sculptures. They lacked mystery and feeling. "In a lot of contemporary work there is no way to enter in or be with the piece."[4] Mary's work depends on allusion and multiple layers of meaning. "I rarely like things to be pinned down to one thing. I like the openness of being able to see it, if the light changes or you move a quarter of an inch, as having a different feeling. That seems to me more like life."

Even as she looks for changeability, Mary turns her back on the vicissitudes of contemporary life and focuses on aspects of the world that are not time-bound. Her approach, though naturalistic in some respects, has nothing to do with realism. "I'm not interested in the urban scene or in making sculptures of someone drinking a cup of coffee," she explains. Nor could her art accurately be called classical, expressionist, or surrealist, though it has elements of all three. She has invented a personal and highly original art in which metaphor and metamorphosis are the two constants. She explores the past as reverie, not history. Following her own poetic vision and formal ideals, Mary Frank is refreshingly out of step with the times and in step with her own rhythm and needs.

11

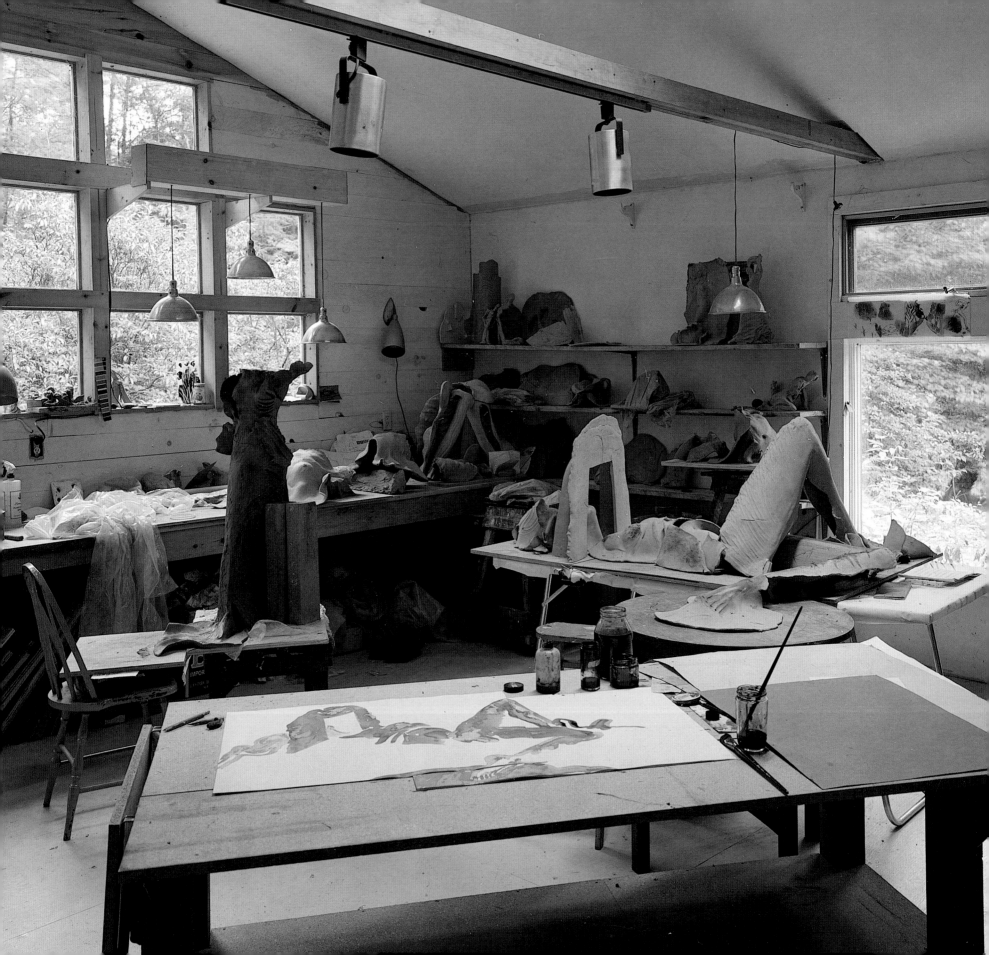

The sunshine pouring through huge southern windows in Mary Frank's loft on West Nineteenth Street in Manhattan scatters light upon a visual clutter that makes one feel the artist has turned herself inside out and placed her memories, feelings, and thoughts on all the surfaces of her home. The ceiling is hung with faded tissue-paper streamers she cut in plant patterns. Walls and pillars are pinned with unframed sketches; the paper curls outward and catches dust. Small sculptures and drawings made on shelf mushrooms are propped here and there in niches. Near the sofa, shelves are crammed with records, tapes, and books. Standing close by is Mary's 1916 Steinway piano, played mainly by Leo Treitler, a well-known musicologist with whom she has lived since 1985. Mary often accompanies him on the flute, and their loft is frequently the setting for informal musicales to which they invite their musician friends; Mary's sketchbooks are full of drawings of violinists and flutists intent upon their scores. There is a personal warmth and speculative openness to Treitler's approach to music. His subjects range from medieval chant to the social and psychological aspects of Alban Berg's opera *Lulu*—he sees the understanding of music as "ever in flux with the changing condition of life and thought."[5]

Beyond the piano is Mary's work space, dominated at one end by her printing press and at the other by her huge gas kiln. In between, numerous tables are piled high with monoprints and with finished and unfinished drawings and paintings, and the studio walls are lined with shelves where sculptures are stored.

There is no clear dividing line between living space and the space where Mary works. In her art she conceives of space not as something to measure but as infinite extension. Similarly, in her life one activity flows into another as she moves from her kitchen table, to her press, to the pedestals upon which she builds sculptures.

Mary and Leo spend five or six months each year at her house in Lake Hill in the Catskills. To reach the house you cross a creek on a wooden bridge, then pass through hemlocks and mountain laurel into grassy paths between flower beds where sculptures in clay and bronze are half hidden by blossoms. The one-story house is both comfortable and ramshackle. Like Mary's art, it unfolds in surprising ways: just as she adds paper when she needs more space for an image, or a slab of clay when she needs to extend a form, she added rooms when she needed more space for life. With its many doors and windows, the house, like Mary's sculpture, has a constant flow between inside and outside.

At Lake Hill, Mary is an avid gardener. If you call her in spring, summer, or fall and ask her how she is, she is apt to tell you first about azaleas, poppies, cosmos, irises, lilies, or black-eyed Susans that have just blossomed. Her urge to connect with flowers is so intense that they turn up not only in sketchbooks, monoprints, and sculptures but also in her dreams. Once she dreamed she was planting nasturtiums at Lake Hill. "Suddenly I hear this sonorous voice: 'Nasturtiums . . . do . . . not . . . like . . . cold . . . soil.' I stop for a second, go back to planting, and then I hear it again, but this time really loud: 'NASTURTIUMS DO NOT LIKE COLD SOIL!' So I stop. Shall I argue with God?"[6]

The Lake Hill studio, 1977

Enclosed between the creek and a hill, Mary's garden is a haven for sculpture. At one end, stumps of trees where the forest has been cut back and a huge, lichen-covered boulder serve as pedestals. She likes to see her works inhabited by mice and snakes and birds. For her there is no absolute division between nature and culture. Thus the paths that wind between her flower beds move up the hill to become covered walkways where the tops of witch-hazel boughs have been tied together to form a kind of living sculpture.

When Mary bought the Lake Hill house and built her first kiln, after she received a Guggenheim Fellowship in 1973, her focus turned from dunes, beach, and ocean to trees, streams, lakes, and mountains. Before 1973 she spent her summers on Cape Cod, where the sea inspired her vision of the human figure pitted against open space. "I learned to draw at the Cape," she once said. "All those naked bodies against the light and against the horizon, the long edge of the earth." The space at Lake Hill is more protected. "'Paradise' is what people often call this place," Mary said. "They seem to choose that word instinctively, without knowing that the word's root, which is Persian, means an enclosed space."[7]

Wherever Mary Frank is, Manhattan, Lake Hill, or Cape Cod, she creates her own atmosphere and draws people in. By imbedding herself in her surroundings, by bringing people to her, she counters a strong feeling of displacement experienced in childhood. She was born in London on February 4, 1933, the only child of Eleanore Lockspeiser, an American-born painter, and Edward Lockspeiser, a prominent English musicologist and critic. Her early life was full of change and loss. "I think I lived in a fair amount of fantasy as a child. Possibly leaving England when I was seven made me somewhat isolated. But, of course, many children have that kind of experience." She spent her first seven years in England, where her parents had a small house in London's Saint John's Wood. Since then, apart from a year or so in Europe, she has lived in the United States.

"I had a very English upbringing," Mary recalls. Her days were dominated by her Scottish nanny with whom she shared a bedroom and whom she remembers as cold and strict. "She told me not to cry when my cat died," she says. Her mother was thirty-three when Mary was born, and though she was, as Mary puts it, "supportive in whatever I wanted to do," she was preoccupied with work. Her father she remembers as remote and unavailable. "He was at work most of the time. Even if he was in the house, he hardly existed for me." A specialist in Debussy, Edward Lockspeiser also conducted for the ballet and wrote not only on music but also on art (on J. M. W. Turner, for example) and on poets such as Edgar Allan Poe, Charles Baudelaire, and Paul Verlaine. "I read a lot of Verlaine in French as a child," Mary recalls, and she continues to read as much poetry as fiction to this day. "My father took me to the Nutcracker and to Petroushka. He also took me to a concert version of Saint-Saëns's *Samson and Delilah*, which was a disaster because I screamed when she cut his hair, and my father was very angry and had to take me out."

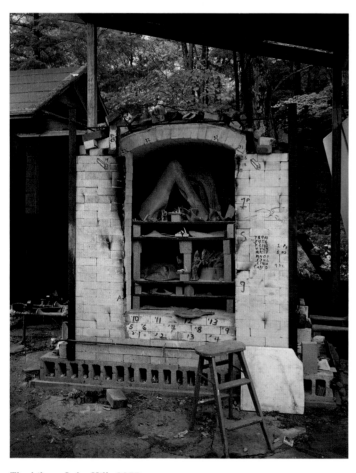

The kiln at Lake Hill, 1977

Mary was a solitary, secretive, well-behaved child. For company, she surrounded herself with a menagerie of stuffed animals, which she preferred to dolls. "I used to put them all on the bed, and I slept on the floor. I lived in my imagination. I had a book of Andersen's fairy tales with very mannered, Art Deco illustrations, which I adored. I read 'Snow Queen' and 'The Marsh King's Daughter' and all the extremely sad stories. The book was wet with tears, and I dried it out on the radiator." There were, of course, some moments of family closeness during Mary's London years. She remembers, for example, her mother making puppets and doll clothes and accompanying her on the piano while she danced in bare feet and waved a silk scarf in time with the music. Up until the age of six or seven she was allowed to be naked often, which she liked. "This was not true of other English children. My mother had certain modern ideas."

The general mood in the Lockspeiser house was one of disconnection and denial. Perhaps that is why Mary's art insists so fiercely on interconnectedness. "My mother couldn't cope with problems or emotional difficulties, and she tried to protect me from them. Nothing was ever explained." If her parents were reticent about domestic conflicts and sorrows, they were equally unforthcoming about the menace of war and the growing fear that London would be bombed. Even though nothing was said to Mary, children have a way of patching together a scenario of disaster out of a word here or a frown there. "One night I heard Hitler on the shortwave radio," she recalls. "It was the first time I'd ever listened to a radio. I remember the scene of adults standing huddled around this object out of which came this screaming, hysterical voice in a language I didn't know. I just knew it was terrible."

In thinking back on her daughter's childhood, Eleanore Lockspeiser concluded that "art was the only important thing in our household."[8] Mary's mother had trained to be a pianist, but her career plans changed one day when she came upon an advertisement with the drawing of a face and the words "Draw Me" printed below it. She drew the face and won a series of drawing lessons. Later she studied with the American Cubist-Expressionist Max Weber, who turned her first still life upside down, then took his palette knife and drew a few modernist edges upon it. Mary recalls that when she was a child her mother painted figures influenced by Picasso's Cubism. Later she became an abstract painter who showed at New York's Phoenix gallery. "Many artists respected her work a lot," Mary recalls. Although Lockspeiser's chief fascination was with color and light, her handling of paint had a sensuousness that was almost tactile. Mary's longtime friend the painter Henrietta Mantooth, who knew Lockspeiser's work well, put it this way: "Eleanore's paintings are buoyant and musical. Over the years her obsessive and multilayered search for form delivered strong, precise, and delicate entities floating to the surface.[9]

In 1939, along with most London children, the six-year-old Mary was evacuated to a series of country boarding schools. "I was very homesick," she recalls. "I felt completely abandoned. On the rare times that my parents visited, I never complained. I was brought up to have a stiff upper lip."

She went to five church schools in four months. "My family was Jewish but

completely atheistic, and I absolutely knew when I went to school that I was different. There was all this hymn singing, prayers, going to church. In one school we sang 'Onward Christian Soldiers.' They put up the words and notes on a very big sheet of paper, and the children with cymbals played red notes, triangles played blue, and drums played yellow. I was in awe of the Church of England service. I loved singing hymns and all the religious ritual. I wished I could be part of it, part of the stained glass windows. When my mother came on a rare visit, I asked her for a Holy Bible. The other kids had them. She was shocked."

In one boarding school, Mary was so miserable that she ran away. "I was a new girl and the only Jew. I climbed over a wall, but they got me back." From another boarding school, two images stand out in memory. Almost every night the children would be roused from their beds and herded into an air-raid shelter buried under a rose garden. "We sat in facing rows wearing nightgowns and gas masks. They said prayers I did not know, and after a while we'd file out of the shelter and go back to bed." The other image is of "children in blazers and gray tunics, ties, hats, and knee socks running with butterfly nets to save cabbages from butterflies. We were told it was to feed the soldiers, to save England. Each of us was given an Oxo box—a little orange and red tin with a laurel leaf inside that gave off a poison that killed the butterflies. We got a penny for each butterfly we killed. I had a hard time killing butterflies. I was mocked for not being patriotic. I decided not to eat any cabbage at meals."

One of the boarding schools gave Mary her first lesson in art. "We were asked to draw a still life, one apple, one orange, and a piece of cloth. We were to try to get the highlight on the apple, and I couldn't. An older girl could. It seemed like a good thing to get." On another occasion the teacher asked the children to draw a bridge in perspective. Again Mary couldn't. "The third thing we were asked to draw was the best. We did drawings of biblical subjects like the birth of Moses. I drew bullrushes and a baby in a straw boat and some attempt at the princess." Mary never would pay attention to the illusionistic devices of modeling in light and dark and one-point perspective, but myths like Moses' birth would continue to attract her fantasy.

In June 1940, to escape the blitz, Mary and her mother took a train to Southampton and sailed to Ireland, where they boarded a refugee-evacuation ship bound for the United States. "This was the last year to leave Europe," Mary recalls. "My father stayed in London. He was in the fire service during the blitz. When he came to see us off at the train I remember being upset when the conductor said that everybody who was not going must leave the train immediately. Instead of feeling sad that my father was leaving, the sadness was turned into fear that he wouldn't get off in time."

Another trauma came as they boarded the ship in Southampton and their wardrobe trunk broke open on the platform. "I just remember seeing things explode, all the stuff falling out. I wasn't concerned about the things in it; I knew it was just a very bad omen. On the voyage to America there were lots of crying babies and children. Everyone talked endlessly about submarines coming north, U-boats and icebergs floating south, because it was summer. We saw the tip of an iceberg. There was a lot of fear. When we arrived in New York everyone was oohing and aahing about the Statue of Liberty, but what really struck me was the neon Maxwell House Coffee sign, with its

flashing picture of the drip, that said 'good to the last drop.' It's still there!"

Mary and her mother lived with Mary's maternal grandparents in Brooklyn for five years. It was, Eleanore Lockspeiser recalled, "terrible for Mary, to have been taken away from her people. And for myself, a whole section of my life was lost. I had left all my paintings in a house that was bombed, and I lost them all. Then, when we came back to the States, I painted and painted. It was my salvation."[10] In coming to America, Mary's mother not only lost her home and husband, she lost her adulthood. The piano lessons she gave to neighborhood children did not earn enough money to give her independence from her father, who treated her as if she were a child. "When I first came to the United States," Mary recalls, "all my mother ever did was paint. Work was her only recourse. My grandfather had to support all of us, because my father did not make money."

Mary recalls that during her Brooklyn years she drew a lot and made things with her hands. Her mother encouraged her. "One morning when I was nine or ten, my mother decided to teach me something. I was sitting on the floor before going to school, and she started talking to me about composition. She told me to draw three things—a tree, a cloud, and something else, I can't remember. So I did, and she said, 'No, no, no.' I had put one thing, maybe the tree, right in the middle, and she said, 'No, no! You can't have it in the middle. That's not composing. Things have to balance. Don't you understand?' She started giving examples. I remember feeling absolutely enraged at being told what I couldn't do. She made me late for school. I lay on the floor and said, 'I won't, I won't make it that way!' And I think that was her first and last attempt to teach me. My horror of any system of 'composition' comes from that experience."

Part of the problem was the formalist ethic that Eleanore Lockspeiser shared with many artists of her generation. Because she saw painting in abstract terms, Mary's mother would turn a reproduction upside down and say it looked just as good that way. "I thought," Mary recalls, "that's impossible with a painting of a crucifix by Giotto, or a deathbed scene."

For all of Mary's resistance to her mother's approach to art, there is no question that Eleanore Lockspeiser's reverence for and dedication to painting was an important force in her daughter's artistic formation. As a child Mary spent hours poring over her mother's large collection of art books. She would remove art magazines from her mother's studio and take them to read in bed. She especially loved *Verve*, a literary and art journal full of reproductions of Matisse, Bonnard, Klee, and Picasso, of Indian and Persian miniatures, Chinese and Japanese art, and of Bill Brandt's photographs, which had for her a powerful attraction. What she saw in these publications and in museums that she frequented with her mother became a storehouse of visual culture from which she drew in her adult years.

Mary's home near Brooklyn's Flatbush Avenue was a three-story house built by her grandfather Gregory Weinstein, who installed his extended family in one half and rented the other. Born in Vilna, the son of a Russian rabbi, Weinstein emigrated to the United States in the 1870s and as a young man founded the multilingual International Press on Varick Street in downtown Manhattan. Mary remembers her fascination when as a child she visited his printing press, and her grandfather would show her the huge

Mary Frank in England, c. 1939

printing rollers spitting out sheets of paper that flew over a line of gas jet flames that dried the ink. "It was like a circus," she recalls. To his seven-year-old granddaughter, Weinstein seemed Russian, for he sang Russian songs, told stories about life in Russia, and often wore his own grandfather's embroidered Russian shirts. She was fond of him, but, she recalls, he was a stern and powerful man and a fierce atheist. "We used to argue," she says, "about social issues."

In contrast, Mary's grandmother Eugenie Weinstein was gentle and submissive. In her youth she had been a seamstress, and though she was now blind from diabetes, her fingers were still extraordinarily agile. "She could knit," Mary recalls, "and she could still sew if people pinned things for her." Eleanore Lockspeiser remembered that her mother had a "marvelous sense of color . . . of form. Of line."[11]

Mary's mother had a brother, who worked for the family printing press, and two sisters, both of whom lived at home. The eldest, born in 1895, was the feisty Florence, who, with Eleanore's encouragement, took up painting after she retired from teaching French. "She went to Black Mountain to study art," says Mary. "Her painting was abstract and mystical, and sometimes rather lovely." The youngest sister, Sylvia, was a successful potter who had her studio in the Brooklyn house. She died in 1945 in her midthirties from Hodgkin's disease. "She was more fun than anyone else in the house," Mary recalls. But, drawn to her aunt though she was, Mary does not think that her aunt's being a potter influenced her own choice years later to make sculpture out of clay. "I was not involved with her work, nor was I attracted to pottery."

When she first arrived in the United States, Mary longed for her father. She wrote to him often, and she remembers sending him drawings. She was aware that her mother missed him also, not because Eleanore Lockspeiser said so—such feelings were never discussed—but because of the tender way in which she tied the strings around packages containing elaborate fruitcakes that she had made to send to her husband. "My father sent me music he wrote for me to play on the piano, atonal pieces that seemed foreign and that my mother wanted me to play. His letters had a distant feeling. He sent me nineteenth-century French children's books, which didn't interest me at all."

As time passed, her longing for her father and for her homeland faded. When the Allied victory was announced, Mary recalls that everyone in her summer camp was happy, "but I remember thinking, I'll have to go back to England, and I didn't want to go. I had little contact with my father, and, after living in the United States for four years, I had lost my English friends. Soon after I came home from camp, I was lying in the bathtub, and my mother came in, and I knew before she said anything that she was going to say that she was getting divorced and that we were not going back to England. It seemed fated. I never thought of myself as the child of divorced parents, probably because the war had already made a separation."

At school Mary once again felt different. "The displacement affected me. At first I was considered to be an oddity. In the 1940s an English accent sounded snotty, so I diligently worked to lose my accent, and within two months I lost it completely." As in England, Mary was shifted from school to school. Her grandfather, who was active on the board of education, was against private schools, but her mother subscribed to

advanced ideas about education and insisted that Mary should go to progressive, independent schools. "She did not care about grades. I was never put under any academic pressure," Mary recalls with appreciation.

At first, Mary's mother won out, and Mary went to a coeducational progressive private school in Brooklyn. "I was given pots of paint," she says. "I don't remember what I did with them, but I still remember a drawing a boy made of grass in which each blade was a different color. Years later when I saw Van Gogh, it reminded me of the boy's drawing." When Mary was about eight, her grandfather had his way, and she went to public school. "I got in a lot of trouble because I refused to stand up and pledge allegiance to the American flag. I told the teacher that my grandparents were Russian. I felt I was not American. My grandfather was very upset. He was proud of being an American. Also, in those days it wasn't a good thing to be Russian."

For seventh and eighth grades Mary was sent to Friends School, a fairly liberal Quaker school in Brooklyn, which, she recalls, was weak in art and strong in music. Then in 1947 she was admitted to the public High School for Music and Art in Manhattan. Although her chief passion from the age of thirteen was dance, she applied to the school as an art student because the school did not offer dancing. A fellow student, the painter Emily Mason, remembers that people were in awe of Mary's talent and ambition. They were especially impressed when Mary made a drawing of a girl with a hoop and had it printed as a greeting card. "This seemed very professional," Emily Mason recalls.[12] The drawing was copied from a Giorgio de Chirico postcard, one of a set of postcards, most of which reproduced old masters like Leonardo and El Greco. When she was bored in math class Mary made drawings based on them.

"I had a good sculpture class in the tenth grade. The woman who taught us was the only dedicated teacher that I had at Music and Art. She said, 'There's no way to make art and chew gum at the same time.' We worked only in clay, which I carved as if it were wood. I made a bird of some kind. The painting teachers did not interest me. I made one painting of Rima [the heroine of William H. Hudson's *Green Mansions*] by putting oil paint on my hand and using my palm as a palette."

Many of Mary's drawings were tinged with melancholy. "In adolescence," she says, "I was intensely romantic, but I don't think that's unusual. I remember drawing a long time ago women standing at the edge of something. . . . In a sense the subject matter was not very different from what it is today." These solitary figures often looking out across the ocean are traditional images of longing in Romantic art. As a young person, Mary says, "I identified enormously with all kinds of loss."[13]

When Mary was about twelve, her mother gave her a set of six Sheffield steel wood-chisels for her birthday. "I think," Mary recalls, "that one of the reasons she gave me the birthday present was that she wanted to carve her own frames, which she did. I didn't have much interest in the chisels, but a year later I used them, and that's when I started sculpting." Eleanore Lockspeiser was delighted with her daughter's artistic efforts. "My mother was almost overflattering. I felt that she needed to have a very special child, and my specialness became a burden. When she would compliment me in front of other people, I would walk out of the room." Even so, this support was essential. Indeed, her mother's own drive to paint "as if her life depended on it"

reinforced Mary's feeling that working is synonymous with survival.[14] But there was a conflict. Her mother's will to work also enraged Mary. "I found her dedication and her drive a turnoff. It meant she wasn't available for me." Although her mother encouraged her to paint, until she was seventeen Mary insisted that she did not want to be an artist. "I remember saying I didn't want to be a painter. I wanted to be a dancer."

When Eleanore Lockspeiser took her daughter to The Metropolitan Museum of Art, "she wanted," Mary recalls, "to look at Cézanne, and I wanted to look at paintings of Queen Elizabeth with lots of jewels, which she said was bad art. I did like a painting of two children by Renoir and a painting of a woman sitting in a green field by Van Gogh. I made a copy of the Van Gogh. And of course I loved [Henri] Rousseau. But what I really went wild for were the Egyptian rooms. For me it was like an ecstasy to be in there. I loved the small wooden sculptures. There was a figure of a walking boy, about one-and-a-half inches high, with one leg forward, the arms down, and a hand that had once held something that is now lost. It's just a sublime figure, extremely finely carved with a tenderness and delicacy. It has stayed with me over the years. Even today I find myself making walking figures."

When her sister Sylvia died in 1945, Eleanore Lockspeiser took over her apartment on Ninth Street and University Place. It consisted of a living room where Mary's mother painted, slept, and ate, a tiny kitchenette, and a small room where the thirteen-year-old Mary slept in a bed placed on top of an upright piano that her mother used when she gave piano lessons. The bed's curved, Empire-style legs hung down around the upright piano "like little wings," Mary remembers. Living in such cramped quarters with her mother drove the adolescent Mary out of the house. In the Village she made all kinds of friends—artists, writers, dancers, politically minded people. She developed a passion for folk dancing. "We danced at the Furrier's Union Hall on West Twenty-ninth Street. You paid seventy-five cents to dance all night and sing American and Russian worker's songs. Pete Seeger, Ronnie Gilbert, Woody Guthrie, and Leadbelly were all singing there."

From the time she was five and danced to her mother's accompaniment in London, Mary loved dancing. She became serious about it when she was thirteen, and for her last two years of high school she switched from Music and Art to the Professional Children's School, also in Manhattan. This was, Mary says, "a very weird place which consisted of very little school. The school did not have regular classes. You could do your work at home. Mainly, I didn't want to be in school. I hung out where all these American Youth for Democracy sorts of people did."[15] During her five years of dance training with Martha Graham, José Limon, and others, Mary only performed once, and not as a modern dancer but with an Israeli group. But dance remained central to her life and work.

At fourteen or fifteen she decided she wanted to join a circus, and she trained for a year with a retired German circus performer who told her he could get her into a touring circus. "I wanted to do web work in which you hang from a rope in different dance positions while the man twirls you around. The teacher didn't think I was very good. He used to poke me with his stick."

Of all Mary's dance teachers, Martha Graham was the most influential. "Graham was ferocious and overwhelming, a tremendous, powerful presence. And a lot of things she said were very loaded. Sometimes she made references to sculpture—to Greek art and to Henry Moore, and I was particularly interested in Moore when I was studying dancing. He was the first sculptor that I felt in some way connected to." Just as Graham brought her knowledge of Moore to bear upon her choreography, Mary incorporated her dance training into her sculpture. Her passion has always been to catch movement in all its potential for continuous unfolding. Graham's idea of dancing, Mary points out, "was certainly from the inside out; it was not things observed coolly." Similarly, Mary's figures move as if propelled by a force spreading outward from their center. With her deep kinesthetic understanding of gesture, Mary, like Graham, choreographs her figures so that each posture seems charged with an intensity that can border on the portentous. "Certain elemental gestures interest me a lot," she says, "like a standing, walking, or running figure, a figure crouching, kneeling, or lying down."

By the time she was seventeen, Mary recognized that she would never be a good dancer or a great choreographer. "At best, if I were really lucky, I would be able to get into the company. And that wouldn't have satisfied me. The people in the troupe seemed like nuns—they didn't have any other life."[16]

Mary is a dedicated worker, but to confine herself to an aesthetic cloister would have gone against her grain. She is attracted to life's variousness; even today she insists upon engaging in numerous activities that have only a tangential relationship to her work. "At the age of seventeen," she recalls, "I gave up dancing and concentrated on art."

She began to take sketch classes in various parts of the city. There was no teacher; participants simply paid a dollar and fifty cents for the privilege of drawing from the model. When she wasn't making life drawings, she kept on drawing those "solitary figures of women." Her first serious attempts at sculpture came when she discovered the studio of Alfred van Loen, a Dutch sculptor who lived down the street. She paid a nominal fee for wood and for the use of his studio and carving tools. He gave her no instruction. "He had a small alligator living in a terrarium, and he yelled at me in Dutch when I broke his tools."

During the months that she worked in Van Loen's studio, Mary produced a few small wooden sculptures. After that she continued making wooden sculptures on her own. They were serpentine, highly polished "figures of girls and of pregnant women, also a woman who was part bird and some torsos of a young boy walking that were based on the Egyptian walking boy in the Metropolitan Museum." The woman/bird was the first of a long series of metamorphic creatures that continue to this day.

Inspiration came not only from Egyptian art but from Alberto Giacometti and Moore. Although she already knew Giacometti from her mother's collection of art magazines, his 1950 exhibition at the Pierre Matisse Gallery on Fifty-seventh Street moved her deeply. Moore she had learned about from Martha Graham and from her mother's art books, and the English sculptor's conception of woman as landscape, together with his insistence on form's mythic and metamorphic potential, impressed her greatly.

Mary Frank, c. 1949

In her junior year at the Professional Children's School, one of her folk-dancing partners introduced Mary to the Swiss-born photographer Robert Frank. Frank was nine years older than Mary. They fell in love and, to the consternation of her mother, Mary spent most of her time at his studio loft at Eleventh Street and University Place, two blocks from her home. Frank's melancholy appealed to her. She loved his photographs and admired his drive to work. "I idolized Robert. He was committed, passionate, and judgmental about his and other people's work. He had a strong, personal, nonintellectual eye, very fast. With him, I learned to see quickly."

In the summer after her junior year, Mary went to Paris to see her father, who was there in connection with work. Infuriated because his daughter stayed out late at night with Robert Frank, Edward Lockspeiser threatened to send her home. She ran away and stayed with friends of Robert's. When the police found Mary, her father placed her in a mental clinic. "The hospital," she recalls, "was one of the oldest in Paris, and it had a beautiful garden. They said I could sit in it, and I did for a half hour, and then I was put in solitary confinement. There was no explanation of any kind. When Robert came, they told him I had gone back to America. After two weeks my mother came and took me home. The experience of solitary confinement had a profound effect on me. It left me with a terrible idea of what it is to be alone."

One month before she graduated from the Professional Children's School in June 1950, Mary became pregnant. A week after graduating, she married. Since she was underage, her mother had to accompany her to City Hall to give her permission to marry. "I was in love with Robert," Mary recalls, "but I had no concept of what it meant to be a wife or a mother."

When Mary looks back on the early years of her marriage she is rueful. For all her gumption and apparent sophistication, she was really still a child when her own children, Pablo and Andrea, were born in 1951 and 1954, respectively. "I was never brought up to cook or to take care either of myself or of anyone else. I was brought up to be an artist. I got very scared, particularly because I realized that being a mother was intruding upon my work." In rebelling against his Swiss bourgeois upbringing, Robert Frank emphatically did not want a hausfrau for a wife, but he did expect Mary

Mary Frank with her son, Pablo, c. 1958

to look after their offspring. And although he encouraged her to work, his professional needs always took priority over hers. Among friends, it was understood that Robert Frank was an important photographer. Mary was his beautiful, poetic young wife. People knew that she was sculpting, but they paid little attention to her work. Mary herself took her work seriously, yet even she would not have described herself as an artist. "I would have said, 'I make sculpture.'"

During the early months of pregnancy and marriage, she continued to make the small sculptures out of wood that she had begun in Alfred van Loen's studio in the winter before her marriage. An Italian shoemaker whom she befriended gave her a piece of rosewood that he used for hammering shoes and a vise, which he installed on her fire escape. She also made small sculptures by pouring plaster into milk cartons or boxes and then carving the plaster when it set. "My main focus was sculpting in wood, which I thought of as a more serious material," she recalls.

For a few months before Pablo's birth in February, she studied drawing with the German Expressionist painter Max Beckmann at the tiny and little-known American Art School on 135th Street near Broadway. Mary recalls that although she frequently visited The Museum of Modern Art, she knew nothing about Beckmann's paintings. "Years later, when I saw a retrospective of his work, I remember actually falling backwards at the sight of all these figures falling out towards me. Now he's one of the artists I admire the most. I studied with him shortly before he died. He was very white-faced, and I think he was probably sick, although I didn't realize it at the time." Beckmann did not come to class often, but when he did come," she says, "he didn't say much. He said what I did was good, but then he'd put his curved black lines like adz cuts all over my drawings, which made them better."

During the 1950s, photography projects took Robert Frank all over the world. From 1951 to 1953, for example, the Franks lived in Zurich, Paris, Valencia, London, and Caerau, Wales. They had planned to start their travels with a visit to Robert's family in Zurich, but Robert decided to enter *LIFE* magazine's Young Photographers Contest, and that kept him in New York for several months. In August 1951 Mary went without him. "What I brought with me to Switzerland," she recalls, "was a little suitcase containing a Chopin Mazurka, a sketchbook, a half a pair of pajamas, and a torn dress. And I brought a few clothes for Pablo and one or two toys."

Robert Frank's father had a cabinet shop, and, in spite of the disapproval of her mother-in-law, who said, "You should take care of the baby and knit socks and cook," Mary went there and carved with a mallet and a small ax. Stifled by the atmosphere in the Swiss-Jewish household and by Zurich itself, she soon "took off with Pablo and got on a train to Paris."

During what Mary remembers as a long, cold Paris winter, she was confined by having a baby and very little money, but when Robert, who had joined her in Paris, was able to baby-sit, she did manage to go to the Louvre on Wednesday nights to draw. "I would be in the vast Egyptian section, and there were only six or seven people there. The 'clump, clump, clump' of footsteps made these echoing stone rooms sound like a real tomb." Mary haunted the galleries with Etruscan, Greek, and Asian art. "I loved Tanagra and Cycladic sculpture and the section called 'Antiquités Orientales,'

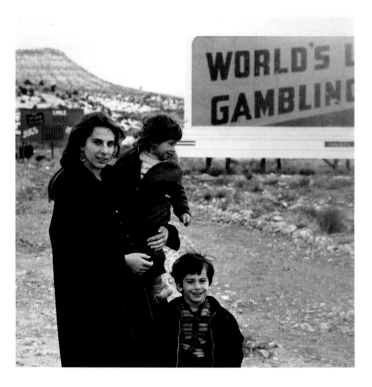

Mary Frank with her daughter, Andrea, and Pablo, c. 1956

which had Middle Eastern art, Mesopotamian." Mary also drew Oriental art at the Musée Guimet, and she spent hours looking at Han dynasty ceramic sculpture at the Musée Cernuschi. "That," she says, "was the beginning of my real interest in Oriental art." Once or twice a week she also went to carve in the basement studio of a man who produced fake Chinese ceramic horses of the Han and Ming dynasties by putting clay horses under corroded, dripping pipes. Perhaps something of the vitality of those equine shapes informs the horses that, years later, she herself modeled out of clay.

The summer following their Paris winter, the Frank family moved to Spain, where for several months they rented a little room over a tiny beachfront restaurant at the port of Valencia. Mary says that living in a Mediterranean culture had a tremendous effect on her. She became friends with the landlady's family, and she helped in the restaurant, cleaning mussels and preparing the ingredients for *paella*. "It was the first time I had ever seen any family life that appealed to me. They were very poor people, but there was real life and spirit there." But she was lonely. "Two days after we arrived, Robert left to go to Holy Week in Seville, and I stayed with the baby, once again alone. *Semana Santa* was going on where I was in Valencia, too. It was very eerie, with all the drums going and saints being carried out of churches and costumes from the Inquisition that looked like the Ku Klux Klan. I remember writing some kind of fairy tale about the Holy Week processions in my sketchbook. Years later I came upon it, and it was really like someone who was living in full fantasy—life was just too difficult."

In October, before leaving Spain, Mary went alone to Toledo to look at the work of El Greco, which she adored. On her last day in Madrid she visited the Prado. "I had dysentery and impetigo and hepatitis, and when I hit the rooms with the late Goyas, the guard said, 'Las ultimas Goyas, las Goyas negras,' I thought, this can't be Goya. I had a fever, and I thought I was hallucinating when I saw the last Goya rooms with ghosts and sorcerers all black with ocher and yellow. Later I realized that I was seeing just what was there."

When the Franks returned to New York in March 1953, they rented a loft in a commercial building on Twenty-third Street between Sixth and Seventh avenues. Because it was illegal to live there, they had to hide Pablo when the building inspector came around. During the mornings, while Pablo was at nursery school, Mary again attended sketch classes and continued making sculpture, either out of wood that she found on the street or out of plaster on armatures. When Andrea was born in April 1954, Mary was happy because she did not want Pablo to be an only child, but she discovered that two children were much more confining than one.

The following year Robert Frank received a Guggenheim Fellowship to photograph the United States, and the Franks gave up the loft and traveled from Texas to New Mexico, Arizona, Nevada, and finally to California. "We lived such a bohemian life," Mary recalls. "It seems to me I had no plans at all. We just took off in a car. It was freezing in Texas, a lot of snow, and I thought we were going to picnic on the grass. Two kids, one of them sick, no place to wash diapers. We didn't know where we were going or where we'd stay." *U.S. 90, En Route to Del Rio, Texas*, the last photograph in Robert Frank's bone-chilling *The Americans*, published in 1958, shows Mary and the

Mary Frank with Pablo, her mother,
Eleanore Lockspeiser, and her grandfather
Gregory Weinstein, c. 1954

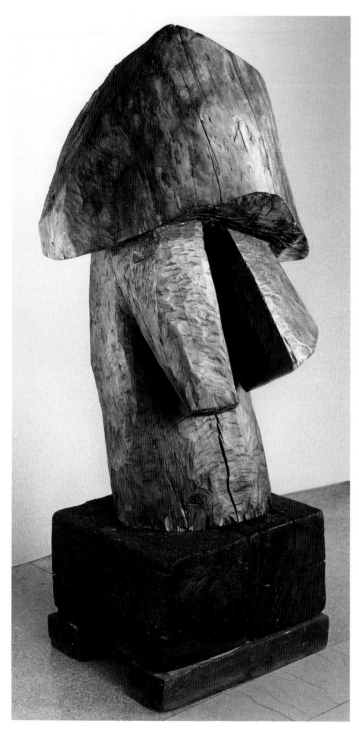

The Apparition. 1959
Oak, wax finish, and reddish stain,
51½ × 30″. The Brooklyn Museum.
Gift of Mr. Jerome Goodman.
70.10AE

children bundled up and half asleep in the front seat of a 1950 Ford. The image has the same bleak, unhinged loneliness that informs all of the photographs of strangers that Frank took during the two years of his travels.

After a month in Los Angeles, Robert wrote to his parents, "Mary has it rough—it is too bad that Mary cannot drive. . . ."[17] Robert Frank continued traveling on his own, while his wife and children returned to New York. They stayed briefly at the Chelsea Hotel before moving into an apartment at 34 Third Avenue between Ninth and Tenth streets.

Tenth Street was the center of New York's increasingly vital art world. The painter Alfred Leslie, for example, lived next door. Milton Resnick had a studio close by, and Willem de Kooning, perhaps the most influential painter of the New York School, lived across the backyard. "His window from the south side faced our back windows, so I could watch him sweeping all the time. He was very clean—always mopping and sweeping." Although she knew many of the artists, Mary did not become involved in the aesthetic and social preoccupations of the "Tenth Street School." Nor did she participate in the heated conversations about freedom, finish, abstraction, and meaning that engaged Abstract Expressionists and their hangers-on at the Cedar Bar. Then, as now, Mary went her own way, finding her sources in ancient and Oriental art and pursuing figuration even when it was clearly out of fashion. "I was working in a very isolated way," she recalls. "I didn't know, nor was I interested in, whatever contemporary movements were going on. It was only much later that I became interested in De Kooning." She would come to admire De Kooning above all the other American artists. Drawn, she said, to his "energy and movement," she incorporated into her own work something of the speed and improvisatory freedom of his gesture, and De Kooning's insistence that the tracks of the process be left visible became an essential tenet of Mary's art. Certainly her words had an echo of Abstract Expressionist vehemence when she said, "In the world nothing is really 'finished.' I do not understand about finishing work."[18]

After Andrea was born, finding time to work was more difficult, but Mary did manage to hire the occasional baby-sitter. "It was always a terrific conflict, tremendous. I was very tenacious, but at great expense all around. I always thought I should be with the children when I wasn't. When I was with them, there was always this pulling. Every woman I know talks about it."

For two brief periods, the first in 1951, the second in 1954, just after Andrea was born, Mary studied figure drawing in the evening class at Hans Hofmann's Eighth Street school. "Robert stayed with the children, and I went once or twice a week for a few months. I hardly knew Hofmann's work, and I liked it less than I had liked Beckmann's. In his class I drew from the model. I did not paint, and I never went to the big criticisms where people brought their work from home. The atmosphere was very intense. I think Hofmann had a lot to give as a teacher, but I wasn't open to it. I really didn't understand what he was talking about. I didn't see Hofmann much, but I remember what he told me. He complained that I didn't put the whole figure on the paper, which I often didn't. Even so, he said, my work was 'psychologically correct.' I

wasn't really involved with Hofmann's ideas at all—all that talk about things like 'push-pull' and surface and depth."

Like Beckmann, Hofmann would draw on Mary's drawings. "He would put *his* lines on, and make the model's head very small. He loved a certain model whose body was large and whose head was small. 'Ach, she iss so beautiful mit her wonderful pin head,' he would say. Those were his favorite proportions, his ideal woman."[19]

To Mary, what mattered most about Hofmann's classes was the interaction with other students from whom she learned as much or more than she did from Hofmann himself. Robert Beauchamp, Miles Forst, John Grillo, and Lester Johnson were among her friends. Some of these people were Hofmann students, others were part of the school's extended art-world milieu. The artist who was most important to her was Jan Müller, one of whose gently expressionist forest landscapes with fairy-tale horses she owns. "Jan was a fantastic painter, extraordinary, very free. He was generous about looking at other people's work. And I was interested in the same imagery: horses, women falling off of horses, landscape, figures that were icons."

During the 1950s, Mary's sculpture became larger, freer, and less polished. In 1953 the Franks began to spend summers in Provincetown, Massachusetts, an artists' colony at the tip of Cape Cod. "I started carving bigger and bigger pieces," Mary recalls, "because I found huge logs on the beach and four people would have to move them. And then I started working in cement, and in the mid-1950s I began to work in plaster on armatures. I made strange lunar barques, lion women, figures in water, figures and horses, crescent moon shapes. The sculptures became larger and rougher. In the beginning they were very figurative. Later they became much more abstract, but for me they were never exactly abstract. They were based on human or animal gestures. Often they were arrow forms, or arched forms that were part figure, part rainbow. Many of the large, arrow-headed figures were based on an Eskimo figure leaning over with a bird on its back that I probably saw at the American Museum of Natural History."

Mary's semiabstract figures from the late 1950s and 1960s stress wood's weight and density. Often she left chisel marks showing as she turned her sculptures and carved them from all sides. "In wood," she noted, "you have time to make thousands of choices with each cut. You're like an animal gnawing away at something. Much later I used power tools for a short time, but it wasn't very satisfactory. It saves time but loses possibilities."[20]

Moore and Giacometti continued to inspire Mary, and her fascination with primitive art, which she often drew at the American Museum of Natural History, exerted a strong influence as well. In addition, she admired the way the Rumanian-born sculptor Raoul Hague's massive wooden sculptures hovered between human torso and brute tree trunk. Another source was Brancusi. "When I was working in wood I was crazy about Brancusi," she recalls. "I still am. He made the base a world upon which ideas and feelings rest."

Like the work of her mentors, Mary's wooden sculptures have an element of primitive mystery. Works like *The Apparition*, 1959, or *Rainbow Figure*, 1965, seem intended not simply as aesthetic objects but as images of magical efficacy. Several of the wooden

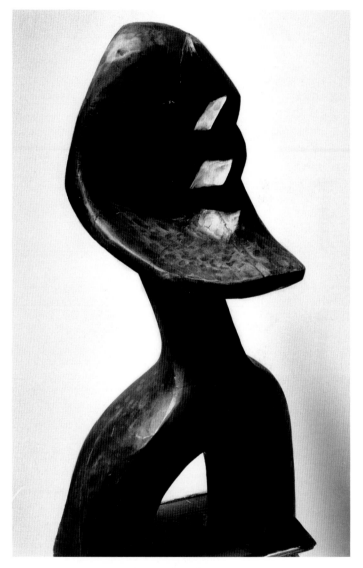

Rainbow Figure. 1965. Walnut, 39 × 21″
Whereabouts unknown

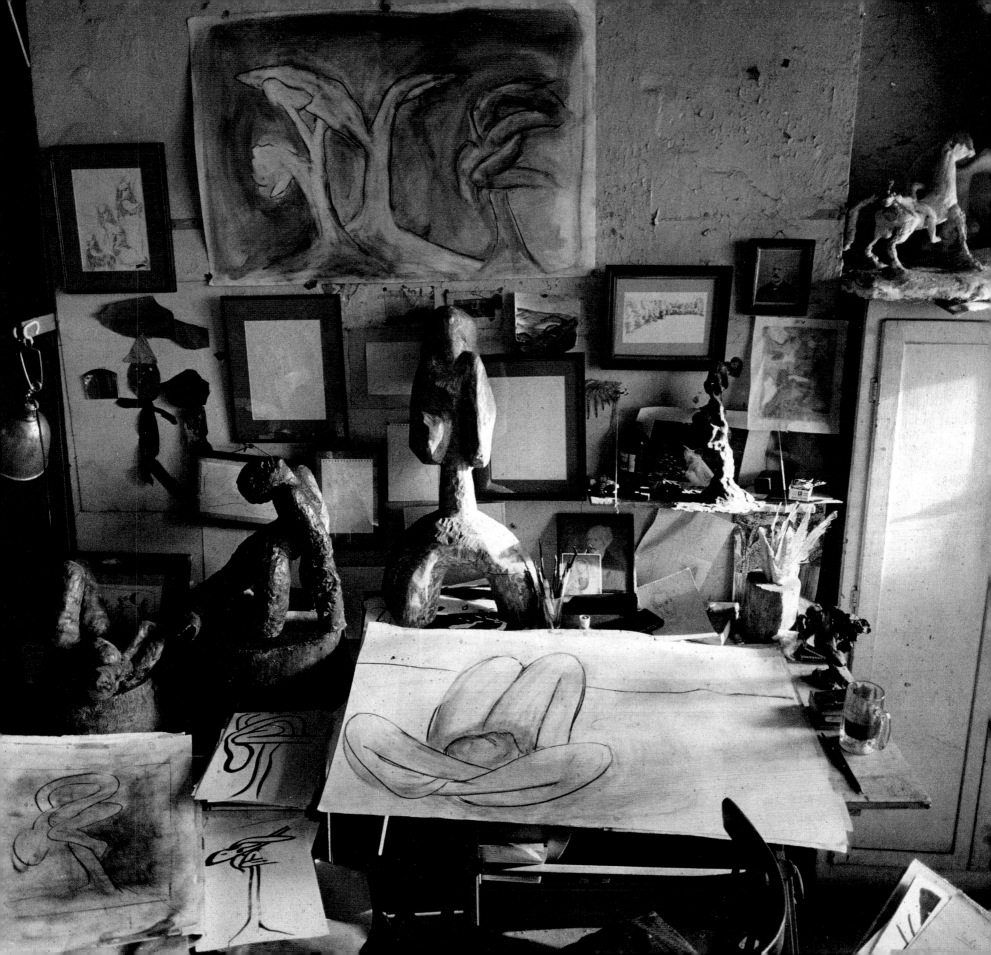

figures, including *Rainbow Figure*, are made out of an upside-down tree trunk with two branches forming an arch. Although they are eyeless, these figures seem to watch us like guardians, and their regard is both attracting and frightening. Even at this early date, Mary wanted her sculpture to look different from different vantage points. Thus, from one side *Rainbow Figure* loops into an arch that could be an arm thrown back, or perhaps the head of a bird, and that is, of course, also a rainbow. From another viewpoint, *Rainbow Figure* looks like an African mask with hollows that can be read as volumes. Mary took the idea of using voids as volumes from primitive art and from the Cubist-Constructivist tradition. It was a lesson she would later explore in ever more subtle ways in her clay sculpture.

Many of Mary's early sculptures seem to be derived from a series of Picassoesque line drawings in which she simplified and abstracted anatomy so that the body became a tangle of tubular limbs. Other sculptures are closer to certain brusque and angular, somewhat Matissean, charcoal drawings of nudes. A comparison of Mary's seven-foot-long charcoal depicting three female nudes with the five-and-a-half-foot horizontal wooden relief for which it was a study reveals the way she works toward abstraction. In the drawing, the nude on the left crawls; the central nude, seen from the waist down, spreads her legs to expose her sex; and the right-hand nude lies on her back with her arms out and one leg in the air. Without knowing the drawing, the sculpture might be seen as a sequence of abstract curves and angles. In the sculpture, the upper part of the crawling figure is transformed into an arrow. The central splayed figure is arrow shaped, also, and her vagina has become a crevasse. The recumbent nude's left arm merges with the splayed nude's left leg. In a contemporaneous relief the figures are further abstracted into arrow-shaped glyphs whose schematized, flattened surfaces recall Mary's love of Egyptian art. When the images from both wooden reliefs reappeared on two fourteen-inch-long wax reliefs, the anatomical glyphs became more painterly and gestural, and their primitive quality was diminished.

Creature, 1964–65, is like a three-dimensional version of the central splayed nude in the relief. Her body arches with an openness that foretells the open-legged, arched-back posture of *Persephone* and of several clay figures of lovers from the 1970s and 1980s. Another splayed wooden figure sits on top of a Brancusi-inspired rough wooden pedestal. The cropping of her head and the frankness with which she bares her sex recall Rodin's *Iris*.

Around 1958 or 1959, while continuing to work in wood and plaster, Mary Frank began to model small figures in wax. A few of them were cast in bronze, but casting was expensive and most of them sat on studio shelves getting bumped and broken over the years. The wax sculptures are full of a kind of spirited movement that was impossible in more stolid wood. Because they are modeled instead of carved, surfaces flicker where the warm wax has been squeezed and poked, and silhouettes are open so that for the first time the figure melds into the space around it, and a landscape setting is created. Mary treated wax as if it were pure, undifferentiated, pulsating energy, an energy that keeps acrobats dancing on horses' backs and that lifts Daphne into the sky.

Mythic themes continued: besides Daphne turning into a tree, Mary made Ledas,

Studies for sculpture. 1961
Ink, 13 × 9½″
Collection the artist

Daphne. 1962
Bronze, height 11″
Collection Suzanne and
Maurice Vanderwoude

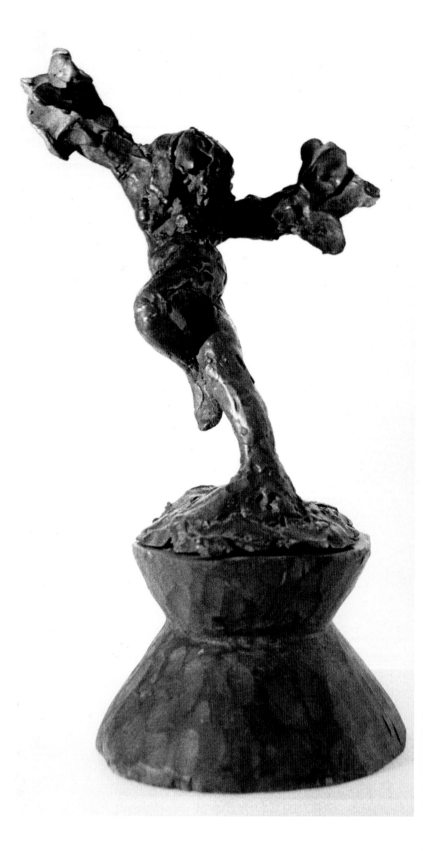

Lion-Headed Woman. c. 1958
Bronze, 5 × 10¾ × 4″
Collection Virginia Zabriskie

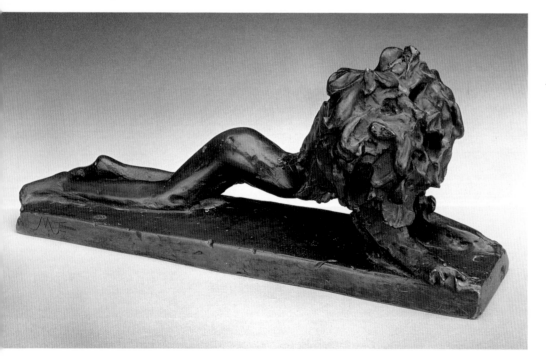

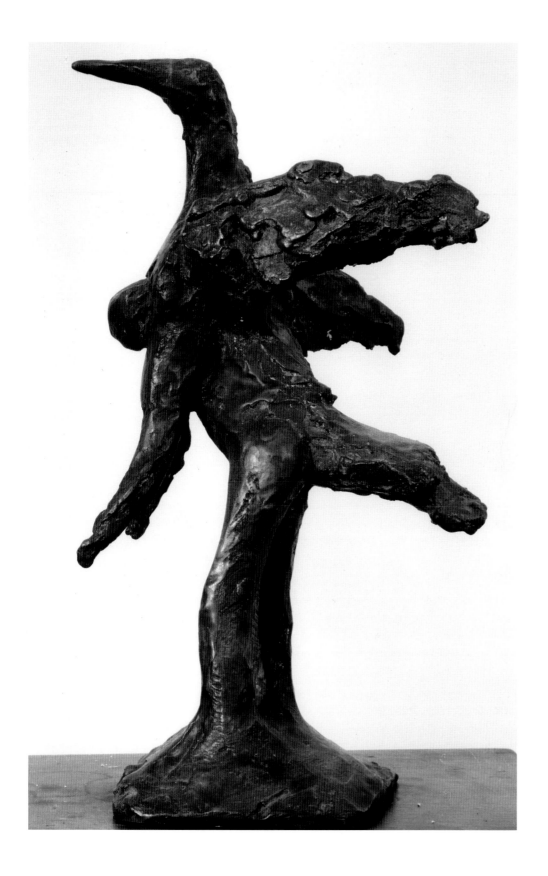

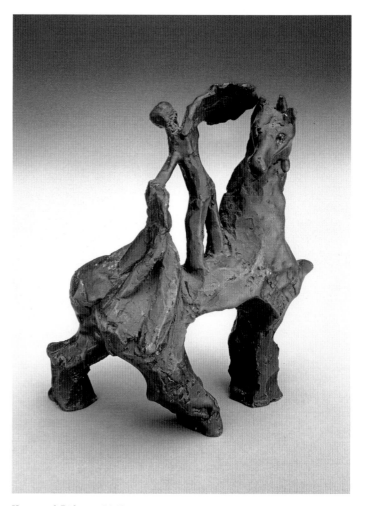

Bird Woman. 1959
Bronze, height 14¼″
Private Collection

Horse and Rider. c. 1962
Bronze, 5¼ × 4½ × 2¾″
Collection Philip Herrera

Exhibition of sculpture and drawings
from 1962 to 1964,
Boris Mirski, Boston, 1965

Clockwise from left:
Torso, wood, height approx. 36″
Arrowed Woman, wood, height approx. 48″
Kneeling Figure, bronze, height approx. 30″
All whereabouts unknown

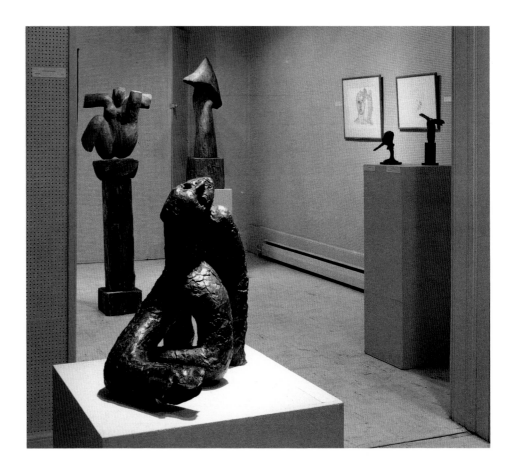

Exhibition of sculpture and drawings,
Stephen Radich Gallery, New York, 1963

On the wall (above):
Passages. c. 1963
Wood, approx. 16 × 66″
Whereabouts unknown

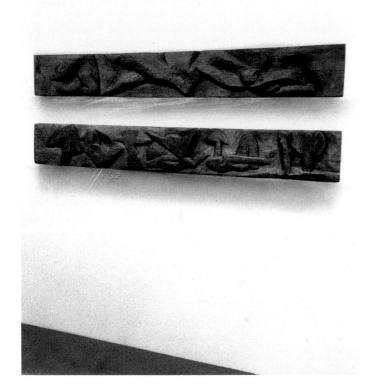

centaurs, and sphinxes. Being such an impressionable substance, wax was the perfect material with which to model several versions of Veronica and her veil, a subject that not surprisingly has held more appeal for painters than sculptors. Among the waxes and the waxes cast in bronze there are also lion-women, bird-women, women in waves, figures coupling, and a number of long-haired women arching their nude bodies backward so that they form a kind of bridge or rainbow reaching to the sky. Some waxes, such as *The Dream Dreaming*, 1959, which depicts a woman embracing a bird-creature, deploy the arrow forms seen in the wooden sculpture, and several of the wax figures are based on Mary's Picassoesque drawings of tubular abstracted limbs.

Like the wax pieces, the plasters on armatures from the second half of the 1950s are improvisational and reveal the process of their making. Also like the waxes, they are light, fragile, and full of movement. The two-and-a-half-inch *Man and Horse*, 1959, pits a slight, off-balance male figure against uncontrollable equine energy and predicts Mary's *Horse and Rider* from 1982. Plaster is applied sparingly, as if there wasn't enough to go around, and the horse seems as ephemeral—and as existential—as Giacometti's emaciated dog.

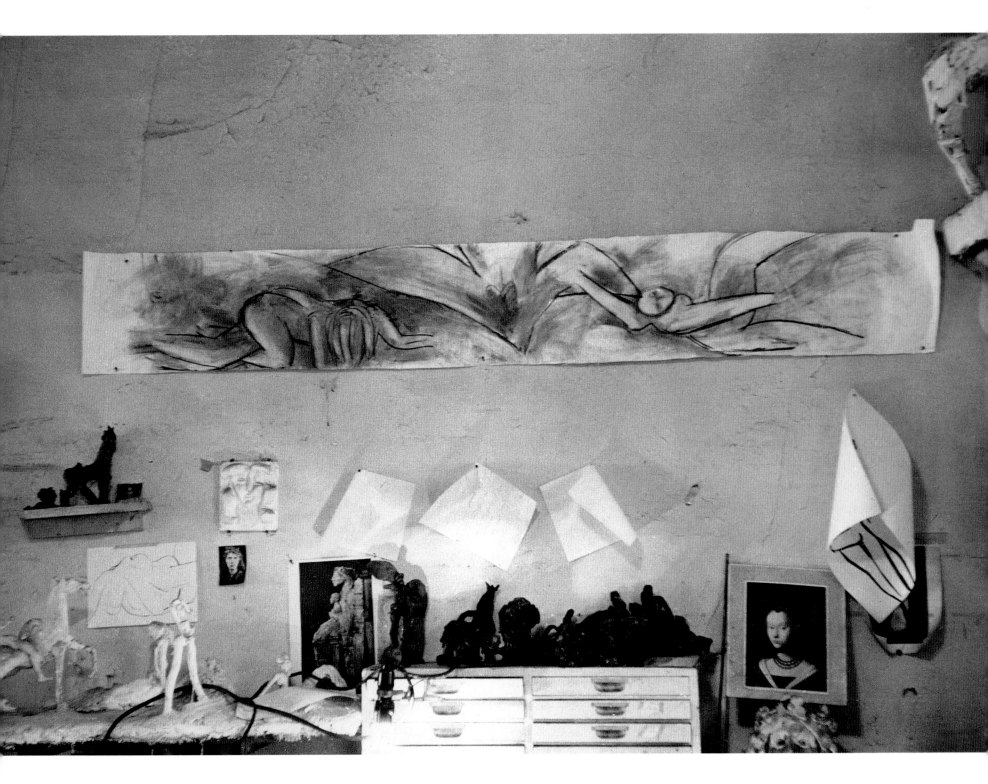

Study for *Passages*. c. 1963
Charcoal, approx. $12 \times 84''$
Whereabouts unknown

33

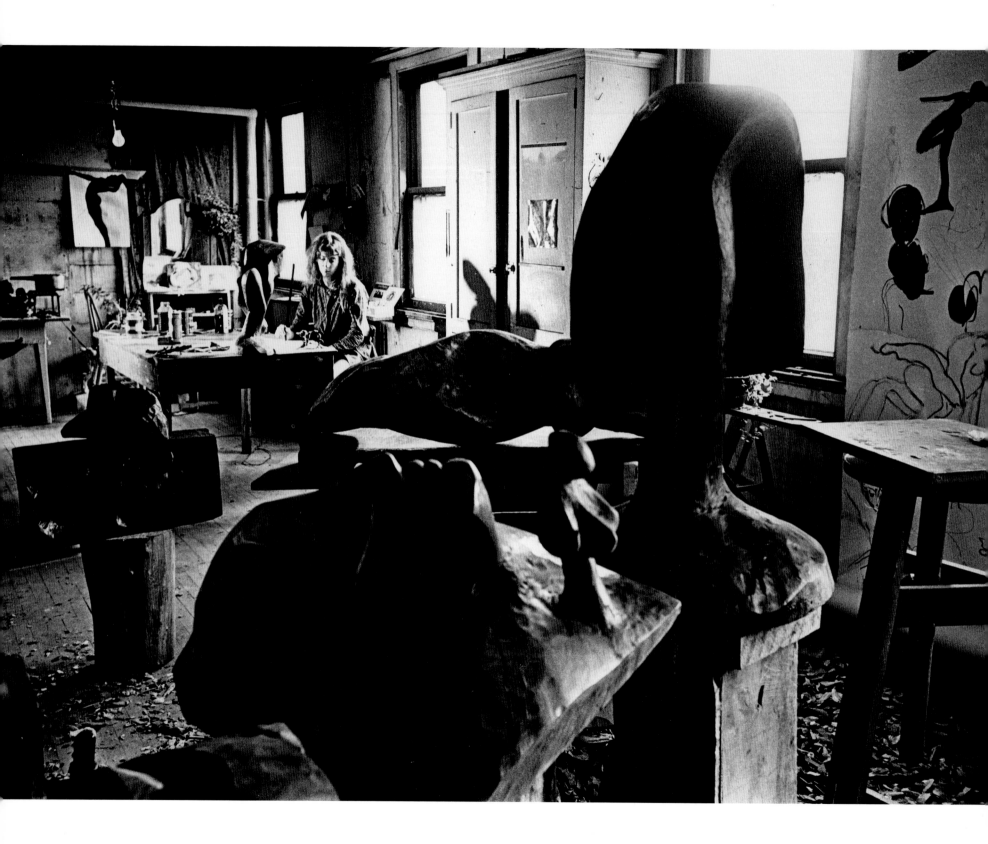

During the 1950s Mary made no effort to forge a career, to exhibit, or to make money. She did participate in several group exhibitions at the Tanager Gallery, a lively cooperative on Tenth Street. Fairfield Porter gave a favorable mention to her work included in one of the Tanager shows, but for the most part she was unknown. "Friends came, saw the work, and they weren't so interested," she recalls. "They didn't find it contemporary." In 1958, because an artist who had planned to show was not ready, the Poindexter Gallery offered Mary a two-person show with the sculptor Paul Harris. For her first exhibition the twenty-five-year-old Mary exhibited large wooden sculptures, small bronzes cast from wax originals by the lost-wax technique, and some charcoal drawings. "It was exciting—lots of people came—but it was nerve-wracking, too. My work didn't seem connected to anything that was being done by anyone else at the time."

It was in the early 1960s that Mary's work began to attract real attention. She had her first one-person show in 1961 at the lively Stephen Radich Gallery on Madison Avenue, and she showed there again in 1963 and 1966. Recognition came also in the form of several grants, and art critics began to take notice as well. In January 1963 Valerie Peterson wrote an enthusiastic article in *ARTnews*, and in March of the same year Hilton Kramer's "The Possibilities of Mary Frank" appeared in *Arts*. Kramer admired Mary's "restless and productive imagination," but he called the wooden sculpture "stolid," "earthbound," and "tree-bound." By contrast, the drawings, he said, "take possession of experience with an exemplary lyric economy."[21] Three years later an *ARTnews* critic was even more complimentary to Mary: "She is so closely in touch with her own creative sources that even a dancer or a bather in a swift drawing can have the evocative and luminous presence of a Klee or a Rilke angel."[22]

Certain of Mary's wood and wax pieces from the mid-1960s began to conceive of the figure not as a self-contained form but as a small vertical in the midst of a landscape. In *Head in Landscape*, for example, a head that looks like a self-portrait is set in a terrain and juxtaposed with a tiny standing figure that could be another aspect of the same woman. To explore this new openness, Mary needed a more malleable medium,

Head and Hand. 1964
Wax, approx. 12 × 18″
Destroyed

OPPOSITE:
Mary Frank's studio,
West 86th Street,
New York, mid-1960s

Foreground:
Head in Landscape. c. 1965
Wood, 11¼ × 19 × 18¼″
Collection Virginia Zabriskie

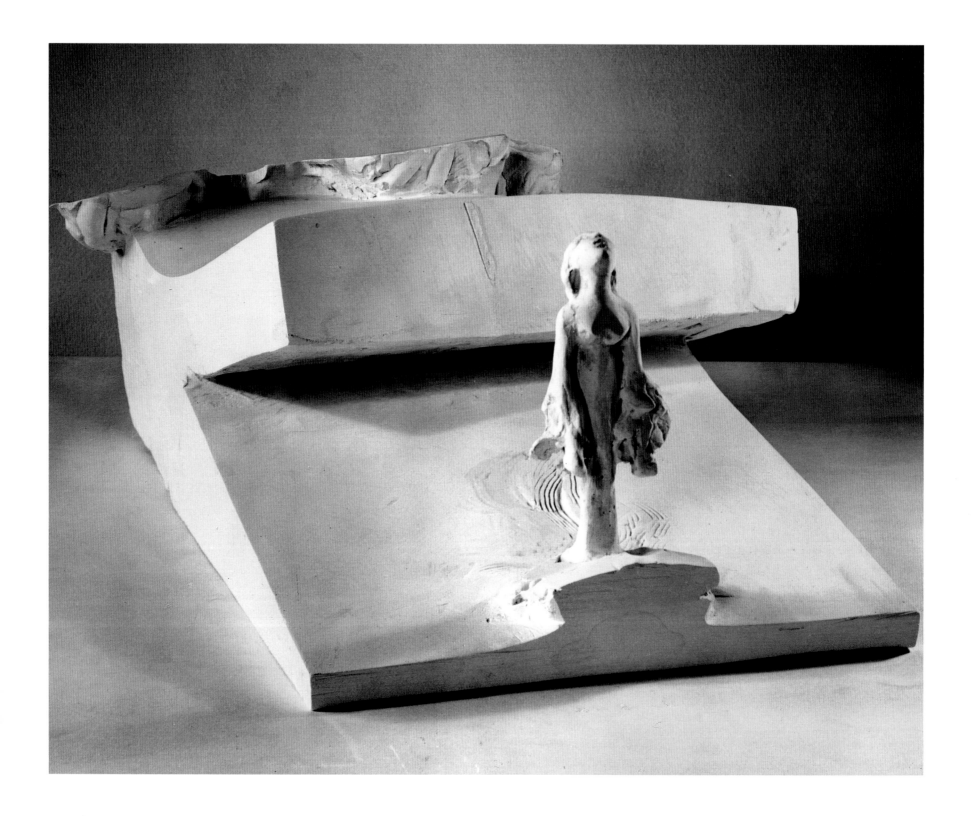

and in 1967 she stopped using wood and wax and returned to plaster, which she now poured into boxes. The plasters have the spontaneity and the unity of impact of Mary's contemporaneous ink-brush drawings. Although most of them measure no more than twenty-four inches wide, their internal scale is vast. "It didn't dawn on me," Mary once said, "that there was no natural way to cut off a landscape in sculpture. In painting you have the frame, like a window. I let the shaping I did of the boxes into which I poured the plaster determine their boundaries."[23]

Mary's admiration for the inventiveness and freedom of Reuben Nakian's plaster sculptures in his 1966 exhibition at The Museum of Modern Art had much to do with her choice of this material. In some sculptures Nakian used a swath of plaster to make a plaque upon which he incised mythological scenes, usually female nudes full of erotic zest. In others he draped swags of plaster over an armature. "I had known his work for a long time," Mary says, "and I always liked the plaster and the clay. The big plaster of *The Emperor's Couch* was a magnificent piece, with the landscape becoming body. Probably I started working in plaster because of Nakian."

Mary found plaster wonderfully responsive to her touch. Plaster can be poured, modeled, reverse-cast (from forms molded in clay), carved, sawed, scratched, painted, and incised. It can be assembled out of a number of parts to make a single structure. Also, it can be added to or subtracted from even after it is dry. "The beauty of plaster," Mary recently said, "is that you can go back any time, even years later, and make changes."[24] Because plaster is quick and cheap, she felt free to try all kinds of unorthodox configurations.

Her technique of pouring plaster resulted in sculptures whose basic format is a horizontal slab squared off by the box that served as a mold. When a few of the plaster seascapes were cast in bronze, they lost some of the freshness and clarity that the contrast of light and shadow gave to plaster, but the dark, hard, luminous metal offered a certain definitiveness that was lacking in the plasters, which tend to have the provisional charm of a sketch.

Most of Mary's plasters from the 1960s depict a small, frontal nude—possibly a self-portrait—standing in the Egyptian stance with one leg slightly forward. The posture implies both movement and hieratic stillness. With stasis and motion in perfect equipoise, the figure can command the vast space suggested by undulations of water or land. But the figure does not impose itself on space; it simply stands there, arms at its sides, a human measure of nature's immensity.

Usually the space is a seascape; a woman standing before a breaking wave embodies that exhilarating sensation of singleness that comes when we confront an elemental force. Perhaps for Mary the erect figure was a kind of talisman, a statement of her instinct for survival. In *Of This Time and That Place*, 1966–67, the solitary female figure stands with her head thrown back as if exulting in both her own strength and in the strength she derives from being one with nature. The wave behind her is sheered off at its lip so that she can never be swallowed in its crash. In any case, she is inviolate; her lower arms metamorphose into what look like branches or perhaps water bursting into foam. Commenting on the origin and meaning of these women in waves,

Of This Time and That Place. 1966–67
Plaster, 10 × 24½ × 15½"
Private Collection

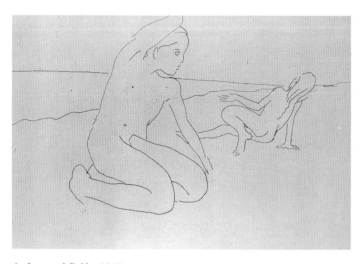

Andrea and Pablo. 1962
Pen and ink, 5¼ × 8¼″
Collection the artist

Mary recognized their mythic dimension. They evolved, she said, from an earlier image of "Daphne coming out of the earth and being transformed back into the substance of it again."25

The figure also came from drawings she made during her summers in Cape Cod, where to this day she can be seen on yearly visits, notebook in hand, walking down the beach drawing the dunes, the bathers, and the distance where sea meets sky. The figures moving along the shore fascinate her. "You lie with your head on the sand. Get your eye down on the level of the snake. I didn't care where I was, only that my eye would be on that level."26 What Mary liked best about this low vantage point was the odd spatial relationships it offered. "I might see my own hand or somebody else's leg nearby, and next to them I see a tiny figure walking at the edge of the ocean way down the beach. I draw the figure tiny and the knee large because that's how it looked to me. People were always coming and going, following the water's edge. And I drew those figures as they would approach, recede, approach—always these entrances and departures and changes in scale. It was very mythic, because people have that look on the beach, always seen against the horizon, against a sort of nothingness."

In her drawings, too, Mary is attracted to figures seen against the sea. Some of the drawings from the 1960s are realistic, such as the one of Pablo and Andrea playing on the sand in 1962 or the 1965 charcoal of foaming waves. Others are more fanciful: a figure stands above its shadow, which takes the shape of a bird; Daphne reaches to become a tree. The most brilliant and dramatic drawings are those in which black ink brushed across paper has the rush and thrill of a bird taking flight. Line is succinct, as in Egyptian frescoes or Greek vase paintings, yet fluent and full of body. With extraordinary command, Mary captures gesture and locates her figure perfectly in space. By thickening the ink or adding pressure to her brush, she suggests volume. As in Franz Kline's black-and-white abstractions, the white paper in Mary's drawings is as alive as the swift black marks placed upon it.

Closest to the ink-wash drawings are a series of small plaster reliefs that Mary exhibited in her 1968 show at the Zabriskie Gallery, where she continues to show today. In several of Mary's plaques bathers frolic in foam, their arms raised, their fingers spread. "When people are standing in water," Mary notes, "they almost always raise their arms. I don't know why. Everyone does. And they look like birds, elbows down, wrists up, hands down. There was that metamorphosis of figures into bird and then into light that took place as you watched from the dunes." As always, Mary starts with observation and moves toward myth.

By the late 1960's Mary had found her own highly original language, a language so consistent within its variety that it is difficult to chart her development. Perhaps because she places greater emphasis on the communication of feeling than on solving formal problems, her work has not developed in a simple progression from one stylistic period to the next. Often she goes back and uses ideas or subjects from years before, and her approach is inclusive—there is no reason why she can't work in several different modes at the same time or even in the same piece. Yet all of her work is immediately recognizable as hers; it is as close to her as her own face. And, though

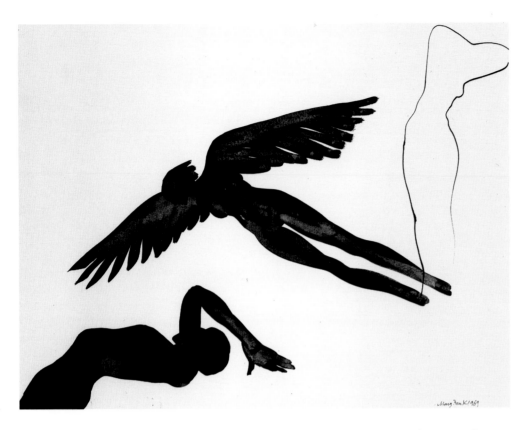

Woman with Bird-Shadow and Man. 1969
Ink, 18 × 24"
Private Collection

there is no programmatic formal development, there are changes over the years that make it possible to know more or less to what moment a given piece belongs.

The myriad sources upon which she draws are cumulative rather than sequential. "There are," she says, "artistic sources, and there are life sources. Sometimes I don't know one from the other. Music has always been a great source for me. I often listen to music while I work. I'm influenced by things I've read. Indigenous art moves me a lot. When I look at art I am bowled over—I mean, the human imagination is of great beauty. Also, friendships with other artists are extremely important. Peter Schumann's Bread and Puppet Theater changed my way of thinking. I think he's a genius. Gwen Fabricant's painting and Jeff Schlanger and Margaret Israel's sculpture have inspired me. I was moved by the way Margaret Israel worked nonstop creating an endless environment that had the appearance of celestial play. Working on monoprints with Michael Mazur has been important as well—the banter and the quick exchanges of ideas about art, about ink, about politics; ideas flying faster than they can be set down. For me, it's a rare experience to work with other people instead of always working alone. I have a real desire for community."

Although she is clearly touched by many influences, both in the art of the past and the present, Mary Frank is essentially on her own. Her work bears little relationship to anything else that is happening in contemporary art. When asked if the current Neo-Expressionist trend had had an affect on the heated color and greater painterliness of her work on paper of the mid-1980s, Mary gives her interlocutor a withering frown.

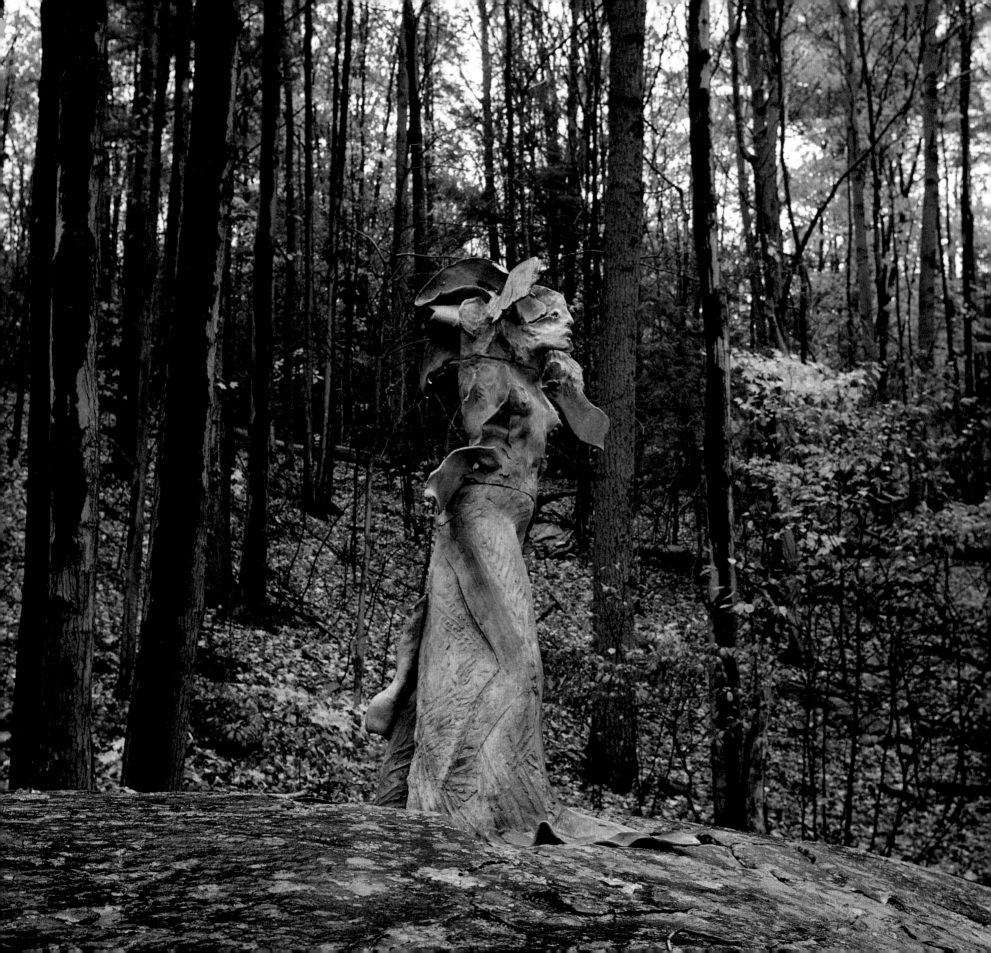

In 1969 Mary and Robert Frank separated. She moved from 201 West Eighty-sixth Street, where she had been living since 1964, to Westbeth, an artists' housing project in the West Village. After the divorce, with large medical bills from being hospitalized with pancreatitis, and with little money, she took a job teaching drawing and sculpture at Queens College Graduate School. For all its difficulty, this was a period in which her sculpture and drawing took on a new poignancy and command.

In 1969 Mary felt that plaster could no longer give form to her vision. "I wanted something else, but I didn't know what."[27] Inspired in part by her admiration for the pottery and sculpture of Margaret Israel, she began to work in ceramic, and since 1969 almost all of her sculpture has been made of clay, some terra-cotta, some raku, but mostly stoneware, which is fired at a very high temperature so that it becomes extremely hard.

Even before 1969 Mary was familiar with clay from her practice of using clay molds to reverse-cast shapes in plaster, and she had made a number of small ceramic wall reliefs that, like her plaster reliefs, were prompted by Nakian's plaques. Yet learning to handle clay was, Mary says, a "big struggle. It wasn't natural. I had no training in ceramics, and I didn't know what I was doing. At first I tried to work in clay as if it were either plaster or wax, and the sculptures were falling apart and blowing up." She took a few lessons at the Ninety-second Street Y with the potter-sculptor Jeff Schlanger. He not only gave her technical advice but also, she recalls, promoted "an open exchange in which we drew together from models and worked together on sculptures."

In the end, clay proved to be the ideal medium for Mary. It suits her earthy conception of form, and it is in perfect accord with the fluency of her vision. After she

Moving Woman II. 1976
Ceramic, 42 × 24 × 28″
Collection of the Friends
of the Neuberger Museum,
State University of New York
at Purchase

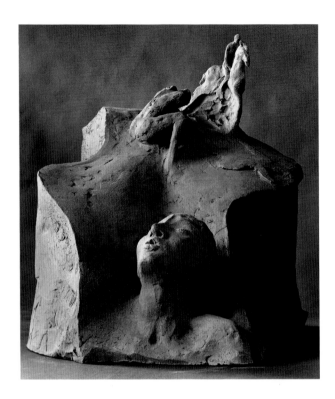

Journey (two views). 1970
Ceramic, 21½ × 22″
Courtesy Zabriskie Gallery

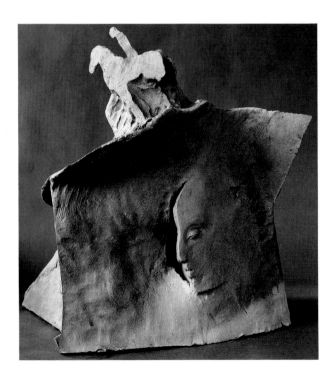

had been sculpting exclusively in clay for a year, she said that she had "never felt as free working any other way."[28] In clay Mary could invent form as she went along, whereas in wood she had to figure out in advance what image she could carve out of the block. "Clay," she said, "is very spontaneous. It's direct, like drawing. . . . Clay is gravity-seeking. There are moments when it seems analogous to flesh."[29]

Mary handles clay in an unorthodox, experimental manner: in life and in art she is impatient with convention. Indeed, there is something unbridled about her creative impulse—she'll try anything, and she is never certain that a piece won't sag, warp, or dry too quickly and crack or shatter in the kiln. Even now that she has been using clay for twenty-two years, her will to explore clay's potential frequently results in the loss of pieces as they are fired.

The critics were enthusiastic about Mary's turn to ceramic sculpture. "Some people felt I found myself with clay—the speed, the imagery—but I never felt I 'found myself' at any particular time. The earlier pieces were just different . . . heavy . . . dense."[30]

In the first ceramic sculptures, hills, dunes, or ocean waves are molded into cumbersome, angular masses as if the clay were plaster poured into a box. Upon these chunky terrains, Mary placed small figures that conform to the landscape's rhythms. Like Chinese landscape paintings, her clay sculptures offer the viewer a number of separate journeys. Whereas the plasters were best seen from one vantage point, the clay pieces are worked from all sides so that the viewer must move around them. A recumbent nude with her head thrown back in *Time Edge*, for example, remains hidden behind the lip of a dune until we shift our position and discover her. The equestrian in *Sea Rider*, 1969–70, is totally invisible from the other side of the immense wave upon which he rides, and in *Journey*, 1970, Mary has placed heads, a crouching nude, and a rider upon a clifflike mass in such a way that they seem to exist at different locations in space and time. The figures' trajectories will never meet, and the weight of their separateness recalls Giacometti's constellations of walking figures in which spatial proximity makes spiritual distance all the more devastating.

Mary's sculptures have no dominant or central axis, and space has no borders. Directional ambiguity, together with a dismissal of the rectangle as a frame of reference, creates a kind of narrative space that has all the imaginative elbow room of dreams. Scale is emotional, not rational. Like a primitive artist, or like an artist as sophisticated as Picasso, she makes forms larger or smaller and places them this way or that according to a subjective idea of rightness or according to the way she imagines it might feel to be inside the skin of the figure she is depicting. As she puts it: "I don't think that anyone feels his head to be necessarily the size it actually is. It depends on mood, on what one is doing, on the time of day. I don't see my scale as a fantasy scale. At the time that I'm doing it, that's really how I see it."

The clay pieces, like the plasters, combine several different sculptural processes— carving, modeling, incising, assembling. But clay's greater hardness and strength were liberating, and Mary's work gradually became more supple and open in structure. The face cut into and then pulled out from the clay slab in *Journey*, for example, would not have been possible in plaster. In *On the Horizon*, 1969–70, the clay waves unfurling into space are light and frothy compared to the weighty waves in the plasters. Here we

see the beginning of Mary's method of constructing sculpture out of thin clay slabs so that air and light interpenetrate with form.

The first clay heads are solid, like those she had modeled in wax. It was only in 1970 with *Conceição Aparecido*, the first split head, that Mary learned to let space mingle with flesh so that the head becomes a container of spirit. It happened by accident. Mary was not happy with the portrait of her friend the Brazilian model Conceição: "I decided to destroy it by cutting it in half with a wire. And then by being willing to give the piece up as lost, I found something." The interpenetration of volume and space is still fairly straightforward in *Conceição Aparecido*. In later heads it will become more intricate and more subtle.

In *Head with Ram*, 1970, the human head metamorphosing into the head of a ram is still treated as a solid volume, but Mary has given this piece another kind of openness that comes from the split between its human and animal aspects. When she made *Head of Pablo* the following year, she neither split nor metamorphosed the head (though there is a suggestion of a goat's head in the swirl of clay that rises up next to her son's face). Instead, she opened up the lower part of the bust by building a mobile structure out of thin slabs that have been cut, twisted, pressed, and propped against each other.

Similarly, in sculptures from 1971 like *Taming of the Harp*, one of several contemporaneous two-part pieces, Mary discovered that clay-slab construction allowed for increased openness, lightness, and spatial complexity. The piece is raised up on an armature—an architectural scaffolding made of clay slabs rolled out with a rolling pin, cut, and set vertically and at an angle to each other. Space moves freely between these buttressings like water around the pylons of a pier. The openness suits the sculpture's theme, which has to do with music and hearing. One section juxtaposes a human ear with a hole cut into a slab out of which a tree grows. The piece, Mary says, was prompted by a Zen story about a harp that many people tried and failed to play. When someone placed the harp upon a hill during a storm, the wind played beautiful music.

"The armature gives a certain thrust to the piece," Mary says. "The initial structure has the bones. I like to be able to see it, and I don't know in advance how much of it will be covered up." Wherever possible the body is its own buttress—a recumbent figure's bent knee, for example, is self-supporting, or the inner surface of a head provides the armature for the outer surface. The transitions between anatomy and armature can be abrupt or gradual, and although the armature itself can metamorphose into flesh, water, wind, or earth, it is usually abstract and geometric in structure. Mary likes the counterpoint between the armature's abstract rectilinearity and the undulant slabs depicting flesh that are laid upon it: "It's as if the body were part place or part dwelling."

With time her armatures became more elaborate, more expressive, and better integrated with the figures they supported. In *Utterance*, 1984, for example, the shapes that function as supports are almost as poignant as the figure itself—indeed, it is difficult to separate one from the other. Mary's armatures hold illusion in check and bring us up short before the concrete evidence of structure and process. In this they are a sculptural equivalent of a modern painter's insistence on the palpable reality of thick pigment stroked onto flat woven canvas.

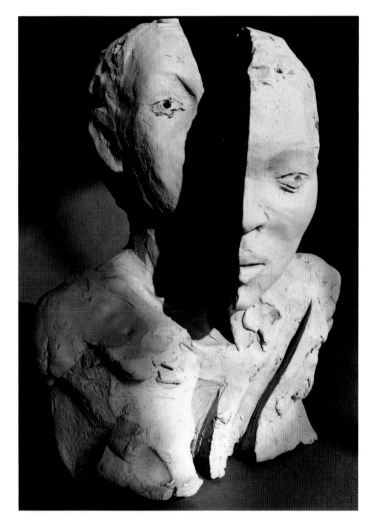

Conceição Aparecido. 1970
Ceramic, 12 × 11 × 9¼"
Private Collection

Head of Pablo. 1971
Ceramic, 19 × 19 × 14″
Private Collection

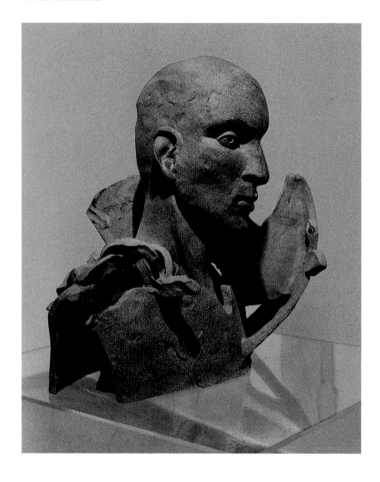

RIGHT:
Taming of the Harp (two views). 1971
Ceramic in two parts, 15 × 10″, 20½ × 12″
Collection Suzanne and Maurice Vanderwoude

On the Horizon. 1969–70
Ceramic, $20 \times 30 \times 22''$
Courtesy Zabriskie Gallery

Woman-Wave. 1971.
Ceramic, $19 \times 27 \times 26\frac{1}{2}''$
Private Collection

On the Horizon and *Woman-Wave*, 1971, give solid substance to an image that appears over and over again in Mary's sketchbooks from Cape Cod summers: hip deep in the ocean, a woman raises her arms to avoid the shock of cold. Whereas in drawings her arms become wings, in sculptures they are transformed into a wave. The wave in *On the Horizon* is a solid mass against which the figure is pinioned. In *Woman-Wave* ocean breakers are tongues of clay that curl around the nude like petals around a stamen. And, like an aquatic Daphne, the bather's uplifted arms become not branches but a hollow swirl of water shaped like a shell. All echoes of the poured plaster process have vanished. A heaving understructure of clay slabs re-creates what Mary calls "the whole quality of the wave—its terrifying energy moving forward and back and spiraling —which becomes very sculptural around the bottom of the body. I worked very hard trying to get that figure moving forward with the force of the water against it."

With clay's greater range of handling comes an expansion of subject matter that is especially evident in Mary's small, sometimes tiny, sculptures. She chooses the most

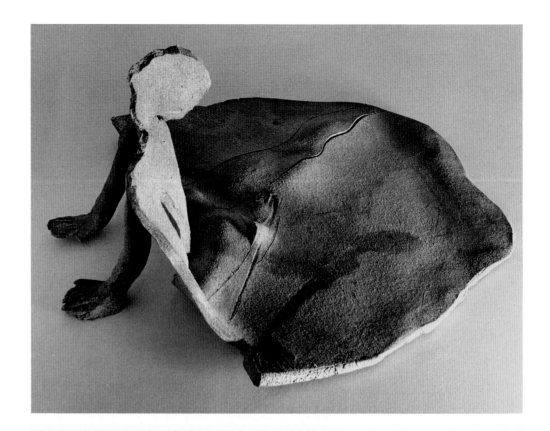

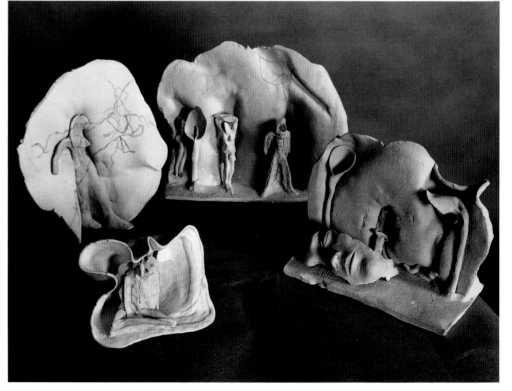

ABOVE RIGHT:
Man Raising Self on Arms. 1976
Ceramic, 8 × 16 × 14¼"
Private Collection

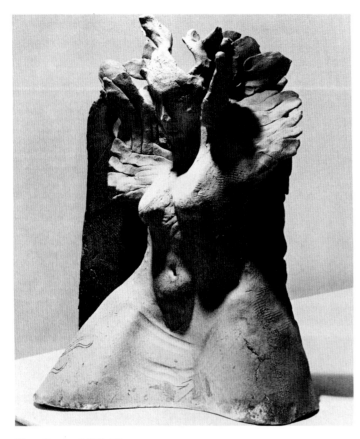

Ghost Dancer. 1972–73
Ceramic, 24 × 12½ × 18½"
Private Collection

BELOW RIGHT (clockwise from above left):

Woman with Paths. 1974
Ceramic, 9½ × 9 × 3½"
Collection Mrs. Robert M. Benjamin

Swords and Lilies Fighting in the Air. 1974
Ceramic, approx. 8½ × 9 × 4¼"
Private Collection

Woman with Lilies. 1974
Ceramic, 8½ × 9 × 4¼"
Collection Robert E. and Lois Gould

Cave. 1974
Ceramic, approx. 6 × 7 × 3"
Private Collection

unlikely subjects for sculpture—landscapes with flowers and clouds, elephants roaming in a vast plain, a woman juxtaposed with her reflection, childbirth, temples, cages, a man pulling away from his shadow *(Man Raising Self on Arms)*, a figure surrounded by intertwining paths that stand for the labyrinths of her mind *(Woman with Paths)*.

While in her smaller works she continued to explore the theme of a figure in an expanse of landscape or architectural space, the human figure in Mary's larger sculptures gradually became more prominent in relation to setting. Thus, in *Torso*, c. 1972, she removed the bather from her watery throne and let her thighs form a base. As in *Woman-Wave*, the torso's upraised arms are transformed into a shell-like wave, but now the wave is larger in proportion to her body; now it subsumes her shoulders and head as well as her arms. The watery swirl looks like a great orifice, and it turns the reddish stoneware bather into a fertility idol. In *Woman in Waves*, 1972, two long, rippling upright clay slabs represent waves that seem to issue forth from the bather's groin. Hands on her breasts, the woman rides a wave's crest, and around her head bursts a mass of striated clay that suggests the rush of surf against flesh. Similarly, in *Ghost Dancer*, 1972–73, the element through which the figure moves (it could be air or water) becomes a mane of clay flanges that spring from the figure's head and shoulders and that look like wings or branches. The figure is no longer integrated into a landscape; rather, the landscape is absorbed into the figure.

Rainbow Woman, 1972, is, like its walnut predecessor *Rainbow Figure*, both a rainbow and a woman arching backward. Her hair falls to the ground like a waterfall, and her tubular limbs made of rolled-clay slabs recall the tubular arms and legs of Pre-Columbian ceramic figures from Nayarit. The backbend motif, familiar from Mary's wax sculptures, appears frequently in her notebooks, and it is a subject that recurs in later sculpture as well. Pressing her belly toward the sky, the arched woman makes herself into an offering. The posture has a more concrete meaning in *Birth*, 1972, where the woman arches to push her baby into the world. One of the most dramatic images of parturition ever made, *Birth* brings to mind the equally ferocious depictions

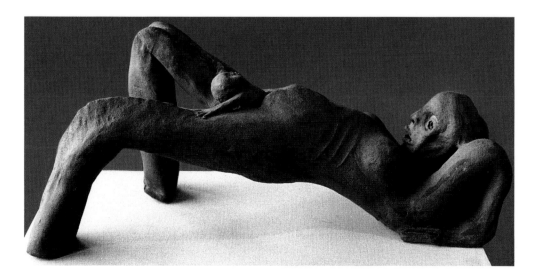

Birth. 1972
Ceramic, 10 × 22″
Collection J. and R. Baron

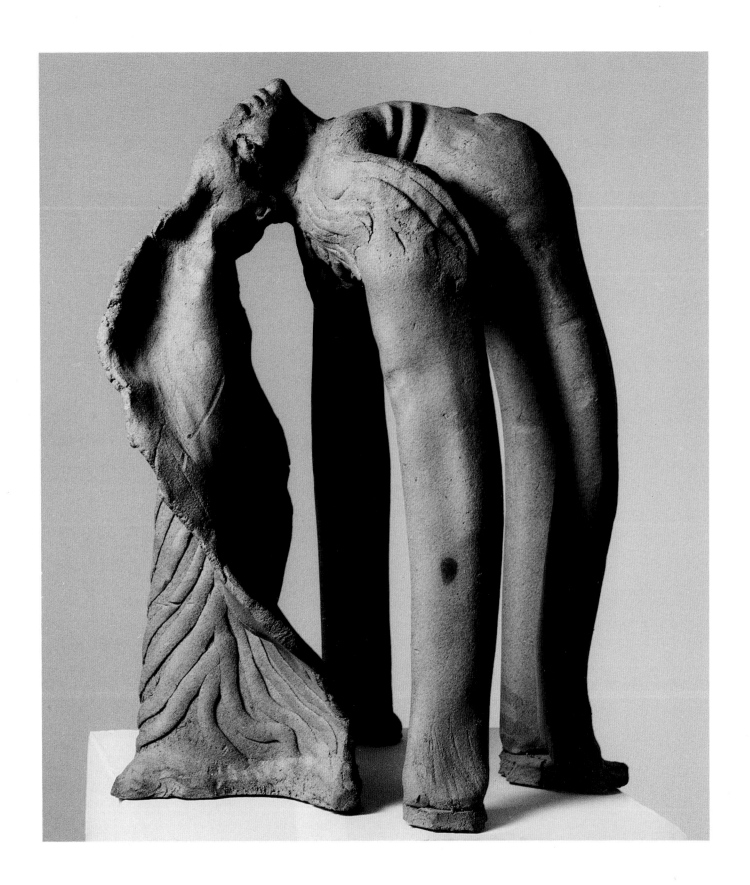

Rainbow Woman. 1972
Ceramic, height 19½″
Collection Mr. and Mrs. V.
Henry Rothschild II

OPPOSITE:
Creature. 1972
Ceramic, 31 × 12½ × 17″
Private Collection

of birth by such Mexican artists as Frida Kahlo, Diego Rivera, and José Clemente Orozco.

In the early 1970s Mary began what was to become a long series of female figures plunging forward through space. In *Creature*, 1972, and *Moving Woman I*, 1973, the substance through which the figures move is indicated by ripples of clay at the figures' bases and by striations where Mary has dragged her fingers through wet clay. *Moving Woman II* (p. 40), from 1976, shows the direction that Mary's work would take in the next years. Hand pressed to breast, clay plumes flailing about her head, this woman cleaves space with a majestic force. The faces of all three women are as trim as ships' prows.

The differences are as marked as the similarities. *Creature*'s head is divided into three parts—goat, woman, skull. No doubt Picasso's psychologically charged, double profiles lie behind Mary's split heads, but in *Creature* the device is used with a primitivism that recalls Mexican popular art (masks, for example, or pottery figurines) as well as Pre-Columbian art. When compared to the other moving women, *Creature* looks put together, not quite integral; her grotesque awkwardness is part of her strength.

By contrast, a single current of energy runs through the body of *Moving Woman I* and unites her with space. Her unity is based on a terrible reality; Mary made *Moving Woman I* after reading about the death of a young woman who was splattered with gasoline and set on fire by a group of youths in the Roxbury section of Boston. This explains the horrific scream on the central portion of her three-part face and the peculiar urgency of her rush into space. The flow that unites the body and joins the body to the landscape is even more subtle in *Moving Woman II*. The air displaced by her forward movement is transformed into volutes of clay that, like the metal protrusions in Umberto Boccioni's *Unique Forms of Continuity in Space*, 1973, bring space into the figure and the figure into space. *Moving Woman II* is a stunning embodiment of the forest that became the terrain of Mary's myth-making after she bought the house in Lake Hill in 1973.

With Mary's turn to clay, other sculptural themes emerged. One, the sundial, is basically a tower or stalk surmounted by a roundish slab whose sheared-off surface catches the sun. This slab is sometimes warped or hollowed out to form a shadow trap or stage where figures and animals enact ritualistic ceremonies that are part of the greater drama of the sun's passage.

The first sundials, made in 1969 and 1970, have heavy, architectural supports reminiscent of the solid, squarish structure of the poured-plaster sculptures. The sundials mounted on these shafts are usually organic in shape, and the concavities hollowed out in them are geometric. In the triangular stage cut into the surface of *Sundial I*, 1970, a standing figure confronts a figure projecting from the stage's wall. The drama is heightened by the play of the figures' cast shadows.

As the sundials developed, they became taller, thinner, more graceful. Their shapes resemble flowers perched on stems. Hungry for light, these blossoms tilt, sway, and open. The top section of *Sundial and Dance*, 1972, undulates like a poppy. In the petaled bowl, lovers embrace. Nearby, but much larger in scale, a face embedded in

Moving Woman I. 1973
Ceramic, 35½ × 19½ × 19″
Private Collection

OPPOSITE:
Sundial I. 1970
Ceramic, height 25″
Collection Dr. and Mrs. Jerrold Lieberman

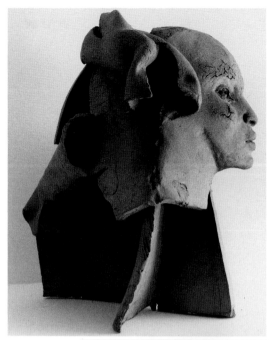

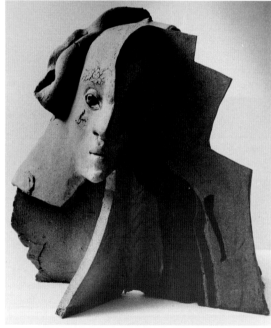

Nighthead (two views). 1971
Ceramic, 20 × 19 × 19″
Collection Suzanne and Maurice Vanderwoude

OPPOSITE:
Sundial and Dance (two views). 1972
Ceramic, 33 × 19 × 16″
Collection Peggy and Alan Tishman

clay stares upward. Such half-buried heads recur often in Mary's sculpture. They look like swimmers floating in water or like sunbathers half-submerged in reverie. Out of sight of the partially buried head and hidden also from the lovers' view is a larger upturned face that rests on the sundial's vertical support. These scale jumps and abrupt switches in orientation suggest the peculiar distance between people on a beach—a figure cradled in the cleft of a dune, for example, and a figure standing on the shore might share the same stretch of sand without ever acknowledging each other's presence. Again the physical proximity and spiritual distance bring Giacometti to mind, but his was the loneliness of city streets, whereas in Mary's sculpture the drama of human separateness is staged in the bosom of a dune.

In the early 1970s Mary made her heads even more open to space. From one side, *Nighthead*, 1971, appears to be a fully modeled female head, but from another viewpoint we see that it is abruptly sliced off just to the left of its center. On the resulting flat vertical plane and continuing onto one of the vertical slabs that buttress the head, the silhouette of a nude painted in reddish-brown iron oxide seems at first to be a passing shadow. The silhouette may also be seen as a thought or the fragment of a dream moving through the head's temple-like inner space.

In *Nightself* and *Head* Mary affixed a small, nude arched woman to the sheared-off plane of a split head. Both of these 1972 heads are cut down the middle and then doubled to suggest that, in thoughts or dreams, a person can inhabit more than one space and time. *Nightself* is made of two separate heads that do not touch. This radical approach to sculpting a head allows Mary to treat the head as landscape. "A head," she says, "is such an incredibly complex thing to try to come near or enter that to do it just as a naturalistic head doesn't seem possible. To capture the movement that goes on in one eye would be enough for a few lifetimes."

Running over the cheeks and foreheads of many heads are miniature reliefs printed from small clay seals carved in intaglio and inspired by ancient Mesopotamian cylinder seals. Some of Mary's seals are flat, most are cylindrical. She uses them to imprint wet clay with reverse images of lovers, riders, horses, birds, hands, and nude figures. Because she usually prints the seals on her clay slabs before she builds them into sculptures, the final placement of the seals is somewhat random. At other times she rolls the cylinder seals quickly over a finished sculpture almost as an afterthought, and placement seems equally arbitrary. The seals' impressions bear no logical relationship in terms of space, scale, or iconography to the figure on which they are imprinted. Frequently they are hidden in hollows or they are just barely discernible on the underside of an arm or leg.

The unpredictable placement and the fact that the tiny relief images only appear in a raking light give her sculpture mystery: the seals are like fossils. Another moment in history seems to be played out simultaneously with the present reality of the figure itself as the past is gathered and coded in human flesh. "I love the idea that I can make a migration of birds from one carved bird just by rolling the cylinder over and over and over. I like the sense of continuity that comes from the way the same bird or deer appears on different sculptures."

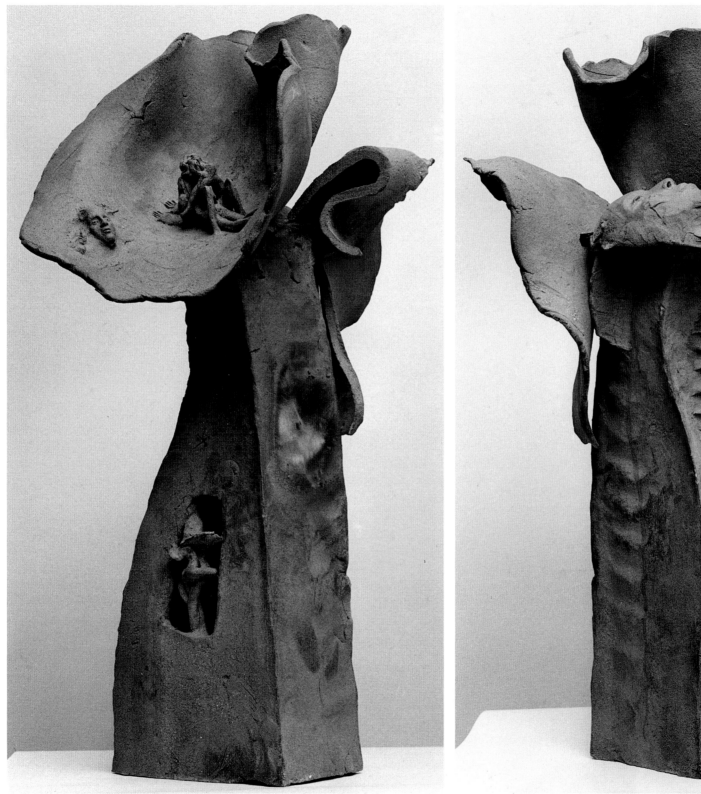
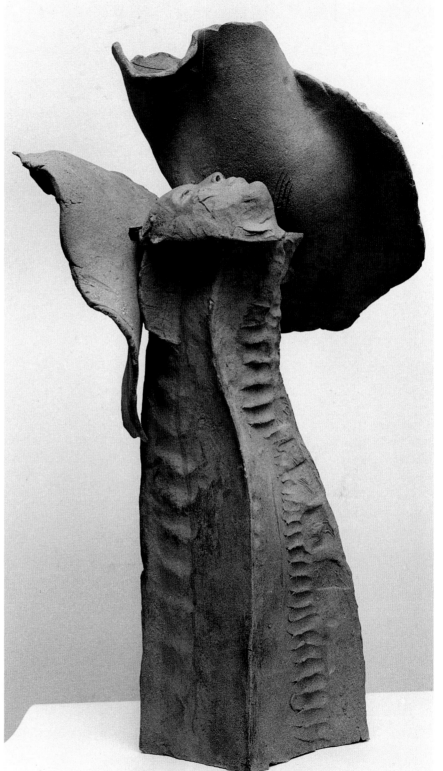

Nightself (two views). 1972
Ceramic in two parts, 24½×36″ overall
Private Collection

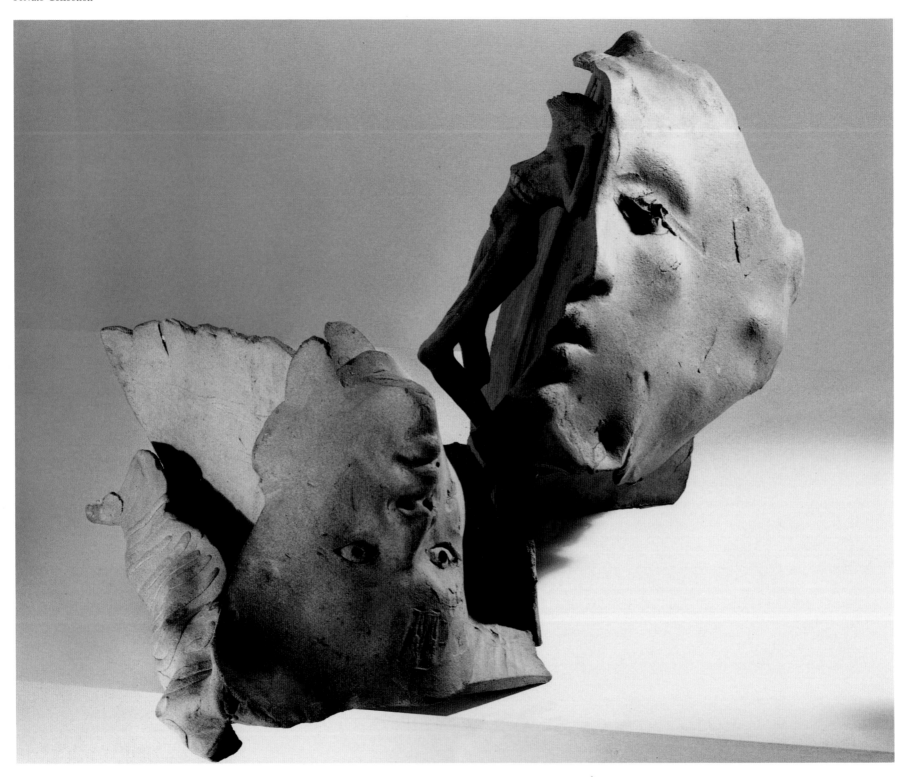

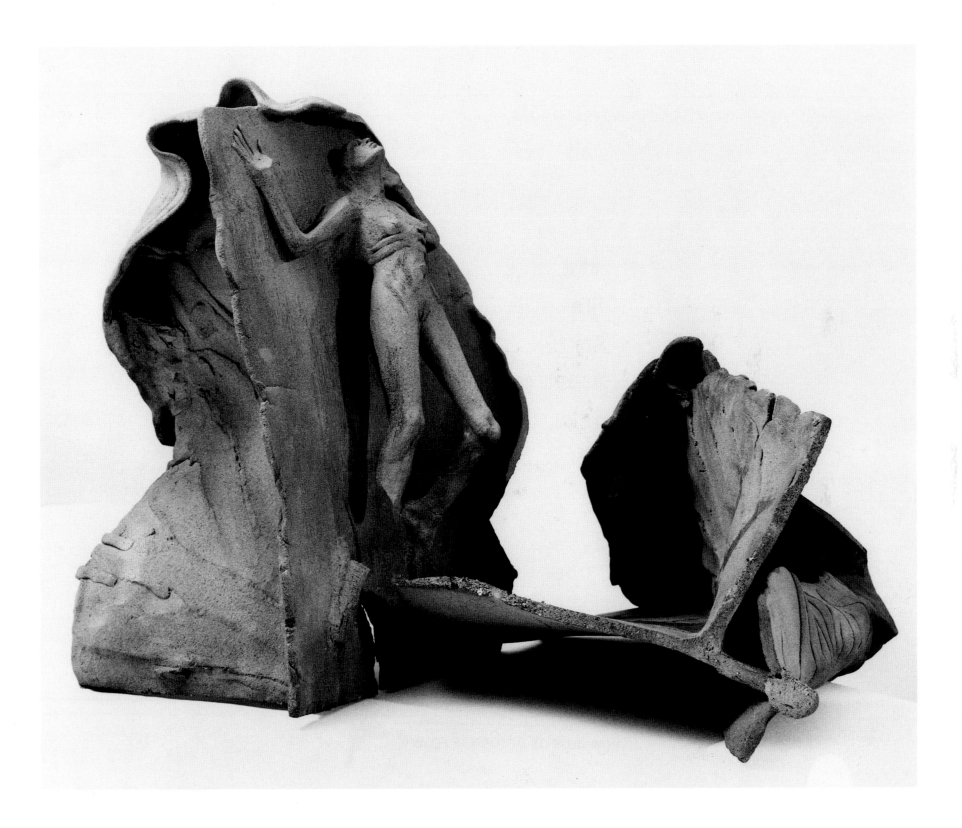

Like hieroglyphs on Egyptian sculptures, the seals give Mary's sculptures a commemorative look: some of them appear to offer information about an event— perhaps a victory or a death—that occasioned the making of the sculpture. In *The War Is Over*, 1972, for example, this look holds an ironic edge. The piece bears witness not to an ancient triumph but instead to the current and ignoble war. The seals that decorate this hanging scroll represent aspects of life that war could destroy: leaping figures, antelope, a boar, and a fern. The scroll's irregular edges make it look like a skin hung on the wall, and the way it is incompletely unfurled and cut through the rolled lower edge carries a note of pathos, as does the inscription taken from a Chinese poem from the late Tang dynasty that Andrea had copied out as a child when she was still too young to read:

> The War Is Over
> The Emperor Screamed
> Calm Summer Afternoon
> Dahlias Were Blood Red
> Victory!!
> We Were Defeated Leaving Shame and Hunger.

Upon another seal-imprinted plaque, this one made to be photographed for a poster that Mary designed for the huge march for nuclear disarmament that took place in New York in 1982, one word is inscribed inside a human profile: "Life." The seals depict figures, reindeer, a branch, a fish—all aspects of life endangered by nuclear holocaust.

In the early 1970s Mary Frank began to feel frustrated by the limits in scale imposed by clay. In 1972, when she began a six-foot-long woman (finished the following year), she figured out a way to make life-size recumbent figures by assembling them out of separately fired sections. "I started with the head and then somehow it just seemed possible to continue. I literally went down the body and then came back to the arm." Since then she has completed some two dozen large figures while continuing to work on a smaller scale as well. The largest upright figure, *Moving Woman II*, 1976, is only three-and-a-half feet tall. For obvious reasons all of the life-size figures, except for two 1981 plaster figures entitled *Running Man* and *Walking Woman*, recline. Without losing the intimacy and spontaneity of the smaller works, the large-scale figures gain in emotional force, and the scope of their ambition is monumental.

The large figures' separately fired sections form a continuous image, but parts are not necessarily contiguous. Limbs can be moved around; position is provisional. Indeed, when these pieces are in her studio, Mary is apt to turn a limb this way or that so that an arm may first be concave, then convex. Or she might exchange one extremity for another; nothing in her work is final. As with the shifting planes that make up a Cubist figure, the sections of a Mary Frank sculpture demand that the viewer put the figure together in his or her mind.

Woman with Outstretched Arms. 1975
Ceramic in eight parts, 91 × 64" overall
Collection the artist

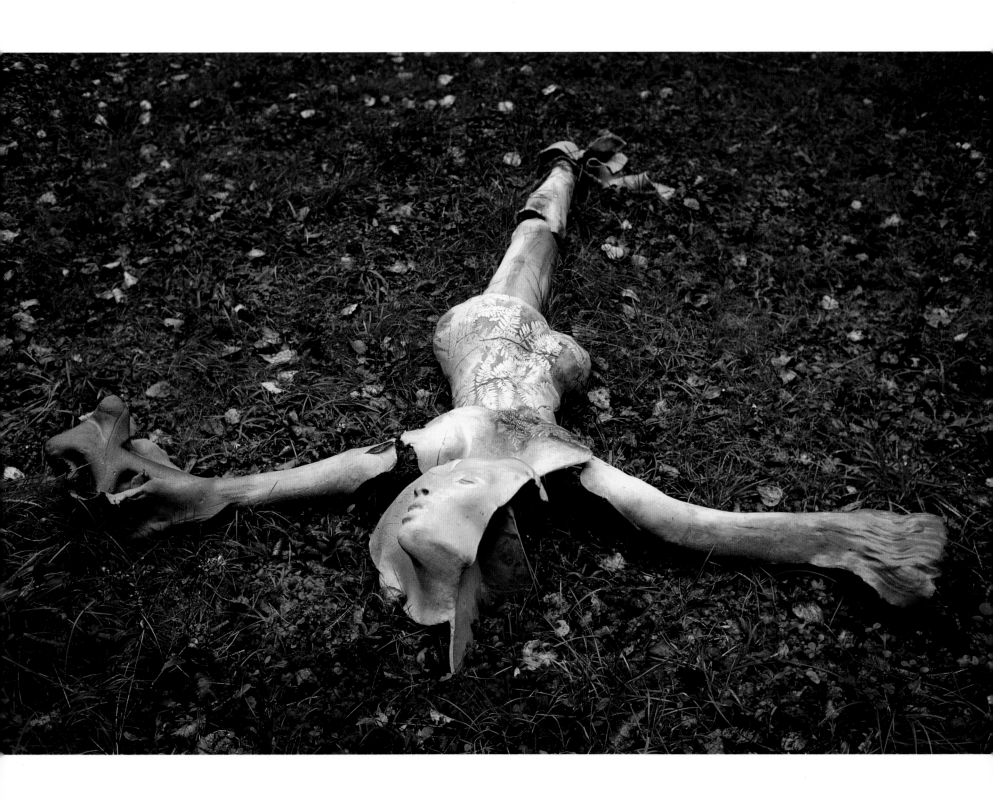

Walking Woman (detail). 1981
Plaster and branches,
65×61×57″
Courtesy Zabriskie Gallery

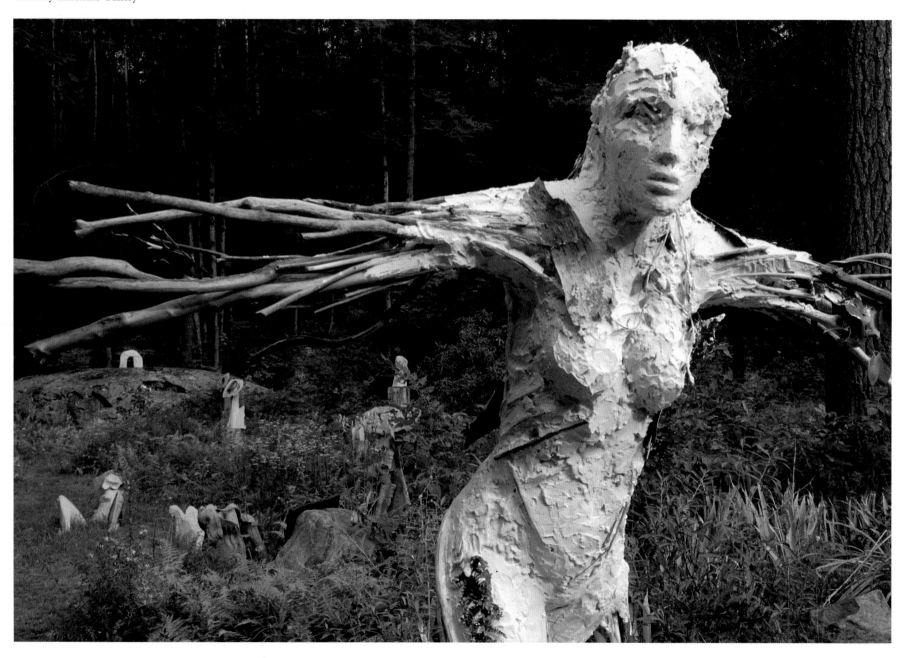

Running Man. 1981
Plaster and branches,
63½ × 25½ × 45″
Courtesy Zabriskie Gallery

Walking Woman. 1981

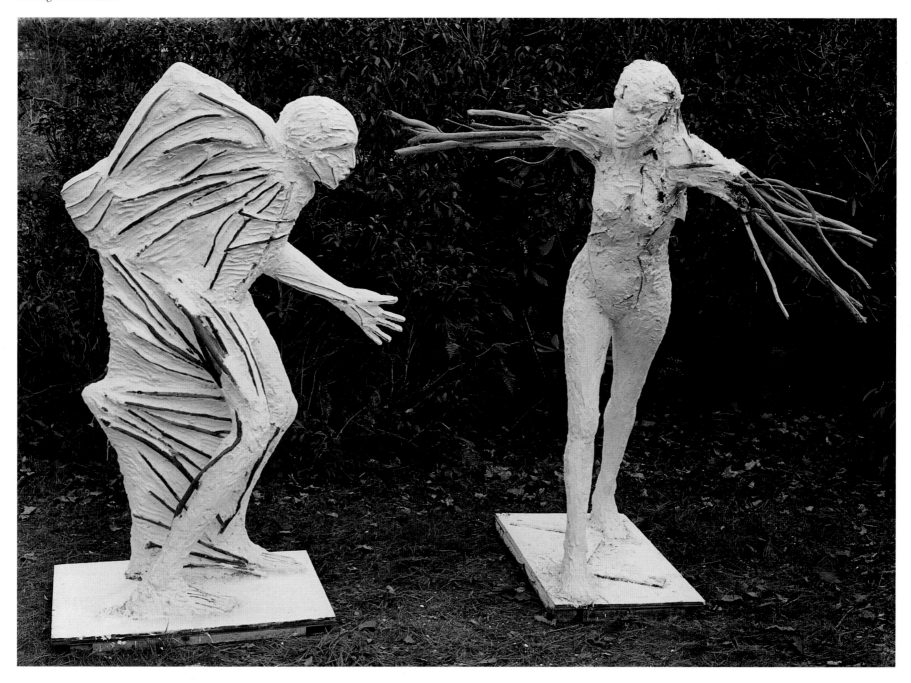

The War Is Over. 1972
Ceramic, 9½ × 7¾"
Collection Suzanne and Maurice Vanderwoude

The breaks between sections usually occur at the joints, giving the figure a natural coherence in spite of the artist's bold departures from verisimilitude. The fragmentation recalls Picasso's anatomical dislocations, his emotionally charged torsion, his ability to turn a figure inside out or to replace volume with void without forfeiting wholeness and function. Like Picasso, Mary distorts anatomy in such a way that her figures seem to be felt from within rather than seen from without. The expressive force of her disjunctions also recalls the fierce breaking up and reassembling of the female body in paintings by Willem de Kooning.

Many people see the fragmentation of the large sculptures as painful, but Mary, with her will to oneness, insists that the separate sections are part of a single flow of energy. The interstices are alive for her: "I don't think of them as voids," she says. The figures often lack a hand or foot, but this is not an amputation. When she looked at ancient Greek sculptures in the British Museum, she often preferred the broken ones—they seemed the most completely alive.

Missing limbs in Mary's sculptures are like missing extremities in drawings where parts are left out so that the viewer can imaginatively complete the image. The undepicted parts can also be imagined as merged with their surroundings—buried perhaps in sand or autumn leaves. If a torso is nothing but a shell and a face is but a mask, this does not make the figure less whole. For in her work, space moves in to fill the emptiness. "I needed to make a figure with a lot of space inside and a lot outside," she says. "The space moves back and forth like breath." As space, joined by light and shadow, flows into form, it carries us with it. This mingling of space and shape suggests a coupling. Etched on a recumbent woman's terra-cotta thighs are lines that track space's entry. Because the penetration of space is so sensuous, these lines also seem to declare sensation's passage.

The recumbent figures are usually female. Men in Mary's work tend to play a more active role. They propel themselves through space by swimming, running, leaping, loving. Six of the large ceramic figures of women lie on their backs with one or both knees drawn up and with their raised arms clasped over their breasts, forming an open gateway that invites the elements to enter. The undulations of bellies and breasts or the steep pitch of a bent knee bring to mind the ancient metaphor of woman as mountain. The earliest of these figures, *Woman with Wave*, 1973, and *Landscape Woman*, 1973–74, seem to be partly buried in water and earth, for they do not have feet, and their bodies are molded out of clay slabs whose curves are cut off before they move down and around to shape a volume.

Fragmentation could imply the sensation of a limb's separateness, triggered, for example, by the tingle of sun and salt on a bare arm, or by water lapping at a foot. The detached limb's openness to space also expresses the almost pleasurable tug of mortality we sometimes feel when we are most alive—flesh sinking into and merging with earth, water, and air. Conversely, the spaces between forms could express the idea of a figure being born out of the earth. The sculptor performs her own kind of genesis: clay becomes flesh, a body becomes landscape, landscape becomes clay. These recumbent nudes are images of multiple fertility: female, artistic, and terrestrial.

Leaping Man (two views). 1977
Ceramic, 15×22×8″
Courtesy Zabriskie Gallery

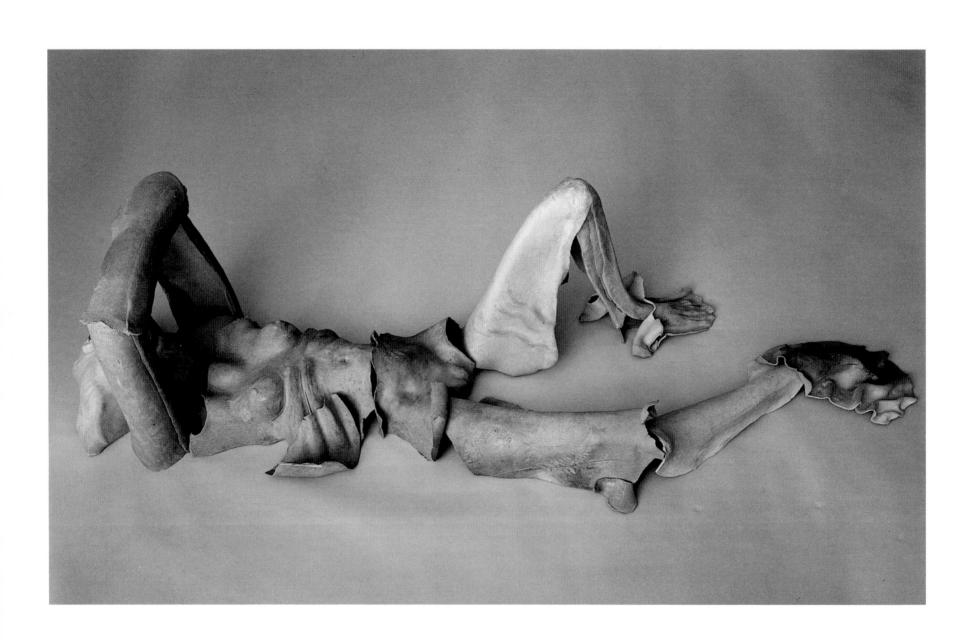

Beginning in 1975 the women with arched arms became less like fertility goddesses and more like corpses. The belly is still rounded, the breast still full in *Woman*, 1975 (in the collection of Richard Lippe). Her knees are still drawn up and open as if she were ready to give birth. But shins and feet are bony, and ribs protrude as flesh sinks back upon or tears away from the skeleton. Like those of the earlier recumbent women, *Woman*'s lips are parted, but now not in rapture; now the mouth is agape. Her single eye with its punctured iris is not, like the eyes of earlier women, closed in reverie. It is wide open, and, like a socket in a skull, it will never close. The arched arms of several recumbent figures have become handless, helpless, and more abstract. The gesture of clasping the forearms over the chest no longer suggests a rejoicing in physicality, nor does it seem to welcome the world. Arched arms now look like the portal to a tomb.

On December 28, 1974, Mary's vibrant and venturesome twenty-year-old daughter, Andrea, was killed in a plane crash in the Guatemalan jungle near the Mayan ruins at Tikal. Mary wrote in a sketchbook: "I'm 41, in February I'll be 42. Andrea died. She was twenty—half of my life but all of hers. . . . I feel my sorrow well up like a hill, a smooth hill with no grass and deep sides. It stretches past my ribs to my hands and beyond, and inside the hill it cries."

In 1975 Mary's mother nearly died from cancer (she lived until 1986), and within a year of Andrea's death Mary learned that Pablo, already stricken by his sister's death, had developed Hodgkin's disease. The struggle with what she described as a "medical forest . . . tapping the trees for answers, digging and probing the hospital halls," did not drown out the horror of losing Andrea, but it forced Mary to keep going. To hold herself together, she worked, but it was a struggle: "I know that part of the reason it has become so hard for me to work," she wrote in March 1975, "is that so many pieces have become so directly connected to Andrea. . . . I am always looking and sensing the shape of her face or glance or gesture—it is some kind of terrible inner research that I don't really want to do nor can I stop." Two years later she remembered: "Sometimes I couldn't even look at the work when it was done. I just felt everything was so totally sad. I can't avoid this imagery, because I feel surrounded by it. Also my mother; Pablo. My daughter's was an actual death, but the others' were the presence of it. Everything I would do would come back to that kind of imagery. . . . I couldn't get away from it except by drawing—from life, from a model, a plant, from something that didn't feel so aware."

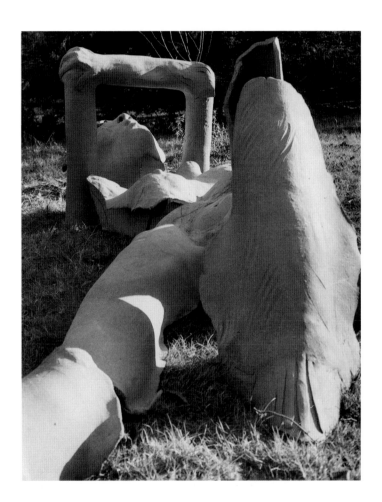

Landscape Woman. 1973–74
Ceramic, 2' × 8'6" × 2'11"
Collection Vera List

OPPOSITE:
Woman. 1975
Ceramic, 2'11" × 8'8" × 2'
Collection Agnes Gund, New York

In a 1975 sketchbook she wrote: "Andrea's things, all over tiny bits of paper—photos, addresses, notes, bills, remembers, jewels, unfinished thoughts, unmailed letters, clothes unsewn . . . saving for a time she didn't have. I try to clean my house, my eyes of these tiny things, the microcosm." Two pages later she said: "Friday—what is it? Pablo has Hodgkin's disease. He's very sick. They will give no prognosis. . . . Andrea, my mother, What's happening. Where is my life—Where is Andrea's—and Pablo's. . . . I keep on trying, Sisyphus—endlessly trying—hoping, wanting to believe—thinking I must have some powers . . . I feel hollowed out, carved out. Tried to work, all bones and old blood color—tearing the paper, working hard and fast but not able to let go—crying. . . . This week is already years old."

"Oh God, I want a sanctuary," she cried out in another of her notebooks. She found solace in the support of friends. In her garden—the birches, the creek running over rocks near her house in the Catskills—she had a kind of sanctuary. By May 1975 she could write: "How could flowers mean *so much?* Who are they for—for us, for themselves, for bees and hummingbirds, for God, for existence?" A month later she said: "The vegetable garden is a great pleasure, although very demanding, almost like a baby—well they are baby plants. Some are adolescent—actually spinach hit its prime and started going into middle age rapidly." And in the same month: "June is really abundance—I always forget how much, although July becomes even more so—In the garden, everywhere foxgloves, fat bees working their way into the throaty places . . . the triumph of patience, the harebells appeared after three years . . . ! The paths weaving all over are beautiful and invite you to move around the space as in an ancient dance. . . . The birches seem more like bones reaching to the sky than ever, and the four or five on the way to the arcade [the archway of tied witch-hazel branches] have a tenderness that touches. . . . What a world it is to sit on the ground in a meadow, lots of chirping and buzzing, whistling, rushing."

This life-seeking plunge into nature's cycles revealed itself also in sketchbook drawings in which every line tracing the edge of a leaf or the roots of a tree is impelled by the artist's gratitude for natural beauty. Mary worked to affirm life, but, she said, "Work is very hard—doesn't flow at all, maybe because I'm not working with what I'm seeing, until [I drew] the poppies." In this notebook Mary drew poppies with dark crevices at their centers and ragged petals that are nonetheless vibrant with life.

When autumn came she wrote: "Schwartzkopf singing her heart out with Mozart . . . knowing all the things Andrea will never know, see, feel anymore—seeing her before me sharp all the time, enraged, crying, laughing, riding horses, moving her belongings from one valise to another—as a baby, long fingers, a lot of thick dark hair . . . looking at the sculptures, part bone, mostly women, some with leaves, the jungle imprinted. The figure of the woman in flames trying to get out. . . ." And a few months later: "I cannot heal him, Pablo—This is not how I thought my life would be—this is not how I thought his life would be. It is not how I thought Andrea's life would be. . . . I must separate myself more from how it has become, but I have had no preparation for how it has become—and I'm afraid if I separate myself I'll disappear or give up—and if I don't I'll die."

Woman. 1975
Ceramic, 22 × 92 × 28"
Collection Richard A. Lippe

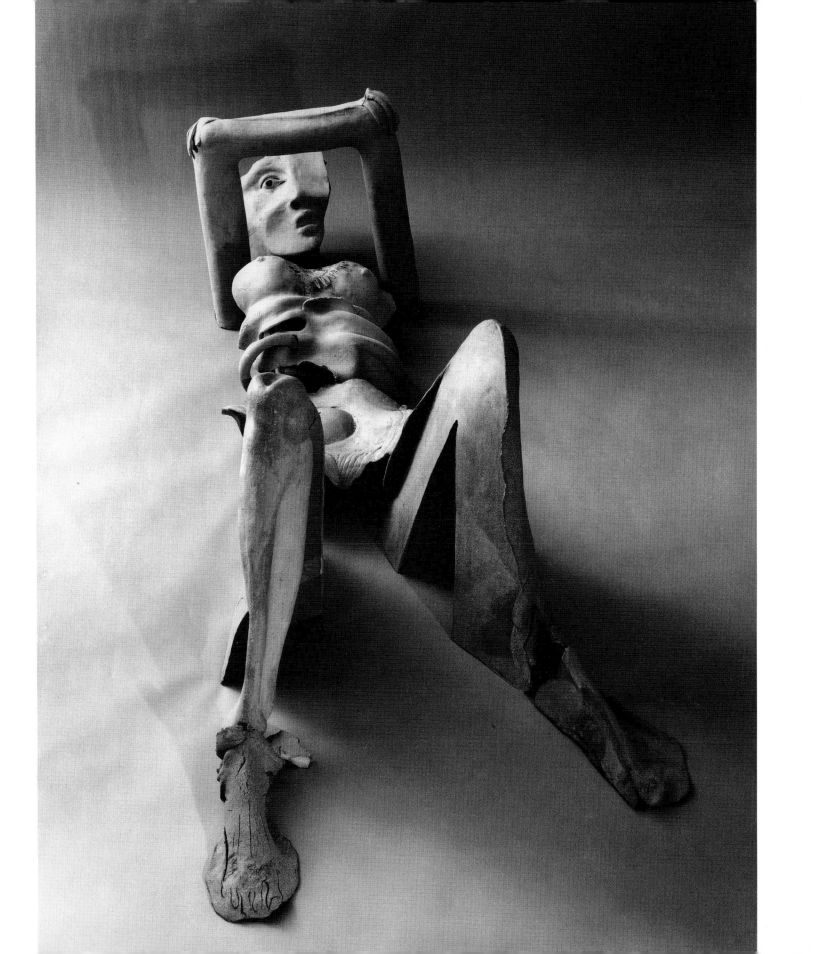

These feelings of being "hollowed out" by pain are vividly expressed in the Richard Lippe *Woman*. In describing this figure or one like it, she mentioned "leaves, the jungle imprinted," perhaps thinking of the jungle where Andrea died at Tikal. Using real ferns and leaves as stencils pressed against her large-scale women's flesh, Mary brushed iron oxide powder around them. During the firing process, the iron oxide oxidized and turned rust color or dark brown—the color of "old blood." The imprinted leaves suggest the idea of the body replenishing the earth after death.

The notion of using plants as stencils came to Mary when she noticed the marks plants left on her own skin after she lay in grass or on fallen leaves—again the intimate bond between her body and her sculpture. Because the plants' imprints make her figures look like fossils, they underscore the sculpture's archaic aura. They also make vivid the notion of mythic transformation—woman into landscape, landscape into woman—that is central to all of Mary's work.

Although it is still poignant with sorrow, *Woman with Outstretched Arms* (p. 57), a Daphne figure from 1975, suggests the idea of transcendence through transformation. Lying on her stomach, arms flung out, Daphne looks like a figure fallen in flight. Yet she is full of vigor as ferns grow on her back and buttocks, arms become water and foliage, and her face turns up to absorb the sun's life-giving rays. The eight parts that make up her body were to have been suspended on a wall, but when Mary saw that Daphne's outstretched arms, single leg, and cast-back head evoked Christ's crucifixion, she decided to leave the figure lying down. Today Daphne lies on the grass beside the Lake Hill house. Mary will never part with her, for however much Daphne is a cry of grief, she is also a paean to earth's rejuvenating powers.

More unremitting in its despair is the skeletal *Woman with Winged Arms*, also 1975. Wings that look like shards fold in toward her body and end in clay slabs. Mary molded one of these slabs on her own hand and placed in its upturned palm a miniature human head, an emblem of loss, of stone-hard memory. The other hand, turned down to caress the earth, bears the imprint of a bison seal. In another recumbent figure from 1975 (in the collection of Mary's friend Agnes Gund), fragmentation takes on a note of horror. Here the figure's union with nature is death dealing, not life giving: transformation means decay. Mary herself was "horrified by the recumbent woman in the Gund collection—its starkness, the straightness of her legs, is really hard to take."

Some of Mary's smaller sculptures from the mid-1970s are icons of grief. A *Kneeling Woman* stares upward and clasps the sides of her head as if she were screaming (p. 1). A man is thrown back upon his arms like a dying warrior on a Greek pediment. A figure lifting his torso out of a flat slab (p. 46 above right) seems to fight for life against the pull of gravity. In some plaques the clay slab is torn open, and out of the earth, like Lazarus, a body emerges. A frantic need for calm and for the relief that comes with ceremony is felt in a scene in which three women mourn over a baby lying on an altar, as well as in several sculptures of enthroned women. One, which is similar to an earlier pietà (p. 127) that expressed Mary's sorrow over the Vietnam War, holds an empty folded cloth in her arms; another bows her head over her empty lap and arms.

Lover. 1977
Ceramic, 23 × 44 × 25"
Collection the artist

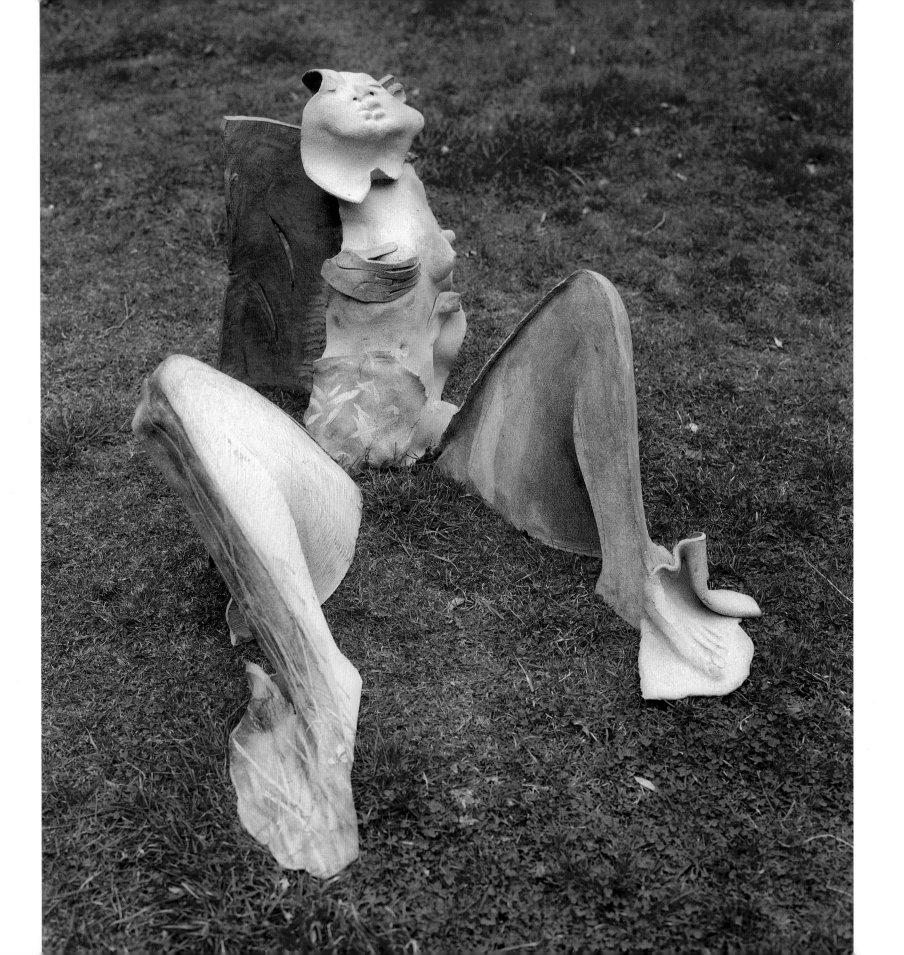

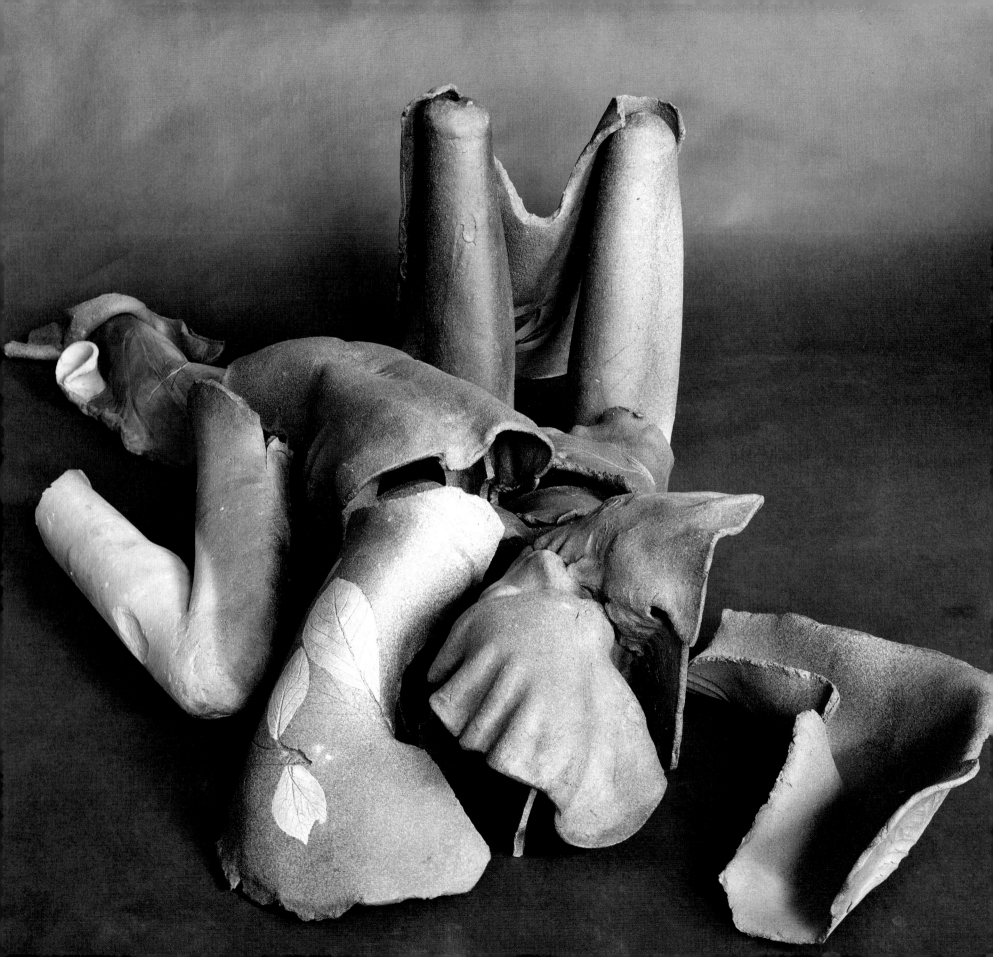

In the 1980s Mary's recumbent women rejoice once more in their earthiness, but sensuality remains tinged with pathos. The *Untitled* woman lying down from 1980 presses her cheek to the ground as if she were seeking solace in earth's dark sound. *Woman with Petal Arms*, from the same year, lies on her back dreaming that her body opens like a flower. *Persephone*, 1985, carries female eroticism's transforming power to a fever pitch. Although the goddess is charged with longing—she longed to return to her mother, Demeter—*Persephone* is primarily an image of ecstatic union with nature. After all, those outflung expectant limbs created the rebirth of spring each year. Mary's large seated figures show a similar change from mourning to joy. The male *Seated Figure*, 1976, with his head cast back in anguish, looks like a dying warrior from Olympia. By contrast, *Lover*, 1977, depicts sexual rapture.

The theme of love pervades Mary's work. It emerges in drawings and prints as well as in sculpture, and it is at once idyllic and erotic. All of her art—even the figures of lament—is sensuous, and in the deepest sense, sexual. Sexuality is seen, for instance, in nude bodies turning into animals or commingling with water and earth. Nothing could be more voluptuous than the folds and hollows that Mary creates as she fondles clay. When the portrayal of sexuality is more direct, it is both heated and innocent, for no matter how much it is based on personal experience, it is always transmuted into myth.

Mary sees sex from the point of view of a woman, and her female figures are neither coquettish nymphs (like those of Reuben Nakian, for instance) nor sex goddesses (like those of De Kooning). They are earthy, self-aware, fulfilled women. The 1974 *Lovers'*

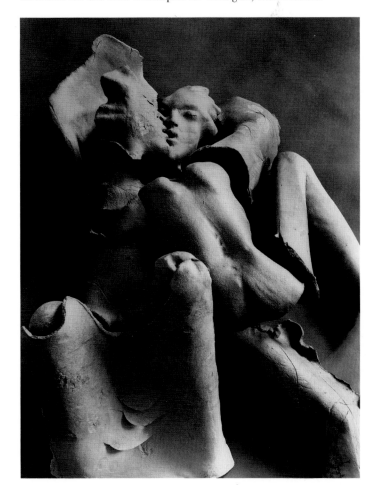

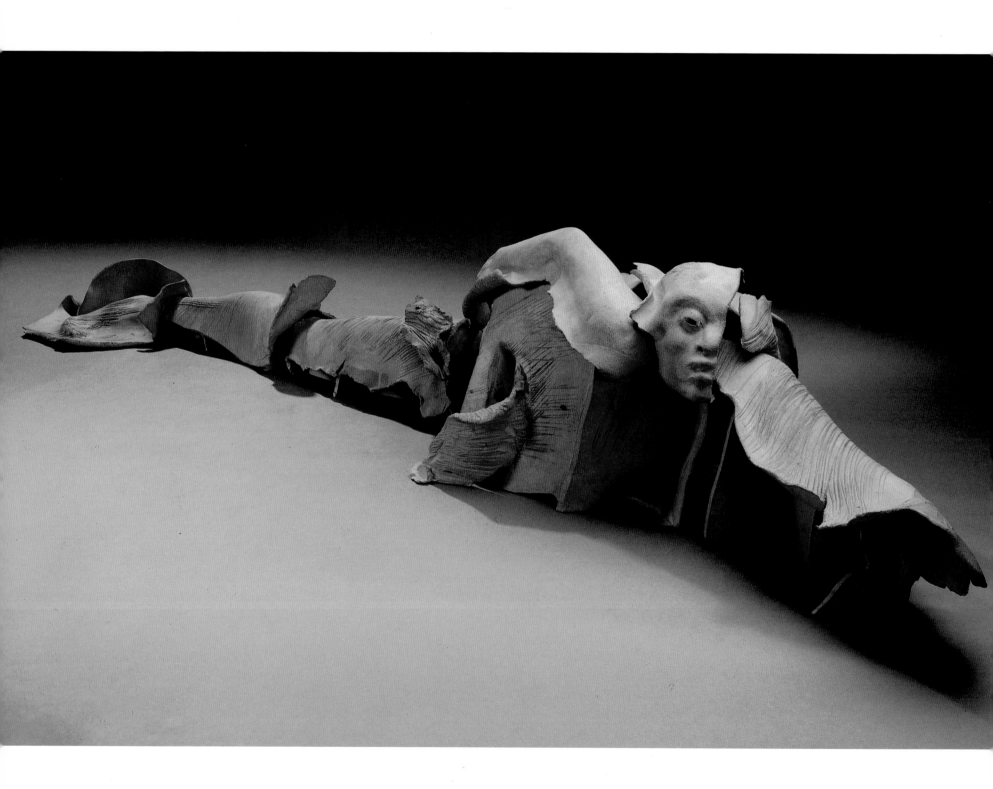

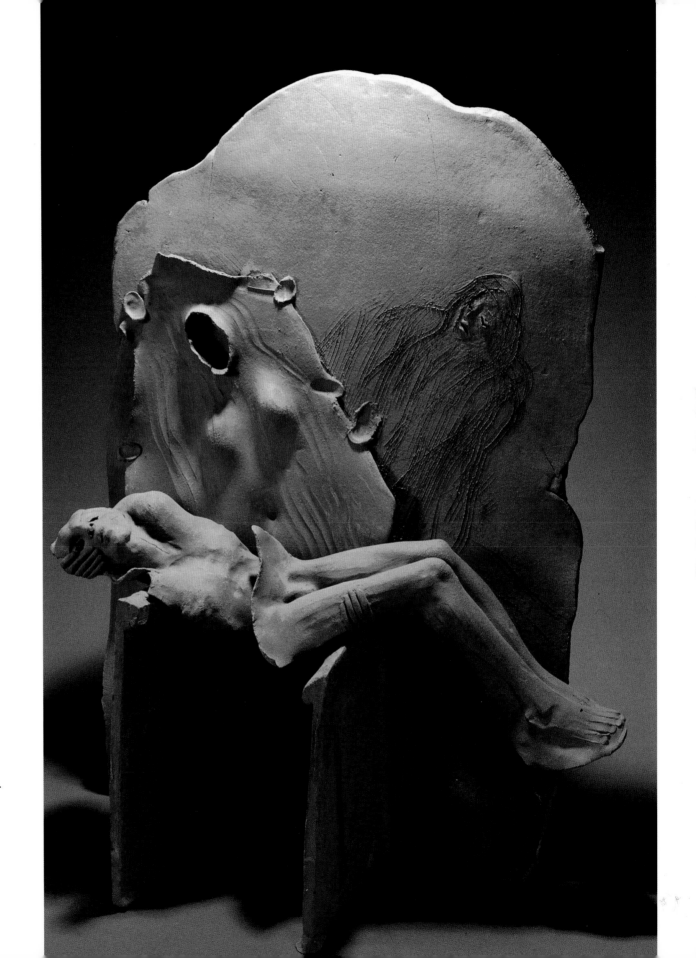

OPPOSITE:
Swimmer. 1978
Ceramic, 17 × 94 × 32″
Collection Whitney Museum of American Art.
Purchase, with funds
from Mrs. Robert M. Benjamin,
Mrs. Oscar Kolin, and Mrs. Nicholas Millhouse.
79.31

Pietà. 1981
Ceramic, 36¾ × 28½ × 17″
Collection the artist

Chant (two views). 1984
Ceramic, 44 × 60 × 38"
Collection Virginia Museum of Fine Arts. Gift of the Sydney and
Frances Lewis Foundation, Richmond, Virginia

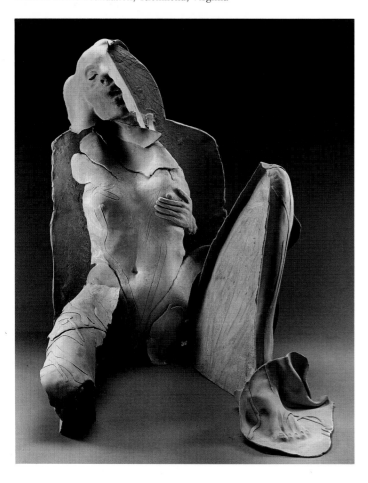

rapturous scrambling of anatomy draws the viewer in by changing dramatically from every vantage point. The posture is as ambiguous as the positions of lovers in Japanese prints. With *Lovers*, fragmentation is not painful. Rather it suggests openness and the sensation of the body relinquishing its existence as a separate, solid entity during sexual transport. Faces that so often in Mary's work are poised, like the features of the saint in Bernini's *The Ecstasy of St. Teresa*, between euphoria and pain, in *Lovers* are clearly suffused with bliss.

When Mary returned to this theme in the 1977 *Lover*, the melee of merging limbs and psyches became sparer and more subtle. Here the couple is so completely joined that it becomes a single body. Two heads are modeled from one slab. Indeed, the faces flow into each other so perfectly that the sculpture can also be seen as a single female nude with her own hand on her breast and her head doubled in sexual fantasy. Beyond that, the idea of the ultimate singleness of each person's sexuality could be intended. The inner thighs and calves are sheared off, leaving a flat terra-cotta surface that makes the leg's open position all the more emphatically sexual. Striations on an inner thigh suggest the heightened sensitivity of flesh during lovemaking. A rectangular slab that supports the torso from behind provides the lovers (or lover) with privacy and place. In a third large seated figure entitled *Chant*, 1984, the woman holds her breast once again, but this time she is single and completely absorbed in her body's song.

In Mary's work from the second half of the 1970s, the acute pain of Andrea's death gradually subsides, but the twin themes of loss and longing that had always characterized her art have a new depth and intensity. Mary continued to long for and dream about Andrea, and there were other sorrows as well: her mother's death in 1986, troubles with love, and Pablo's emotional problems. "He struggled to recover from the crisis of Andrea's death," Mary recalls, "and from Hodgkin's disease, which was eventually in remission. His life has been full of turbulence and great losses. With all this, he has never lost his artistic eye and his desire to understand natural phenomena."

Pietà, 1981, came at a moment in her life when Mary felt totally bereft. As in the earlier Vietnam pietà, the lower body of a Madonna-like mother becomes her own throne as she sways with grief over the young male body stretched across her lap. The mother's upper torso is reduced to a jagged clay slab with a few streaks furrowed into it by fast-moving fingertips. A gaping hole is cut into the clay where her weeping face should be. Again one is reminded of Mary's description of feeling "hollowed out" by mourning and her fear that if she tried to separate herself from her loss she would "disappear." Behind the slab that stands for the mother's body is a larger upright slab upon which Mary scratched the image of a distraught woman who must be another aspect of the same mother—the part that can wail outwardly without becoming a shadowy void. The two grieving women are attached to each other by clay hinges so frail that one feels the mother with the hole for a face could, at any moment, fall forward upon her dead child. *Pietà*'s psychological subtlety and formal grace testify to Mary's move in these years towards a multilayered poetry that loses nothing of her earlier work's directness.

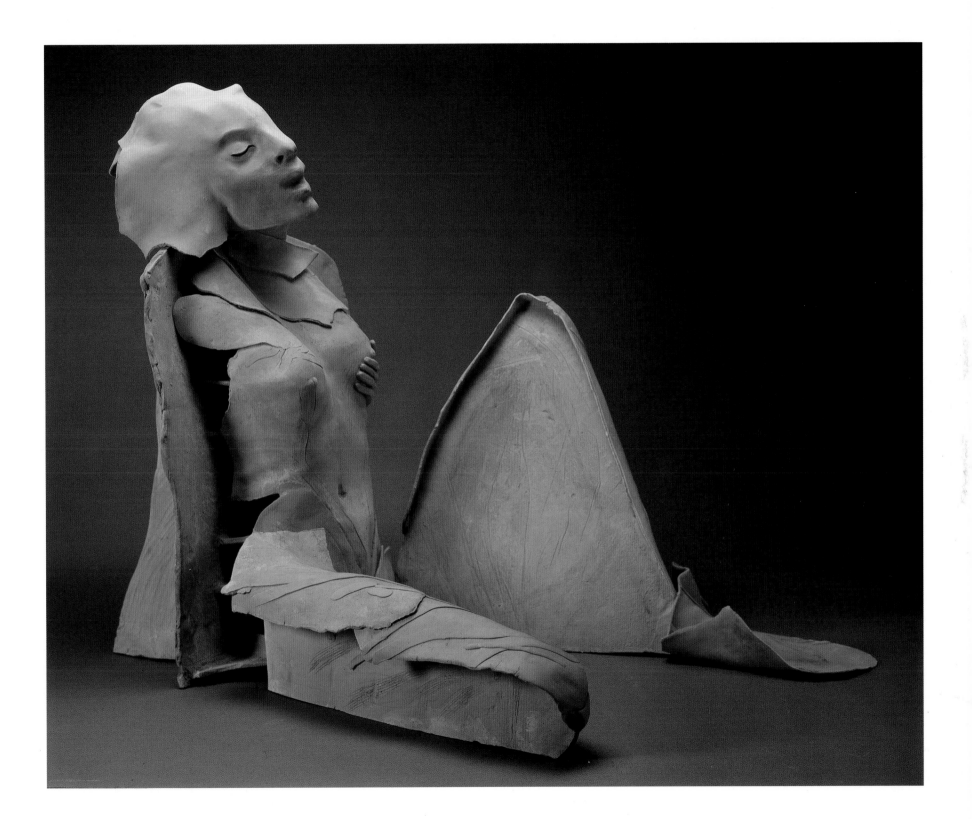

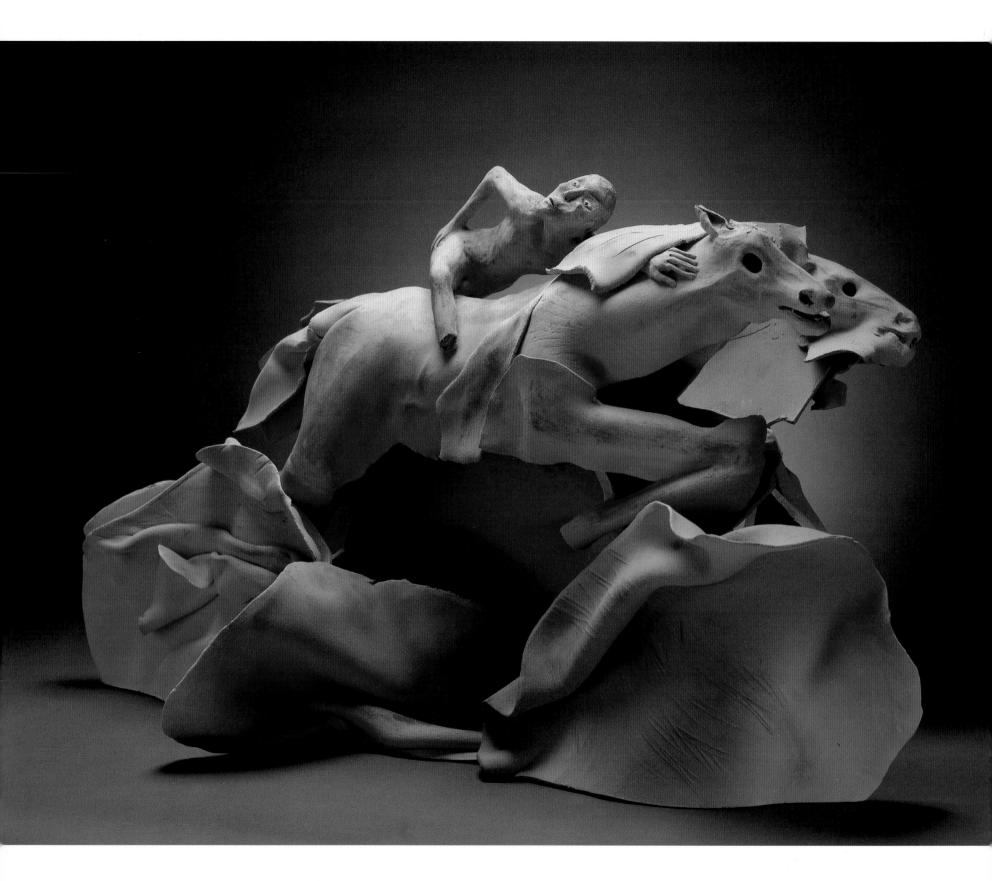

The following year, when Mary made *Horse and Rider*, her life was no less embattled. The motif of the rider, a traditional metaphor for the journey through life, has attracted Mary since she began to draw. In her early bronzes, the rider was often an acrobat or a dancer, and the journey was touched with the tender melancholy of the Italian commedia dell'arte. By contrast, the 1982 *Horse and Rider*'s headlong dash suggests panic and despair. Life at full throttle carries its death inside. Rib bones protrude. Eyes are skeletal hollows. Strain and fear deform the mouth, cut the horse in two.

The piece has many artistic forebears—Chinese ceramic horses of the Tang and Ming dynasties, Degas's bronzes, Jan Müller's paintings of mythic equestrians, Picasso's war-racked packhorses of the Guernica years. The split horses recall also the visionary horses in José Clemente Orozco's murals. All unbridled impulse, Mary's horse (or horses) does not belong in the racetrack or the pasture. It belongs in an apocalypse.

Mary is reticent about revealing her art's sources in her personal life. In speaking of *Horse and Rider*, she prefers to talk about discoveries made while the piece was in progress and after. "In the beginning," Mary recalls, "it was one horse, and then, because of torsion and pressure from fire in the kiln, the horses pulled apart. It could have destroyed the piece. The figure might not have been able to span the gap."

Like Rodin, Mary sometimes makes various extremities for a given figure before deciding on what is right. In the case of her monumental *Horse and Rider*, she tried four or five different riders. The slight nude equestrian that she finally chose looks back over his shoulder with an expression of horror as he tries to keep his mount above a widening chasm. There are handprints where the rider stretched forward to hold the horse's neck but failed to get a grip. Speed is accentuated by clouds of turbulence that make a terrain for thundering hooves.

Not only does the form of Mary's sculptures change during the process of their making, their meaning changes, too. And meaning continues to evolve with time. After she finished *Horse and Rider*, she recognized its relationship to an experience she had had ten years before at Canyon de Chelly in Arizona. "I saw the shadow of a crow below me on the canyon wall. Then I heard the crow, and after what seemed a long time, I saw it. I wanted *Horse and Rider* to have this same kind of awe. At the time, I tried to draw and make sculptures of the canyon, but *Horse and Rider*, made ten years later, is closer to my experience."

In 1984 when she made *Utterance*, Mary's life was calmer and more full. She had met Leo Treitler in February, and his companionship and love did much to soothe her sorrow. Sculptures like *Utterance* reveal a new serenity. It portrays a standing woman leaning toward her outstretched arm upon which walks a small, stiff-legged horse that looks like a geometric-period Greek bronze. The woman's gaze is wondrously tender as she watches the horse move away. When Mary made this sculpture, the horse stood, she says, for the memory of Andrea. As she relinquished pain and let the horse walk into the distance, she continued to cherish memory.

Mary Frank's figures of women share certain characteristics that make them archetypal. When they walk they churn space, but their movement is arrested as in Egyptian

OPPOSITE:
Horse and Rider. 1982
Ceramic, 23½ × 48 × 28″
Collection Everson Museum of Art,
Syracuse, New York.
Museum Purchase with Funds from
the J. Stanley Coyne Foundation

Detail of *Horse and Rider.* 1982

Utterance. 1984
Ceramic, 39½ × 18 × 26″
Collection Mr. and Mrs. C. P. Thacher

OPPOSITE:
Detail of *Utterance.* 1984

OVERLEAF, LEFT:
Winged-Arm Woman. 1976
Ceramic, 26¼ × 13 × 17″
Courtesy Mr. and Mrs. Harry W. Anderson

OVERLEAF, OPPOSITE, LEFT:
Walking Woman. 1980
Ceramic, 31 × 23 × 13″
Private Collection

OVERLEAF, OPPOSITE, RIGHT:
Arrowed Woman. 1977
Ceramic, 20 × 17 × 7″
Private Collection

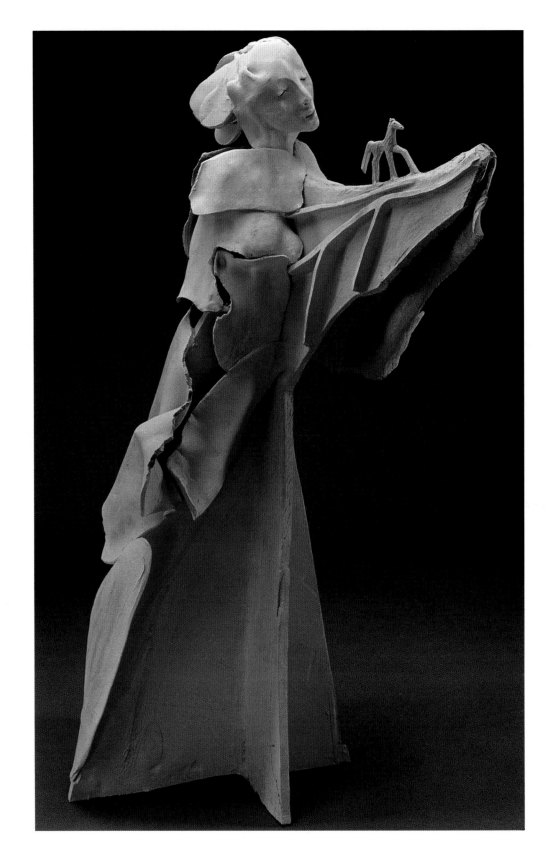

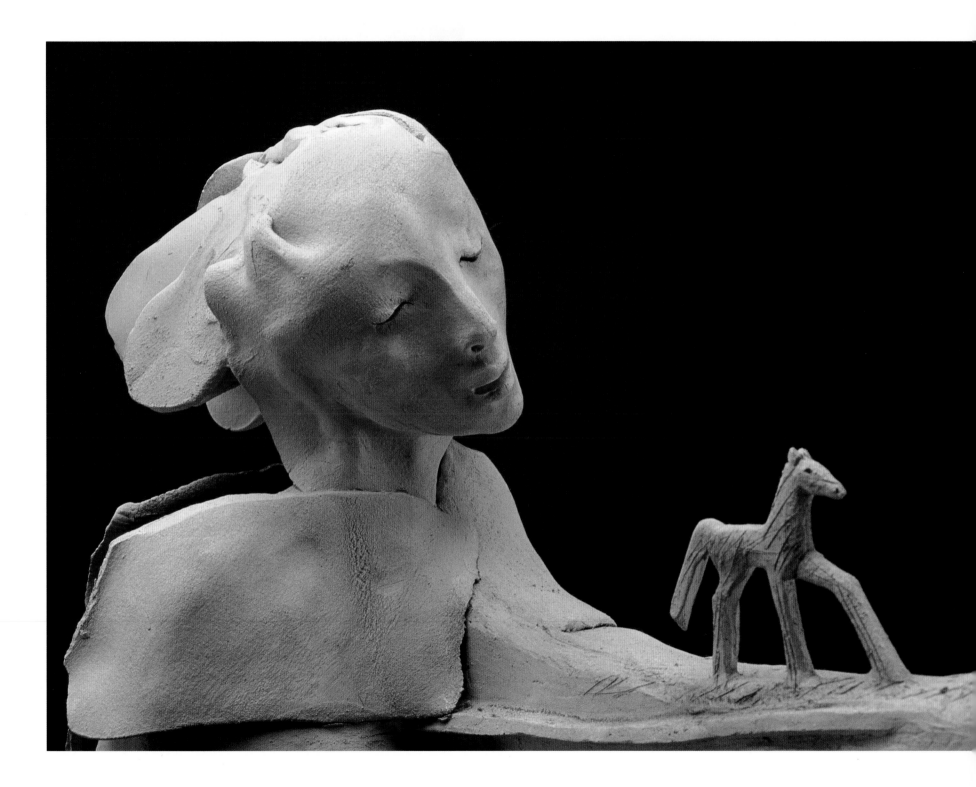

statues where weight is equally distributed between two straight legs. This walking/standing stance is also favored by Giacometti, who, like Mary, used it to catch timeless immobility trapped within momentary gesture.

The ceremonial stance is echoed in *Winged-Arm Woman, River Figure*, both 1976, and *Arrowed Woman*, 1977, three medium-size sculptures of walking women so aswirl with motion that they seem at first glance to have nothing to do with Egypt and to be closer to the Iris figure from the Parthenon or to Botticelli's airborne nymphs.[31] Similarly, in *Walking Woman*, 1980, and *Three Dancers*, 1981, Egyptian stasis is hidden beneath surfaces that billow into wings, branches, and river eddies. The sensation of radiant energy and air swishing across forward-moving limbs is almost baroque.

"I tend to like work that has an urgent quality to it," Mary says, and, whether moving or standing, her figures appear caught in states of extreme energy and emotion. But the urgency is never bound by purpose. Movement is impelled by emotions that are so deep they become pure undifferentiated feeling. In this her figures are like dancers —indeed, some of Mary's sculptures represent dancers. At once impulsive and ceremonial, *Sufi Dancer*, 1980–81, and *Three Dancers* dance to stir the forces that give life. In her 1987 commencement address at the School of the Museum of Fine Arts, Boston, Mary described a West African dance that she had seen: "The gestures go from the heart, to the sky, to the gods, to the rain, to the sun. They go back to the heart and to the beloved, back to the heart and to the earth, back to the heart and to the four directions, six really, including up and down. . . . There is no indifference or irony toward any of these that are being saluted." She could have been describing her own ceramic dancers, their incantatory mood, their lack of "indifference or irony."

In the almost animal intensity of their physical presence, Mary's female figures capture the peculiar alertness with which she hungers for the world. Their faces could be imaginary self-portraits, for they have her vulnerable, creature-like quality, and their features are so carnal that they seem to belong as much to the body as to the head. Many are caught in a trance that equilibrates between anguish and rapture. Often the faces look vaguely Egyptian or African, or they bring to mind profiles from ancient art. Mary delights in their nonspecificity; she sees them as coming from a time before human beings divided into races.

The origin of her women's features, Mary suggests, is a black-and-white photograph of a Himalayan doll's head that she saw as a child in one of her mother's copies of *Verve*. Perhaps because it reminded her of her own fragility and helplessness, the head haunted her. "It was," she says, "a quickly made terra-cotta doll's head from India with deep, lidded, half-open eyes and an open mouth. Imagine the poignancy of this face. I seem to have absorbed it. It has stayed in that place behind my eyes, and it keeps on reappearing." The doll's head was only an inch or two tall, but it became large in Mary's memory. "For *years*," she said, "I've been trying to make that head. I'll never be able to make that head! But in the attempt to make it I've come up with a lot of other heads."[32]

If the source of her women's physiognomy cannot be pinpointed, neither can their

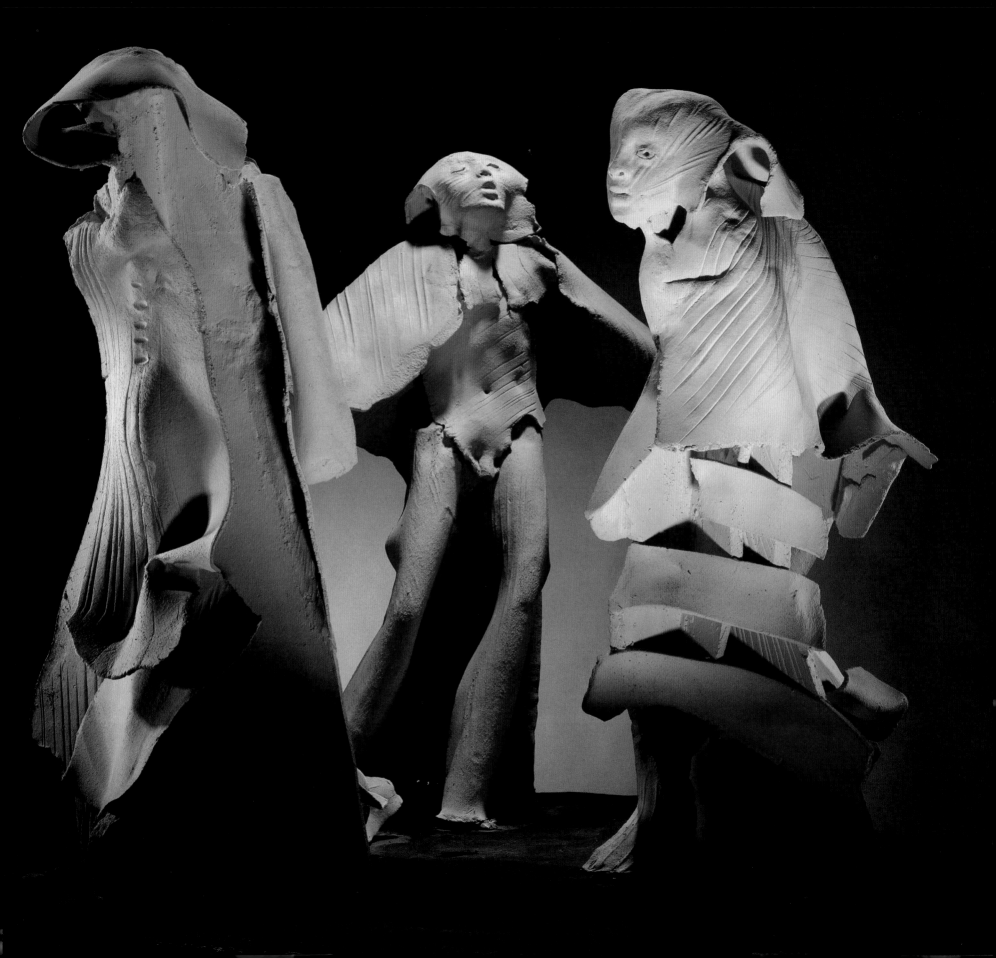

personality or type. They are everywoman. Mary told the graduating class in Boston that she tries to make sculptures that show "what I feel it is to be human. What life on earth is, or might be. It is very important for me to find a vocabulary or series of images that feel strong enough to put all the feelings I have in. Sometimes I have the image of a ship that could be loaded up and could move through time." Mary Frank's women are like that ship. They are strong enough to carry a large cargo of feeling. And Mary does not mind if viewers see them in their own terms. "I want to make something that allows various readings," she says.

The faces of her women are, Mary allows, "in a state—maybe a state of grace, not necessarily in the Christian sense, but in a sense that is conveyed by the Yiddish saying: 'Out of longing, and out of song, time was created. And, there is always just enough time for one more day.' I want to make that state of grace palpable." Such grace depends on equipoise: Mary's women express a perfect equilibrium between awareness of what is happening inside and outside the self—the same inside-outside equivalence that prevails in the open structure of her figures. *Persephone*, for example, listens to the promptings of her dark underworld even as she rejoices in sensations of sun, wind, and earth that touch her from without. Similarly, the sculpted heads respond to the outside world while their hooded eyes look inward.

After Andrea died, the split heads took on a tragic connotation. The idea of being cracked open is made vivid, for example, in *Head with Ferns*, 1975, and sorrow's suffocating force is expressed in *Head with Petals* from the following year. Now Mary's heads faced upward rather than forward. Eyes are closed, but not in transport, and ferns stenciled on a cheek or clay petals wrapped around a face suggest that flesh fertilizes life after death. *Head with Petals* might also allude to a primitive welcoming of mortality that sometimes accompanies moments of extreme feeling: "Once I lay on the grass in the fall when all the leaves were dropping. I remember feeling that this would be as good a time and a way to die as any. It was a kind of acceptance, a peace, a feeling of being part of nature. I felt that there couldn't be any more, that life could not get better."

OPPOSITE:
Three Dancers. 1981
Ceramic, 29 × 34 × 25″ overall
Collection the artist

ABOVE RIGHT:
Head with Ferns. 1975
Ceramic, 11½ × 19 × 17″
Collection Vera List

BELOW RIGHT:
Head with Petals. 1976
Ceramic, 10 × 21 × 17½″
Collection Vera List

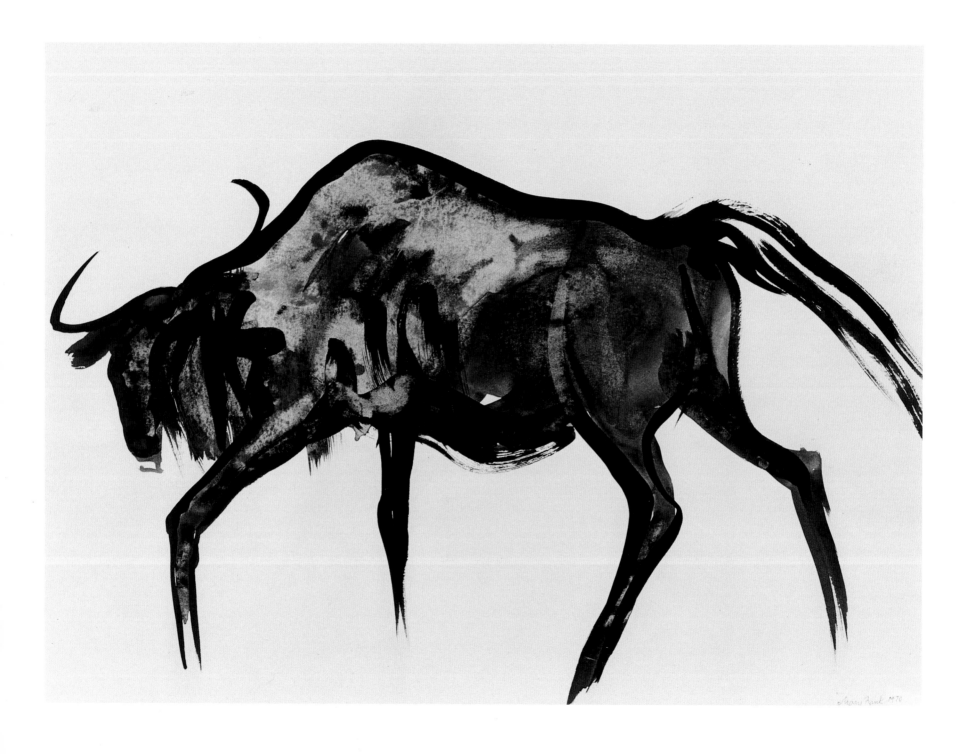

Mary Frank is a compulsive and prolific draftsman. In the last twenty years, she has filled more than one hundred sketchbooks and sheet after sheet of paper with drawings that are sometimes done from life and that just as often spring from her imagination, or even from dreams. She draws on anything that strikes her fancy: leaves, birch bark, fungi, color-graded paint chips, rolls of paper used by house painters for taping walls, foldout paper booklets from Chinatown. In 1986 she molded handmade paper into a relief and then painted on it. She also makes collages, rubbings of sculptures made expressly for that purpose, and "shadow papers" in which she draws with scissors, cutting lines that shimmer when seen against light. More recently she has been experimenting with combining a painted image on glass superimposed on a charcoal drawing.

Long before her sculpture won critical approval, Mary was known for the excellence of her drawings. *New York Times* critic Hilton Kramer noted their freshness and spontaneity when he reviewed her show at the Radich Gallery in 1963. The drawings, he said, "take possession of experience with an exemplary lyric economy, and even the more conceptual of them—those specifically designed to articulate a sculptural idea— are freer in their fantasy, freer in their transformation of the perceptual into the conceptual, than anything that comes through in the sculpture itself."[33] It was not until Mary turned to plaster and then clay that her draftsmanly and sculptural visions came together.

Mary is largely self-taught, and whatever formal training she had was in drawing, not in sculpture. Later, it was drawing she taught at the New School for Social Research in the second half of the 1960s, and at Queens College Graduate School in the first half of the 1970s her teaching placed more emphasis on drawing than on sculpture.

Even when she is making sculpture, she thinks partly in terms of drawing. Speed and immediacy are more essential to her inventive process than deliberation, analysis, and construction. Indeed, she is almost allergic to conventional notions of composition or design. She does not try to balance shape against shape or volume against volume within a given space, nor is there a strong pivotal point to structure form's unfolding. Rather, she molds clay as if she were drawing out a narrative, inventing as she goes along, finding the edges and giving them the free-flowing rhythm of a drawn line.

In figural sculpture, to a great extent posture dictates form. Because Mary's own

Andrea. 1961
Pen and ink, 9½ × 9½″
Collection the artist

OPPOSITE:
Wildebeest. 1971
Ink, 18 × 24″
Courtesy Zabriskie Gallery

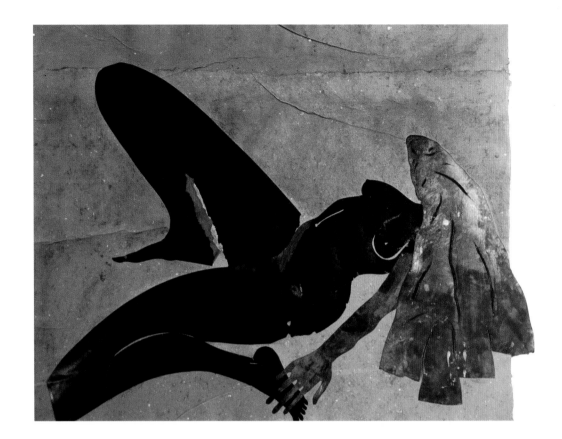

Persephone. c. 1985
Colored ink on paper stencil collage,
pastel and watercolor
on gray handmade paper support,
24¼ × 33⅜″
Courtesy Zabriskie Gallery

Persephone. 1986
Pastel, 41⅝ × 29¾″
Collection John A. Torson, New York City

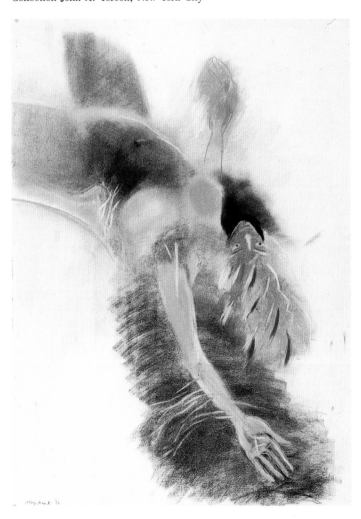

gestures generate the movements of the figures she depicts, she arranges her figures in terms of a sequence of curves and swirls, swellings and sinkings that are dancelike and musical in feeling. No one form dominates. Often the various parts that make up her larger sculptures are so numerous, and they relate to each other and to space in such intricate ways, that it is unclear where one shape ends and another begins. Adding to the complexity is Mary's insistence that her sculptures should not deliver their full impact on first glance. As a result, her configurations usually have no bold, easily graspable structure or profile.

She does not see drawing, printmaking, and sculpture as clearly distinct forms of expression. "There's a lot of exchange between them. They learn from each other," she says. In a 1974 notebook she wrote: "Sculpture could be just a deepening impression, like a deep fossil, an etching that keeps grinding or pushing thru and comes thru to the other side. Also, many drawings . . . [could be] sculpture risen to the surface, the colours flaking off, swept on and raked off—maybe a gardening of the paper. Some things, forms, take root. Others are more like passing air—the bird's shadow for an instant." Frequently Mary draws on wet clay with her fingertips or with a knife, and she draws on dry clay with glazes. The shadow papers in which she cuts lines of light into white paper could be seen as somewhere between drawing and sculpture. "I often feel," she says, "as if I'm doing sculpture when I'm drawing or making prints. I draw

in a very physical way. I'm using my hand a lot, not just the point of a pen or pencil. It feels three-dimensional even though it's flat."

Her work in every medium is fluid and painterly. Although she has an idea in mind, she follows the insights and chance effects that occur during the process of work. Gesture is all-important. "I love the gesture of work, watching someone do work they do well or with experience, with certain essential gestures, nothing wasted. There is a grace that Walt Whitman talks about." When Mary works, her movements have that same quality of necessity. Grace and economy of gesture characterize her drawings as well. A single curve can define a figure from head to toe; a few ink strokes can capture the roughness of bark or the bushiness of leaves. "Sometimes," she says, "it's interesting to see how little I can use to convey a lot."

As in her sculpture, form in Mary's drawings is defined in terms of linear continuities, not in terms of weights and balances. Besides the bond between the artist's gesture and the gestures she depicts, there is the union of the materials and the subjects she chooses. The ease and fluency with which colored ink spreads and puddles across paper, for example, makes it exactly the right medium with which to render a nude bather with fish flowing through her transparent torso. Like a Chinese master, Mary gives the material itself breath and life. It is, she says, important to "be in touch with that place where the medium—whether it's ink or charcoal or pencil or crayon or whatever—touches the paper. . . . It's a very emotional place. It's very physical."[34]

To Mary, drawing is by no means a subsidiary aspect of her artistic activity. She spends more time drawing from her finished sculptures than drawing for them. The drawings from sculptures are more elaborate and finished. Indeed, most of her studies for sculpture are quick sketches in notebooks, "just marks on paper," as she describes them. "I don't [always] make them for that purpose, but they turn up very close in a sculpture—sometimes a few years later."[35]

Her 1987 exhibition at The Brooklyn Museum examined the way Mary takes a sculptural theme, in this case Persephone, and explores it in diverse works on paper. "I started drawing the creature," she recalled. "What a luxury to have a life-size sculpture in the studio to work from in night- and daylight and near and far space."[36] Drawing a sculpture forces her to see it as it really is, not as she would like it to be. "If I've made a sculpture and then draw it, I see that sculpture differently. And then, from that, sometimes I may make other sculptures."[37]

To keep her hand and eye true, to keep from falling into style, Mary regularly draws from the model. Bold charcoal sketches and colored ink-wash drawings capture the energy of models as they move about her studio. She thinks of her models as friends and collaborators, not as passive objects. "I've worked with several models over long periods of time. I do not pose them. They pose themselves—mostly they are moving in space. Sometimes I ask them to stop and occasionally I ask for a pose if I really need it. For twenty-five years I have worked together with my friend the dancer Luly Santangelo. She brings such a full range of expression to movement that it is a challenge to equal her intensity."

Like two of her idols, Rodin and Degas, Mary tries to bring movement onto the

Woman and Fish. 1979
Ink, 18 × 24"
Collection the artist

stillness of paper without having it seem to stop. In a 1974 notebook she wrote that Degas's "endlessly practicing" dancers were "metaphors for his own endless drawings. . . . I understand so well those drawings of the dancers while they moved— what is it [that is] so exquisite about the attempt even tho I know it is impossible. Maybe it's like being a hunter. Seizing on the immediacy." Often she depicts her models in two different positions in time so that a nude might have two heads or four legs. When she follows a model's movement in a series of charcoal drawings, her lines are as dynamic as the bodies they delineate. "It is very hard to catch them in motion like that, you have to work so fast. It's a never-ending struggle, but when you come near it, your work is injected with the life they have."[38]

Mary says that when she carries a sketchbook her way of looking is different. "I'm watching for things. I'm making choices about what to use, because I'm in a state of drawing, and often it seems to me that it's like being a hunter or an animal. I'm listening. I'm tuned. It's a quality of attention." In terms of tracking the lines of a figure in motion, perhaps the greatest challenge comes when she draws actors in rehearsal. For years she has sketched the performers of Joseph Chaiken's Open Theater, a vanguard group that came together in the 1960s. Her notebooks are full of wonderfully free sketches of scenes from the Open Theater's productions of *Electra, The Dybbuk,* and Jean Claude van Italie's *The Serpent.* In addition, she has designed sets and costumes for performances like *Big Mouth,* a 1985 Talking Band production.

One of the things that Mary loves about drawing in a darkened theater during a rehearsal is that she has less control than when she draws a model in her studio. She must work fast to catch passing gestures. "You have to trust kinetic memory. If you have drawn a lot for years, there is more that you can trust than you would realize. I like the combination of control and lack of it. You are not as likely to fall into the trap of habit." Drawing at the theater is, she says, "meditative. I empty myself. The whole thing is very inspiring. It makes you breathe—inspire."

The fact that the actors she draws are, like her, struggling to invent gestures that will communicate extreme emotions attracts Mary. "You wouldn't be able to (or want to!) draw the real-life situation that corresponds to what you see in the theater—all these states of being, a person, for example, murdering his wife. The theater drawings have been a great source for me, the gestures, the relationships of people moving on a stage."

Another challenge is drawing at the zoo, at aquariums, or birds, insects, and snakes in her garden. Mary's notebooks are a peaceable kingdom inhabited by lions, bears, and elephants, horses—countless horses—as well as goats, cows, deer, birds. The sketches are often accompanied by notes: the octopus she calls "the supreme choreographer"; of swans she says, "except for snakes you can't get much more arabesque than swans"; and the swallow "swoops over the water meeting himself halfway." Goats' importunate greed stopped her pen before she could finish her sentence: "The big problem drawing six goats is they try to ea. . . ."

Because she is so in tune with the creature part of herself, Mary is in tune with animals, and she sees no division among the kingdoms of animals, plants, and human

beings. In one of her drawings, a woman leans down to look at her shadow, which has the profile of a horse. In other works, a man's shadow takes the shape of a stork or a butterfly, a head becomes a ram, a goat, a bird, a flower. "When people ask me why I depict animals," she says, "I always want to ask them why they don't. We are still living on the earth with animals, though so many have already become extinct."

Animals populate Mary's dreams, some of which she jots down in notebooks. Once she dreamed of whales coming up onto the Cape Cod dunes and dancing "in the dark green of the laurel."[39] Another time she dreamed of a "toucan, green and black, with orange and yellow wings, beautiful beak, its head up, beak open, wings outstretched, singing Italian opera! . . . And all of a sudden I realized there was a chorus in the back, on a hill, with about twelve other toucans, wings raised, singing a chorus!"[40] Recently she dreamed that a parrot sat on Leo Treitler's shoulder. "It became a hummingbird with wings like morning glories. I said, 'Watch these wings. They're going to open like morning glories untwisting their petals.' As I said it, two baby hummingbirds flew out of its mouth."

When she draws at the zoo, Mary tries to catch animals in motion. "You don't have any choice. They aren't going to sit there for you. Even snakes. You think they're sleeping, and all of a sudden they shift."[41] Her animals, like her people, have an essential grace that is free of the specific psychological freight usually borne by human gesture. Their leaps and darts are instinctual and unpredictable like the leaps and darts of the inventing mind. A grazing horse in a sketchbook is a particular horse, but when it reappears in a monoprint or in a larger drawing, it becomes Mary's idea of a horse, outside of place and time.

Drawing is, Mary says, "a drawing-in process . . . a kind of breathing." Her sketchbooks form a visual diary. To look through them is to enter her head and to look out from behind her eyes. Certain subjects attract her hand over and over again. One subject is friends, but the portraits comprise her least interesting drawings, for Mary is a keener observer of gesture than of facial expression. The struggle to get a likeness right leaves little room for her transforming imagination, and she forfeits the rhythmic momentum of her mark-making hand. Even her powers of observation seem to be stifled. It is as if in depicting a sitter's features she were following some convention for making eyes, nose, and mouth. When she makes a flower, on the other hand, she approaches it over and over from all sides, alert as a cat in pursuit of a dragonfly. She draws as if she had never seen a flower before, as if her line were just now inventing its blossoms.

"I like to switch mediums," Mary says. "Each one has a wholly different feel." Her drawing implements include pencils, ballpoint pens, quill pens, brushes, crayons, and pastels. Marks made by Chinese brushes vary from wide, soft washes to fine, taut black lines. With them she has made drawings of the lake near her Catskill house that look almost Oriental. When she makes drawings of nudes with thin, ungraduated ink or pencil lines, her spareness and precision bring Matisse and Picasso to mind. By contrast, the energy that erupts in her colored-ink drawings comes close to German Expressionism.

Drawing what she observes can be a way of trueing up the imagination: In a 1970 notebook she said that her art is dead when she finds "a solution and I stop really seeing. . . . I try to go out and draw what I see as if the act of observing will purify me. Sometimes it does, because I mostly see more than my preconception of "it"— tree—flower—bird—the preconceptions are very static. It is the quality of life unexpected . . . that makes a drawing, and when they are awful it is because I'm clutching at some 'thought out' solution—a preconceived idea of space—horse and figures, whatever. The moment it loses all its nowness and becomes dry." Fifteen years later she wrote: "No matter how far I go from what has been seen, observation is the bread and salt and wine. It is the bone without which work gets flimsy. It's best when some nerve is touched so that the hand-heart-eye work as one. Freedom to work from observation transformed."

But there were times when she felt she didn't transform enough. Indeed, she goes back and forth on the observation-transformation issue. In a 1974 notebook she said: "Lately I work too much from life! Is that possible? Not enough from my head—what I see behind my eyes. . . . I have become too absorbed in observation!! It is a pleasure and a sort of balm, but it becomes a little bit like being a reporter and not an autobiographer." The very next entry said, "I don't work enough from life!!"

The handling of space in works on paper is analogous to that in sculpture. There are the same disjunctions in scale, the same directional shifts, the same fragmentation and surprise. If, for example, she draws a head, and then on the same sheet a horse or a hand, the images may be unrelated in terms of space and scale. The head might be huge and the horse tiny, either because the horse is far away, or because the head has greater emotional importance. Or it could be that she simply drew the horse at a different time and paid no attention to the drawings that preceded it. Some drawings are, she says, "accumulated on the page. . . . If I want to draw something and open a sketchbook and don't find a blank page, and I'm impatient to draw immediately, then I just draw either over what's already there or add to it. But I have a very selective eye. I really don't see what was there before, so I'm not composing with it."

For Mary a sheet of paper is not a stage on which to place her figures, nor is depth a measurable portion of space. Space appears to go on forever. "For years," she told a critic, "I drew nudes that could've been in the air. . . . Then at one point I felt I had discovered the horizon, like someone who 'discovers' the umbrella—as if it hadn't been around all along. It was like discovering gravity—it put everybody on terra firma."[42]

In spite of that "discovery," many of the works on paper present a horizonless expanse of space. Or there can be two horizons, as in *Passage*, an oil painting on plaster from 1986. Here an extra horizon line is inserted in what should be the middle distance in order to give a horse a place to walk. This wayward approach to space may seem childlike, but it is also a deliberate rejection of conventional unities. Equally wayward and purposeful is Mary's disregard of the rectangular limits of her paper. When she draws, her focus on her motif is so consuming that she does not see what she is looking at in relation to the forms and spaces around it. "At first maybe I only want to draw the shoulder, neck, and head of a man, and then, all of a sudden, I don't know

why, I continue working down his body, and then it's very important to have his knee." As a result, figures are frequently too large for their allotted space and are cut off by the framing edge. If she feels they need to be completed, she does not hesitate to add another sheet of paper. Moreover, she sees no reason why the new sheet should be lined up with the old one, and her formats are often irregular.

The fiercely sexual energy of *Persephone*, for example, needed room to breath, so Mary added sheets of paper along the right and bottom edges to accommodate an arm and a leg. "I care about where the form has to move to," she says. "I grab anything I can grab at the moment. I can't help it when the given space is transformed. I'm literally extending out. But the form is more whole than if I had left off that foot or arm or whatever it is that I need there. It doesn't seem fragmented to me, it seems whole."

The addition of sheets of paper to create an irregularly shaped drawing surface has an affinity with the way Mary adds flattened slabs of clay until a sculpture is complete. In both sculpture and drawing, when the figure is a single image running continuously across several parts, the disjunction adds tension, and the lines or openings where the parts meet hold illusion in check and bring the physicality of the work into focus.

This refusal to respect the boundaries of the paper's edge corresponds to Mary's concept of space as unlimited extension. "The rectangle and the square are very arbitrary shapes," she points out. "I don't think of a rectangle as a given. It's not a holy thing. The Chinese worked on that wonderful shape—not a circle, not a square, a lot like a winter melon. Prehistoric painting was all done on modulated, curved, corrugated surfaces, roofs and walls of caves. Things went in all directions, north, south, east, west, up, down, sideways, diagonally. There wasn't this idea of the rectangle."

A number of drawings from the early 1970s deploy asymmetrical inner frames inspired by the inner frames in Persian miniatures. As in her sculpture, in her drawings Mary enjoys the play of inside/outside space. In *Charlemont*, an ink drawing of 1971, for example, she placed three human legs and a night landscape populated by running antelopes inside the inner frame. Ink-wash clouds burst through the frame, and a solitary antelope stands on the frame's indented left edge. Similarly, she notes, Persian miniaturists paid no heed to the rectangular limits of their decorative inner frames. "If a branch of a tree went out," she says, "it went beyond the frame."

The most congenial format for someone who conceives of space as infinite extension and who wishes to convey the sensation of unfolding time is the scroll. Mary has made a number of horizontal scrolls, some, such as *Places I Have Been and Memories of Places I Have Never Seen*, only a few inches high and drawn on a roll of plasterer's drywall tape. *Voyage*, 1969, on the other hand, is twenty-five feet long and several feet high. In this scroll's imaginary terrain, one motif leads to the next in a visual and gestural stream of consciousness, and the spectator travels across the paper, meeting animals, people, flowers, and exquisite fragments of landscape. As in Mary's sculptures, the flow of incident is full of surprise. "Things break off and I stop them, or I come back and start a whole different subject matter on a very different scale. Also, things are superimposed. . . ."[43] In one section of *Voyage*, for example, two

Charlemont. 1971
Ink, 11 × 13¾"
Private Collection

The Pond. c. 1970
Ink on map, 25½ × 36½"
Collection the artist

horses are drawn over two deer. In another section a pair of lovers overlaps a male figure who seems to be falling through the sky.

Similar in style and subject to *Voyage* are the numerous black ink-wash drawings from the mid-1960s and early 1970s. Most of them pit an upright figure against a vast space. Usually the figure is simply a black silhouette formed by a few swift brushstrokes. Sometimes the ink is thinned to a mottled transparent gray, and in a few drawings the wash that gives body to a figure is profiled in darker ink.

The depiction of setting in the ink-wash drawings is as spare as the delineation of figures. There may be a horizon line or perhaps an indication of distant mountains or curving shore. Even when there is no definition of setting, the figures moving against the blank white paper create their own locale. Because she is more concerned with unfolding narrative than with the presentation of a single incident, Mary's figures usually do not overlap to create an illusion of depth (although they may be superimposed to suggest multilayered, timeless reverie). Instead, spatial relationships in her work tend to be lateral—one is struck more by the way figures move across the flatness of the paper than by their movement into depth.

Over the years the range of style and feeling in Mary Frank's drawings has grown. From time to time she makes careful studies of the nude model, such as *Conceição*, 1976–77. Even in these fairly conventional life drawings, she manages to fix the viewer on the meaning of gesture. For she sees an equivalence between motion and emotion. "When I am moved," she wrote in a 1975 notebook, "my eyes move, my heart, sometimes my hands and body. The Earth moves, the stars, we are all turning slowly— toward what—"

Mary's approach to the figure becomes freer and more expressionistic in two charcoal

90

drawings of crouching nude men and their shadows, one from 1980, the other from 1982. Lines now double and triple. They skitter away from the form-defining edge, then return to the motif again and again to keep the search going. At the time she made the 1980 drawing, Mary was trying to approach what she called "difficult, less beautiful subject matter." She said she made "two drawings of a man who looks part human, part simian, part something else, which I liked, because they went further than just being good drawings of the male figure, which doesn't really interest me at all. Both these drawings have some other quality. One is extremely sad. In the other, the model moved—he was leaning over and, instead of adjusting to the new pose, I just continued drawing. He seems to be sinking into his shadow."

Feeling is even more high-pitched in two 1982 charcoal drawings, *Walking Woman with Arrows* and *Separation*. The woman-and-arrow theme began with Mary's early wooden sculptures and it continues in clay sculptures such as *Arrowed Woman*, 1982, and in a number of monoprints as well. "I see the arrows as a lot of different things, like directions, conflicts. Often they are air or water moving around a body. They come out in the works that are most disturbing. The arrows in the five monoprints of walking women from 1979 or 1980 were connected to my feelings about Pablo. Originally I felt the arrows when I was watching waves move around rocks. I feel them in animals, too. The arrow is a beautiful form."

Made at a juncture in Mary's life when she felt bereft and divided, the skeletal figure in *Separation* stands on a hilltop that is as bleak as Golgotha, and its bony body is rent in two like a tree struck by lightning. Behind the figure the sky turns into a cyclone where the artist's fingertips attacked the charcoal. Other lines seem to have been scratched by the figure's flailing arms. This frightening but powerful drawing was

Conceição (two drawings). 1976–77
Charcoal and sanguine,
each 24 × 16¾″
Courtesy Zabriskie Gallery

Crouching Man. 1980
Charcoal, 25 × 19″
Collection the artist

Separation. 1982
Charcoal, 25¾ × 40″
Private Collection, New York City

Walking Woman with Arrows. 1982
Charcoal and pastel, 44 × 30″
Collection Virginia Zabriskie

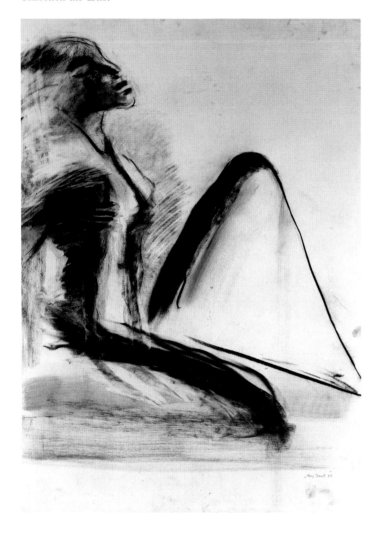

Chant. 1984
Charcoal and pastel,
41½ × 30″
Collection the artist

Mary Frank's studio,
West 19th Street, New York

On the wall (above):
Vaulting Woman (Kate Gamble). 1986
Ink and watercolor, in five sheets,
each 38 × 25″
Collection Kenneth L. Freed

among several strewn on Mary's studio floor during a fallow period. When this visitor pointed to it as evidence of productivity, the artist dismissed it as if it were too grim to take into account.

Both *Separation* and *Walking Woman with Arrows* reveal Mary's move toward expressionism. Her strokes are bolder, and she freely distorts and transforms the body. A year later when she drew a pair of lovers on a hill, the figures look more like mummies than skeletons. So urgent is their symbiosis that male and female flesh merge to form an amorphous clump. Clutching each other, not in delectation but in despair, the lovers seem the last survivors of cataclysm. More recently, Mary's Persephone drawings deploy the same exacerbated strokes to send a more sensuous message, and in a series of vaulting women from 1986, her brush charges space with so much physical energy that the paper seems to vibrate.

Among her most astonishing drawings are the shadow papers begun in 1977, when she was sick in bed for two weeks after a trip to Morocco. Into sheets of white paper that usually are no larger than a foot by, say, a foot and a half, she cuts lines of light that perfectly evoke the tremulousness of lovers or the fragility of flowers. The image is always kept simple; otherwise, given the delicacy of this medium, it would be impossible to read. The light-filled openings where the paper's cut edges have ever so slightly pulled apart are given a semblance of substance by actual shadows that mimic modeling.

The shadow papers demand an even more intimate viewing than Mary's other work; at first all you see is white paper with light coming through incisions. The moment when the cut lines assemble themselves into an image is breath-catching. For the artist it is a surprise as well. "I'm drawing with scissors. The scissors stay still and the paper moves and bends. I'm inside-out and upside-down. I get lost and have to go by trust."[44]

The shadow papers are a natural development from Mary's sculptures in which she cuts shapes into clay slabs and then pulls the shapes outward so that their edges fill with light and shadow. They were also inspired by Matisse's cut-and-pasted papers of the late 1940s. Whereas in Mary's paper cutouts the image is drawn by light, Matisse's *papiers découpés* are composed of colored shapes cut out of papers painted with gouache, and the shapes are collaged onto an opaque surface. "He had vastly more freedom, because he could move shapes around on the paper. The endless tack holes bear witness to the quantity of changes. What I'm doing is locked into the format of the original piece of white paper. This is the one medium in which I don't have extra possibilities. I can't add a second sheet of paper or take lines away after they are cut."

In their virtuosity and astonishing control, both artists' cutouts bring to mind early-nineteenth-century silhouettes, but unlike the silhouettists, who tried to hide all evidence of process, Mary (and Matisse, as Alfred H. Barr has pointed out) reveals the strokes of her scissors. Both artists have described the technique as sculptural. Matisse compared his scissors to a sculptor's chisel when he said, "To cut to the quick in color reminds me of direct cutting in sculpture."[45] For Mary it is more like cutting into slabs of clay.

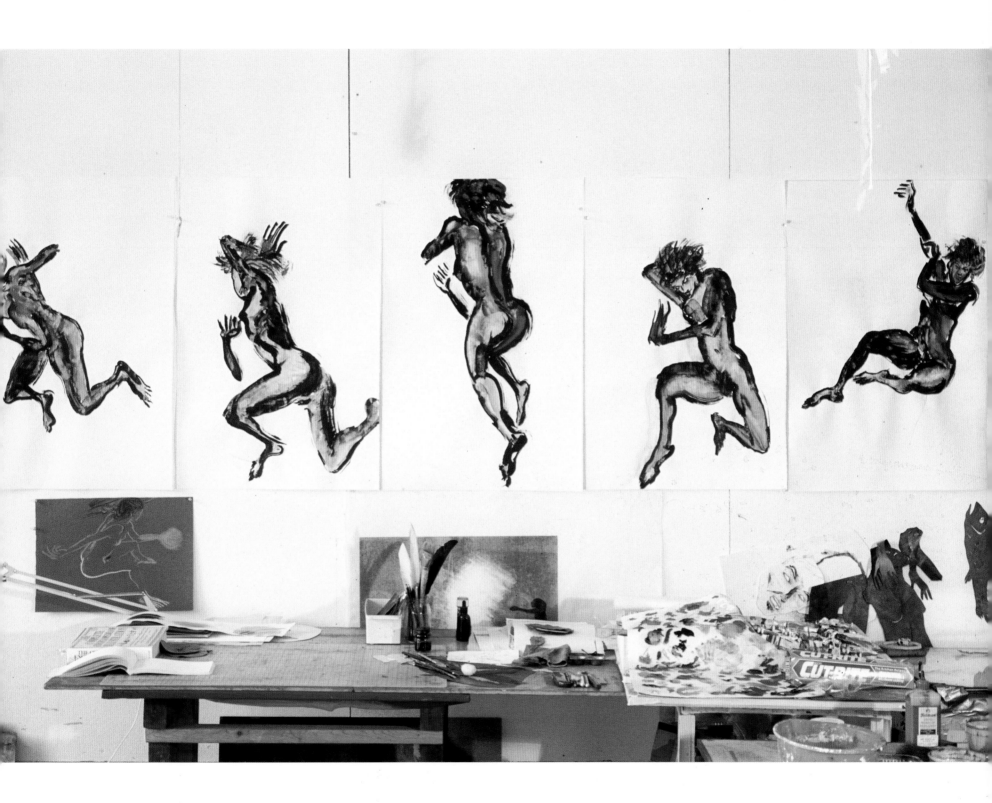

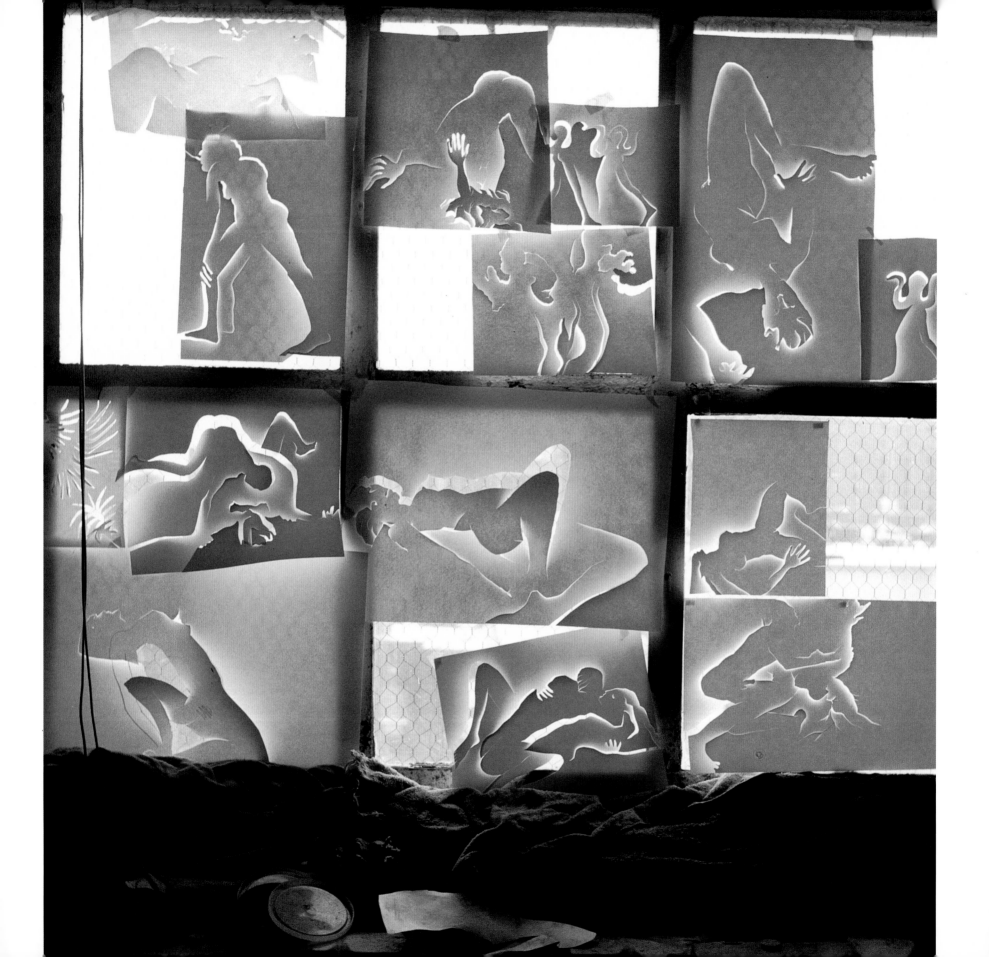

OPPOSITE:
Shadow papers. 1978
Cut paper, various dimensions
Collection the artist

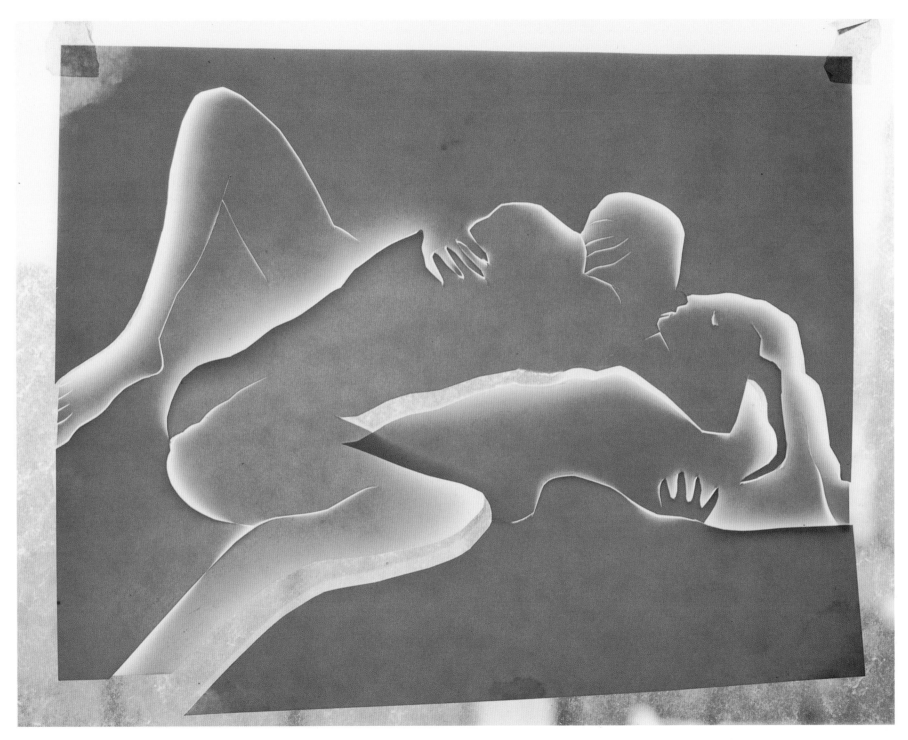

Lovers. 1978
Cut paper, 10 × 12″
Collection the artist

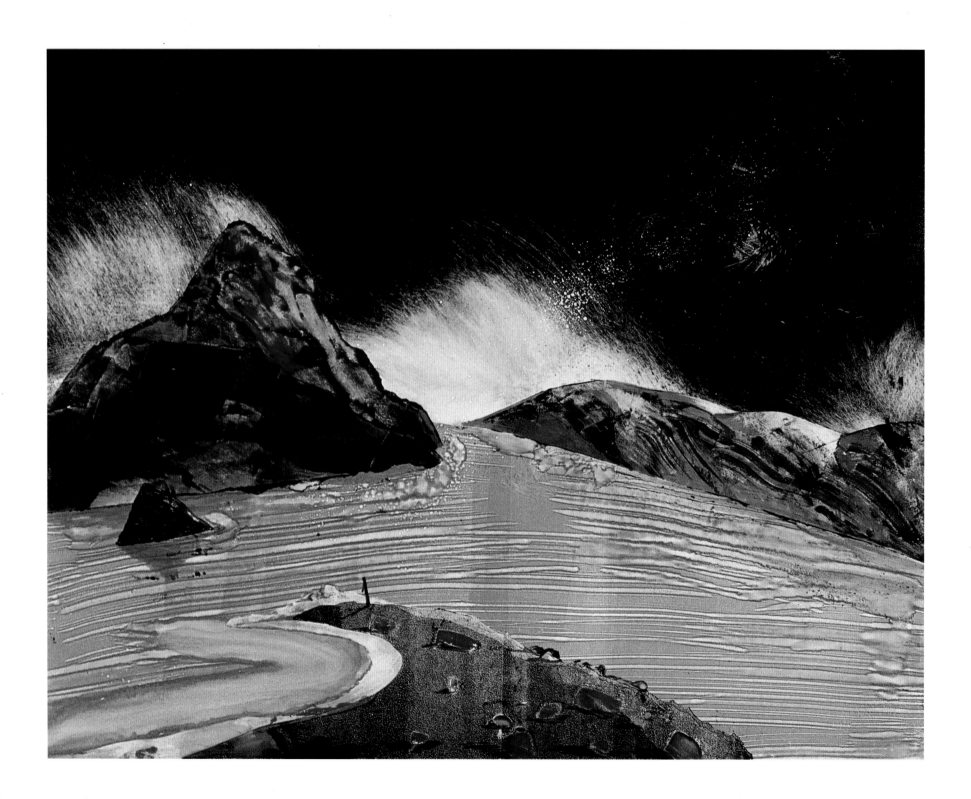

In the last fifteen years Mary has become increasingly engaged in monoprints—direct transfer prints made by the most free, painterly, and primitive of print processes. Degas, who pioneered the technique, called it "drawings made with greasy ink and put through a press."[46] To make a monoprint, an image painted on a metal, glass, or plastic plate (Mary uses zinc and aluminum) is transferred to paper either by pulling the plate and the paper through a press or by pressing paper on top of the plate by hand. Either way, a unique image is produced; there can be a series, but never "states" or editions. The print can be touched up with pencil, oil, or ink after it has been pulled from the press. A few of Mary's monoprints, like many of Degas's, are heavily reworked with pastel. In addition, the monoprint process can be combined with other techniques, such as drypoint etching.

Mary began making monoprints by chance in 1967 when a painting she had made on glass broke and she laid a piece of paper over it in order to transfer the image. "Afterward a friend told me, 'That's a monoprint.'" Over the years her monoprint process has become so complex that often she is unable to recall how a certain image or effect was achieved. In a 1982 notebook she dutifully described the three stages by which a particular monoprint was produced. At the end she wrote, "Clear now?!?" But it wasn't clear at all. In another notebook she spoke more lucidly about her own fascination with the process. "Tremendous curiosity to see where it can go. It starts with an image. The plate is smooth. I can wipe any of it away leaving parts. We talk, the plate and I—at best we sing. Changes, change. Colours fading from having lived too much, used up, others appearing—The plate is generous and mysterious, often more interesting than the print. It retains all its layers. The print only some. Figures appear—entrances, deaths. The colors build, layering like excavations. All the gestures, the sweeping, the imprinting, pressure, the dried edges, the yielding of olive to sap green—of black to Payne's gray. . . . Must have equivalents to life as it is known, imagined, feared, and dreamed of."

When she is making monoprints, Mary is in a state of high excitement that she compares to participating in improvisational theater. Because ink dries quickly, there is a strong time element. "I work in a kind of frenzy," Mary says. "There's a lot of preparation and planning, and I often have a very definite idea in mind, but I change things in response to what I see happening on the plate. In every medium the hand has its own life. It makes marks and gestures that are not deliberate. I often think of them as tracks of animals. There is a dialogue between materials and the original intention that is both a pleasure and a warfare." Being open to chance keeps her art alive (and increases its mortality rate so that she must throw a lot of work away). But there is

Male Head. 1980
Monoprint, 16 × 20″
Collection the artist

Male Head. 1980
Monoprint, 16 × 20″
Private Collection

OPPOSITE:
At the Edge. 1984
Monoprint, 28 × 35″
Centro Cultural del Arte Contemporáneo,
Polanco, Mexico

Lovers. 1977
Monoprint, 21 × 29½"
Courtesy Zabriskie Gallery

nothing passive in her approach. Mary is so knowledgeable about the behavior of her materials and so sure of her vocabulary that she can create situations in which certain kinds of "accidents" will occur. "Accidents," she says, "are *your* accidents. To some degree you can feel them coming, so you harness them or throw them out."

In life and in art, Mary needs room for change. When she walks about her studio or down a street, she is apt to suddenly turn this way or that as her eye and mind are signaled by a new image or idea. Like clay, the monoprint process can accommodate such change. Mary loves the ease with which she can alter, wipe out, and add shapes and colors to the monoprint plate. Also like clay, the process catches all the physicality of Mary's form-making gestures. Its expressive range is vast; sometimes the image seems nothing but a film breathed onto paper. "I choose," she says, "to work with mediums that are somewhat ephemeral." At other times the prints are densely layered, almost sculptural.

Mary paints on the metal plate with lithographic and etching ink and oil paint. Her tools are fingers, rags, rollers, and both ends of paintbrushes. She also has hundreds of stencils that she cuts or tears out of paper or metal—figures, parts of figures, fish, horses, birds, and flowers. These she places on her plate, rolls with color, and removes. Sometimes she flips or shifts the stencils so that the same image will appear in reverse or in another position in the same print or in an entirely different print. The stencils are the perfect device to express Mary's notion of flux and interconnectedness. In a print series, arms and legs formed by stencils detach from bodies and fly about in space or attach themselves to other figures. The freedom with which she assembles and reassembles anatomy is analogous to the way she sculpts figures out of movable and sometimes interchangeable parts.

In a series of lovers from 1977, her stencil was a cutout cardboard couple whose limbs she could manipulate like those of paper dolls. In the first print, the lovers are an inflammatory red set against a black background. Next she turned the stencil over and altered the position of arms and legs. The result is two pairs of overlapping lovers. One pair is pale and transparent—perhaps an afterimage showing where the lovers were at an earlier moment in time. Colors are scrambled by flipping the stencil and by reinking the plate. In the third print in the series, the lovers and the background are both a luminous blue-green, and a pattern of frost crystals sparkles in the deep dream space of passion's aftermath.

Handling stencils that are heavily layered with ink and sometimes laid one on top of the other feels, Mary says, sculptural. "I'm pushing things around and cutting, tearing. These gestures are like those involved in making sculpture. And the content, too, keeps going back and forth. A lot of prints come after sculptures." Using stencils is also, she says, "like a collage where the collage itself becomes the printing plate." Indeed, Mary, who enjoys the carryover from one medium to another, occasionally uses her old ink-encrusted stencils to make collages.

Skeletal Figure, 1975, a monoprint that, like many contemporaneous sculptures, depicts a woman lying with her arms arched over her chest, is actually a three-part collage. Mary pasted the stencils that she used to make the woman's bony limbs on top

Skeletal Figure. 1975
Monoprint and collage,
66¾ × 20½″
Courtesy Mr. and Mrs.
Harry W. Anderson

of the monoprint itself so that the figure looks flayed. Tacked unframed to Mary's studio wall, *Skeletal Figure* bore witness to Mary's mourning during the months after Andrea's death. Over time, the collaged sections curled outward, making the print into a kind of relief. To Mary the curling seemed as natural as a tree dropping leaves in autumn. But a few years later, when she prepared *Skeletal Figure* for framing, she pasted down the collaged limbs, thus curtailing their horrific reach into life.

A less macabre skeletal image, also made from numerous stencils, appears in a series of dinosaur prints from 1980. "I've been drawing dinosaur skeletons for years," Mary says. "Those dinosaurs in the American Museum of Natural History are magnificent sculptures. They have such a quantity of bones and all these extrusions on their heads and tails. I love the spaces between the bones. You can see Calder, Moore, Giacometti, Arp, everyone there in the dinosaur room. You know, dinosaurs were around before there were flowers, when the world was all green. No one knows what sound they made. They may have lived in silence."

For Mary one of the fascinations of the monoprint process is working in series. She inks and reinks the plate so that each of some six or seven prints is different. "I love the possibility of having the past, present, and future at the same time. In sculpture when you make a change, you lose what you had before. Working in a series, you try to keep the image alive as long as possible, but all the work has to be done in one long session on one day, otherwise the ink will dry. . . . When I make a series, there isn't a logical progression from dark to light. By reinking and wiping part out, often the fourth print is dark again. The process is an enormous layering."

Sometimes "ghosts" (images that are offset from an already inked plate onto the roller and then rolled out and printed again) disappear and then turn up in paler versions later on. Mary loves the vaporous quality of the ghosts, the fact that, like cylinder seals printed on clay, at first you might not see them at all, and then they take you by surprise.

Another pleasure in working in series is the ability to follow a figure's movement. "It's like saying 'now' all the time," says Mary. " 'Now this is how it is; now it's this way.' " Reusing the same inked plate also gives color a peculiar translucence. "There is a point just before oblivion, just before the image disappears, when the color has a very wonderful quality; it is the quality of something that has been almost used up."

Mary's engagement with monoprints has led to her growing fascination with color. In the beginning, her monoprints were mostly black-and-white. Gradually she added colors. Each new color was an event. "I started to put out a full palette, and then I never finished because I started working." Since 1980 color has become more luxuriant but no less unusual. "I felt a real need for more color in my work. It was like a primal need. Color is so new; it has been a great struggle." In her expanded palette, colors are no longer conceived primarily in their relation to black and white. Her prints are full of red, pink, orange, and magenta. "Now I have a great desire for what would be called 'heated' color," she said in 1987. "I often want the beings in the pieces to be really saturated, because they're in a state of transformation."[47]

In a notebook from the early 1970s, Mary expressed her reverence for color: "Has

Dinosaur. 1980
Monoprint, 24½ × 35″
Private Collection

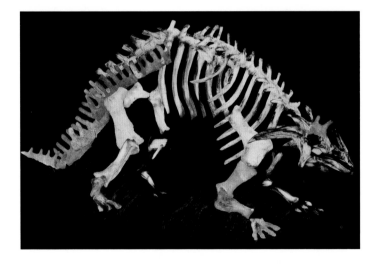

Dinosaur. 1980
Monoprint, 24½ × 35″
Collection Whitney Museum of American Art.
Purchase, with funds
from the Print Committee. 83.13

The Forest. 1976
Monoprint in six sheets,
each 22¼×30″
Collection Raymond Learsy

anybody ever seen the power that turns the grasses green? What is the source of color? It [pigment] was ground for weeks by blind people in India and Persia. In the Middle Ages no one except royalty could wear purple. Color was longed for. . . . We take it for granted, get it like toothpaste in a tube. . . . [I] feel it's important to think about the austerity of colors used for 1000s of years—basic chromes, earths, iron oxides, black, burnt carbon, white, bone, animal or human or bird shit, and always blood: the effort and desire and urgency of people [all] over the world for other colors—their significance and power—their rarity. The Tyrian purple for Greek kings, the yellow of imperial palace tiles in China. The preciousness of lapis lazuli—how much per virgin—the colors of paint being cities of Italy, Umbria, Sienna, Naples yellow, or provinces or whole countries connected to their empowering and predominant color, Turkey, turquoise."

The early monoprints, printed by hand on small sheets of paper, picked up the themes of her sculpture—a woman pitted against sea and sky, Daphne, the horse and rider. In *Woman in Wave*, 1967, the water curling around thighs is as tangible as the swirls of plaster in contemporaneous sculptures. As Mary explored the process, her prints became more painterly and more nuanced. They also became larger, and they covered a broader range of subject matter. She began to assemble several similar prints pulled from the same plate to make one work.

In *The Forest*, 1976, for example, six separate prints arranged in two rows form an irregular rectangle. Together the prints record changing aspects of a scene in which a female nude crouching beside a tree disappears and reappears. The continuities of light, color, texture, shape, and placement from print to print offer an almost filmic sense of movement through time. In *Disappearance*, also 1976 (p. 9), and in a number of Daphne prints of the same period, the image of the nymph turning into a tree runs continuously across three sheets of paper arranged in an asymmetrical cross. As in the 1975 sculpture *Woman with Outstretched Arms*, the figure evokes a crucifixion. Pain is augmented by fragmentation and disjunction. Even as Daphne seeks wholeness by rooting herself in the earth as a tree, her body rises to the sky in a kind of ecstatic ascension. Coming shortly after Andrea's death, this image has a tragic connotation.

During this period, flowers enter Mary's prints and take on an iconic presence. *Tulip*, 1976, glows and swirls upward in an orgy of growth. It is a kind of resurrection. *Amaryllis*, also 1976, makes a luminous ascent with its two great blossoms reaching like wings or like Daphne's branched arms. Again there is a religious mood to the print. The amaryllis could allude to an ascension, and there is the promise of rebirth in the bud that bursts free from the amaryllis's stalk. The bubbling and graininess of the iridescent ground make the flower seem to blossom in a vision.

Making a monoprint or drawing of a single flower is for Mary a way of focusing her energies. In a 1970 notebook entry she wrote: "I often imagine that I could work from just one bit—one bud—one hand—one eye—one spore—that would be enough to chew and digest . . . but that is not at all what I do. I continue culling—gathering, grasping, and snatching from everything and everywhere."

With time, the flowers became less majestic and more joyous. In monoprints of

Amaryllis. 1976
Monoprint in two sheets,
each 22¼ × 30″
The Metropolitan Museum of Art. Purchase,
Stewart S. MacDermott Fund, 1977
1977.550AB

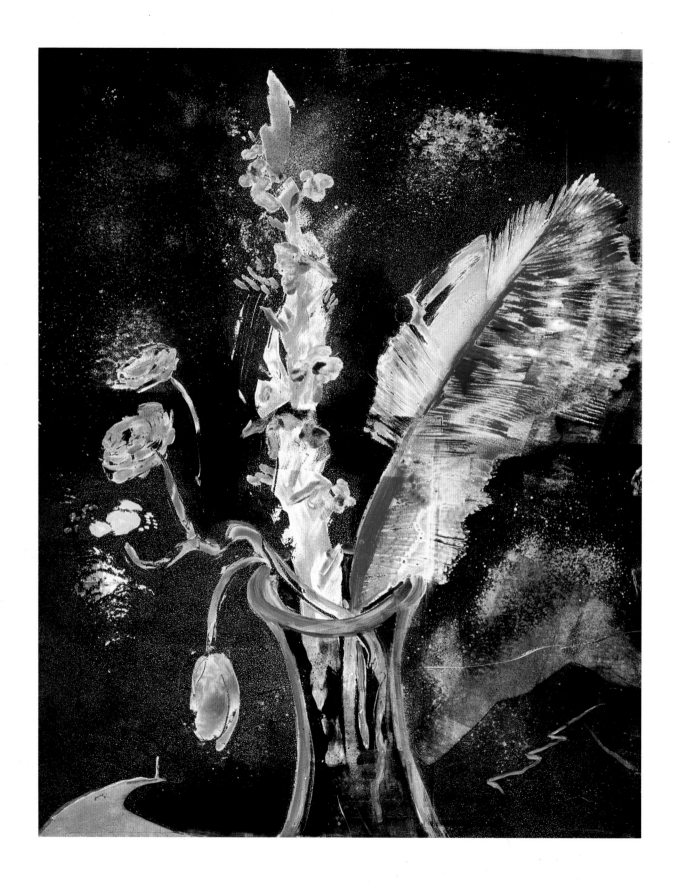

Flowers and Cove. 1988
Monoprint, 30 × 22¼"
Collection the artist

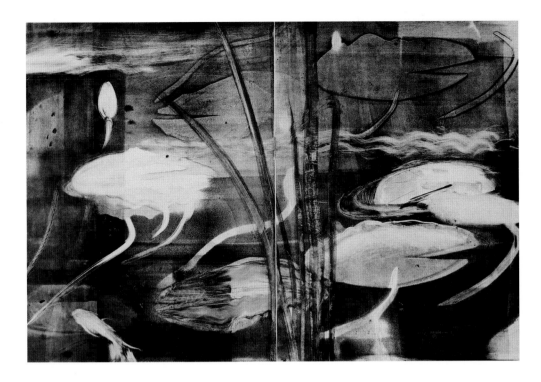

Waterlilies. 1977
Monoprint, 25¼ × 37¼"
Collection the artist

poppies from the late 1970s, the petals' transparent glow is carried over into the transluscence of space around them. In a notebook Mary wrote: "Planting poppies, Sept 78; it is in a way in gratitude for what they have given me (in the monotypes) and so I put others (real ones) back in the ground and hope they will rise up with their full fervour and poetry."

At this time Mary's attention was also drawn to the tiny water-lily pond that Pablo made in her Lake Hill garden. She made a series of increasingly large and intricate monoprints of water lilies as well as drawings in various mediums. In the monoprints she pursued elusive reflections and jostling shadows on and under the water's surface. Flux is structured by verticals and horizontals laid down by the edge of the roller as it spreads broad swaths of ink onto the plate. Amid a jungle of lily-pad stems darts a fish whose quivering trajectory is caught in one pink stroke. The doubling of forms that comes from reusing the same inked plate and the wet, blurry look typical of monoprints are perfectly suited to the subject.

Mary's approach to water lilies—indeed, her approach to all natural phenomena— moves in rhythm with, rather than standing back and taking aim at, nature. This intimate, nonaggressive approach recalls the hours she spent looking at Chinese and Japanese painting. The water-lily prints made her think also about Monet's huge paintings of water lilies that she had seen in Paris: "He was dealing with acres of water lilies, which made them more abstract, and I was trying very hard to draw three water lilies, three leaves, one goldfish, and two stems in that tiny pond."

In the mid-1980s Mary made a number of monoprints that she describes as "explosive flowers." Wild bouquets set like a Matisse still life before mirrors and

windows burst into dark-defying brightness. They have the visionary glow of the monoprints of single flowers from the previous decade, but they are abundant and exuberant rather than iconic; instead of hieratic stillness, we now have flowers that dance. The intense color of some of these monoprints reflects her happier state of mind. "The flowers," she says, "are explosions of color, and they are connected to living with a man I love." A contemporaneous notebook tells of her pleasure in her relationship with Leo Treitler: "These years, miraculous meeting, losses, colours demanding more and more—rising transparent, speaking always 'now,' always here pierced with love. . . . My lovingness with Leo is extraordinary."

Mary's joy in finding a love that was neither taut with longing nor threatened by loss is revealed in another series of prints from the second half of the 1980s as well. In them, people, horses, herons, fish, and even centaurs sail through space as Mary shifts her focus from earth to sky. Freed from earth-bound clay, Mary invented an imagery of ecstatic release. Unfettered by notions of up, down, right, left, near, far, her creatures float in an unlimited space that projects out from the figures' motion and emotion and is continuous with them. The sky—or the ground against which creatures float—is thus not a void. Its color and light are as sensate as flesh. "I want," says Mary, "the surface around the figure to be alive, to reverberate with its life."

When a piece is made up of more than one print, space is structured by the lines where the sheets come together. In many prints the verticals and horizontals left by the roller create a loose grid that recalls the gold-leaf squares that form the background in Japanese screens. In the screenlike *The Time Is Now*, 1985–86, a monoprint made up of six panels, each depicting a single leaping nude, roller marks play against an oceanic tumult of reds and blues that is a kind of thickening or firming-up of space, what the artist calls a "firmament."

"*The Time Is Now* started as a single figure and developed over a number of weeks," Mary recalls. The piece was made from four stencils of figures. The man in the second panel is a ghost of the man in the sixth panel. The women in the third and fifth panels come from the same stencil as well. Repetition disrupts temporal reading and makes us see that, as in all moments of extreme joy, the instant is endless, and all time is encompassed in what Mary calls the "now."

"*The Time Is Now* was an attempt to create a sense of being in the moment," Mary observes. "Space is like a stellar perspective." Kinesthetic empathy carries us to this horizon-free perspective of transport. And the "firmament" where these figures dance is, Mary says, "a substance or a place where people can be transformed—by color, by light, by sound. By experience. By love."[48]

The leapers' transport might have a darker side as well: the notion of flying off the world and floating in boundless space holds its terrors. The stencil-drawn bodies seem to be moved by a force outside themselves. Are they euphoric, or do these figures dance on the void? Do they ascend to joy or flail as they fall into hell's hot light?

Bearing titles like *Origins*, *The Fifth Trumpet Call I*, both 1984, or *Natural History*, 1985, the mid-1980s prints depict the evolution of life not as biology but as prophecy. In one of her notebooks Mary quoted Antoni Gaudí: "Originality is the return to

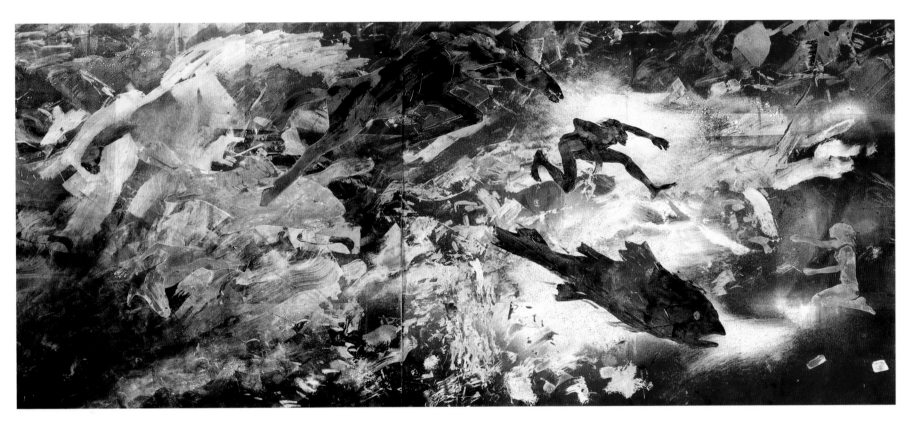

Natural History. 1985
Monoprint, 27½ × 62¾"
Collection Betsy and Frank Goodyear

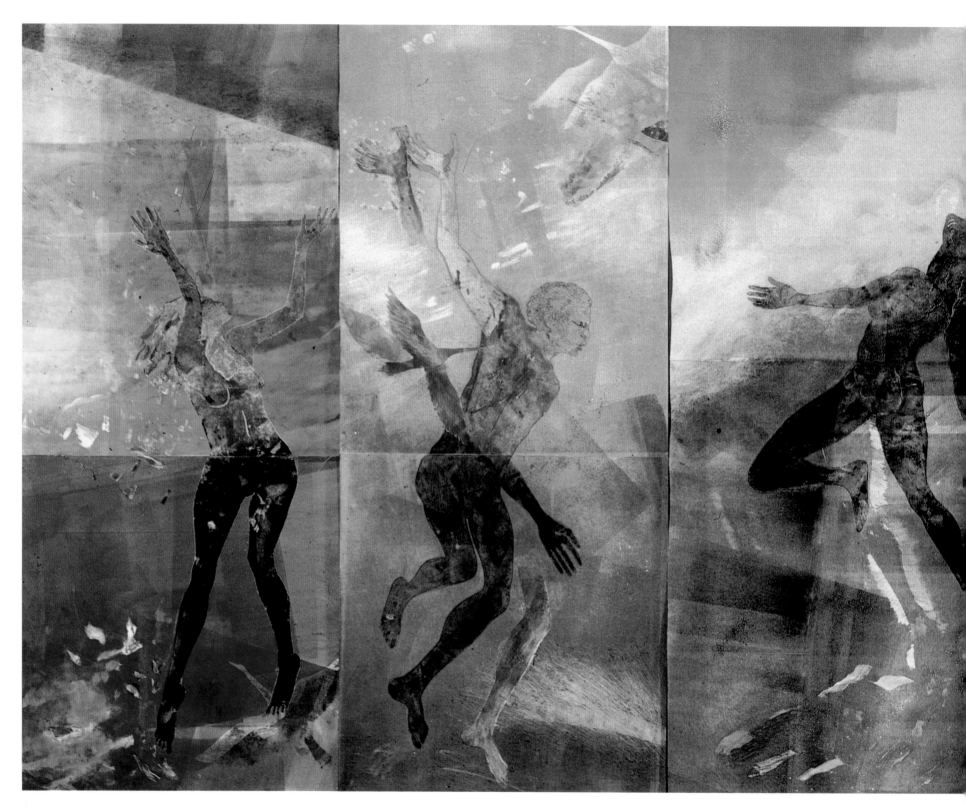

The Time Is Now. 1985–86
Monoprint in six sheets,
5′3″ × 13′9″ overall
Collection Jane and Raphael Bernstein

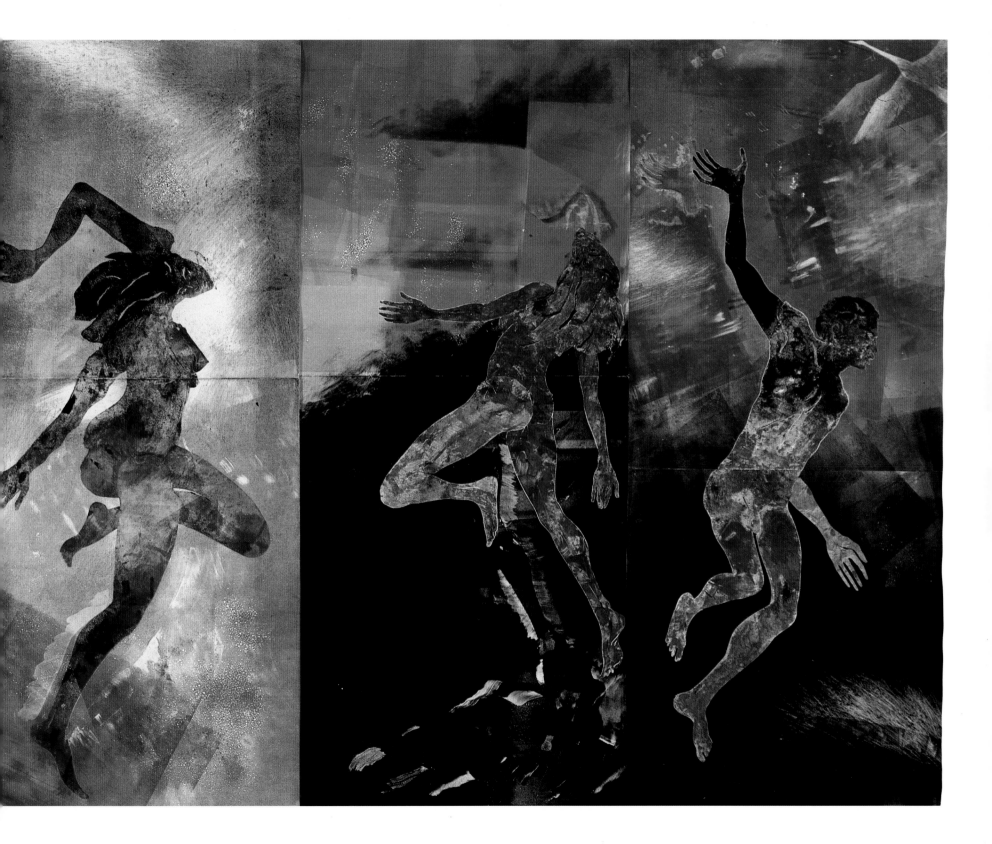

The Fifth Trumpet Call I (diptych). 1984
Monoprint in two sheets,
35 × 55½″ overall
Collection Mr. and Mrs. Sidney Singer

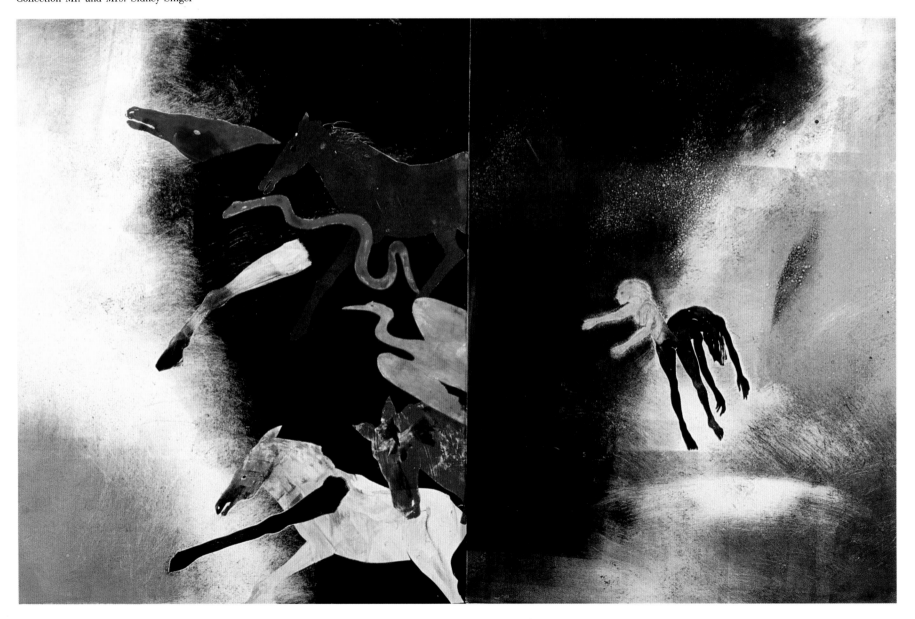

Dawn Horse. 1984
Monoprint, 28 × 35″
Private Collection

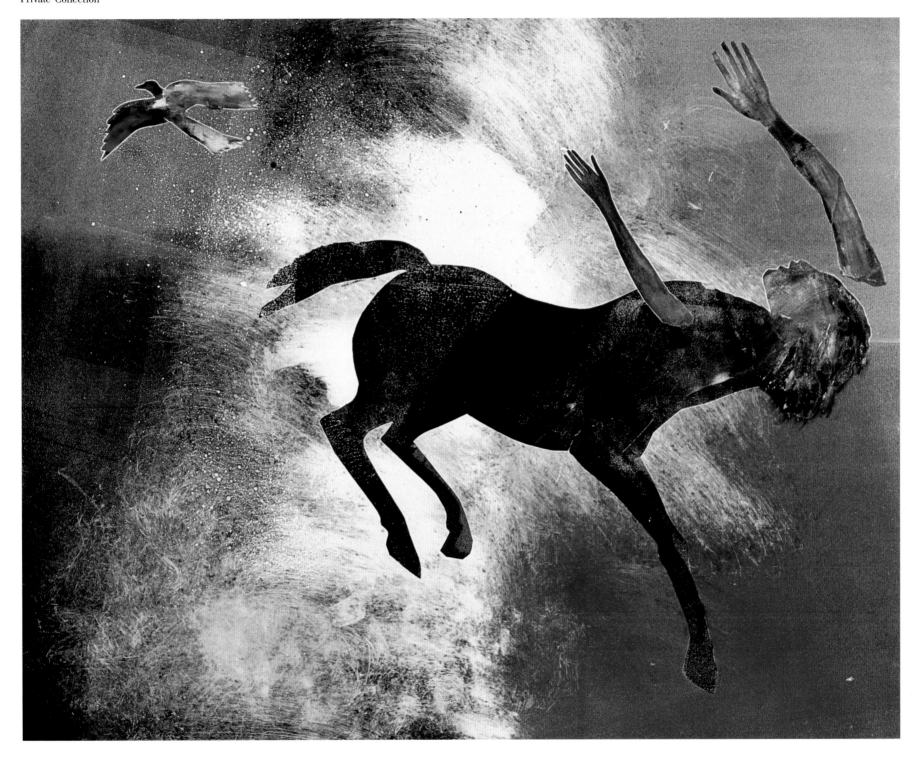

origins." She added her own thoughts to those of the Catalan architect: The origins to which one must return are, she stipulated, "one's own."

The prints with floating creatures speak of both the artist's original self and the origins of history. In *Centaur* and *Dawn Horse*, both 1984, for example, the women-horses flinging their arms heavenward, like the woman sprouting a new self in *The Fifth Trumpet Call I*, are images of genesis. Although the atmosphere in these prints is apocalyptic, several of them hint at life's regenerative powers. In *The Meeting* a woman catapulted through colored light is touched by the hand of a man reaching out to her. The encounter of male and female in *Natural History* is as fraught as that of Adam and Eve. Red with desire, the man leaps toward a crimson woman who kneels on the opposite side of the paper. She in turn stretches her arms to him.

Mary's capacity for joy is equaled by her capacity for grief. Not long after she produced *The Time Is Now*, she made a series of monoprints on the theme of the Holocaust. Here there are no dancers, no flying snakes or centaurs. Here history is too horrible to transform. "I had been making these very celebratory monoprints, and I felt good, and it seemed to me somehow that that was the mode I was in. And then, there I was, making these carts. There are times when things just come from . . . other places."

In contrast to the vivid color and exhuberant movement of the airborne nudes in *The Time Is Now*, the series called *The Cart*, 1985–86, is relentlessly black, white, and gray. All the prints are diptychs. On each sheet, one or two images appear in various combinations. One is a gaunt shaven woman wearing a concentration-camp uniform whose stripes substitute for prison bars the viewer feels but cannot see. The other is a cart piled with corpses and stranded on a stretch of railroad track. In some prints the

OPPOSITE:
The Cart. 1985
Monoprint on rice paper,
25½ × 38½″
Collection the artist

The Cart II. 1986
Monoprint on rice paper,
24¼ × 39½″
Collection the artist

prisoner appears twice, side by side with herself. This doubling is haunting: at the same time that it devalues her image, as in the multiple printing of a newspaper photograph, it also impresses her on our mind. In some images she is dark, in some she is light. Negative or positive, she stares the stare of death in life and asks us only to bear witness.

The series, says Mary, was prompted by a fleeting image that she saw on television. "It was a photograph of bodies from a concentration camp piled on a cart and covered with snow. In a Japanese book I saw photographs of the siege of Leningrad with dead bodies in the streets in the snow. Two years later I did this series of monoprints. It was very difficult for me. I felt the subject was taboo. The bodies in the cart waiting to be buried are the ultimate image of abandonment. When it snows, it snows on everything."

The cart and the captive are printed on rice paper whose parchment-like fragility reiterates the bodies' ephemeral quality. Form is rendered in a starkly literal manner. Lines defining shapes are thin and brittle as if the artist felt it would be wrong to indulge in the swoops and meanders that impell her drawings of creatures and flowers.

Her procedure was simple. She inked the plate, laid a sheet of paper face down over it, and then drew on the back of the paper with a pencil, a fork, or her fingernail. "I started working blindly," she wrote. "My fingernails felt their way on the back of the paper transferring black marks from the inked plate underneath. The subject was teaching me."[49]

The subject continued to inform her. After she finished the print series, she did a painting of *The Cart* in oil on a plaster panel (1986), and more recently she painted the prisoner on sheet metal so that silvery reflections shining through and between brushstrokes suggest memory's shimmer.

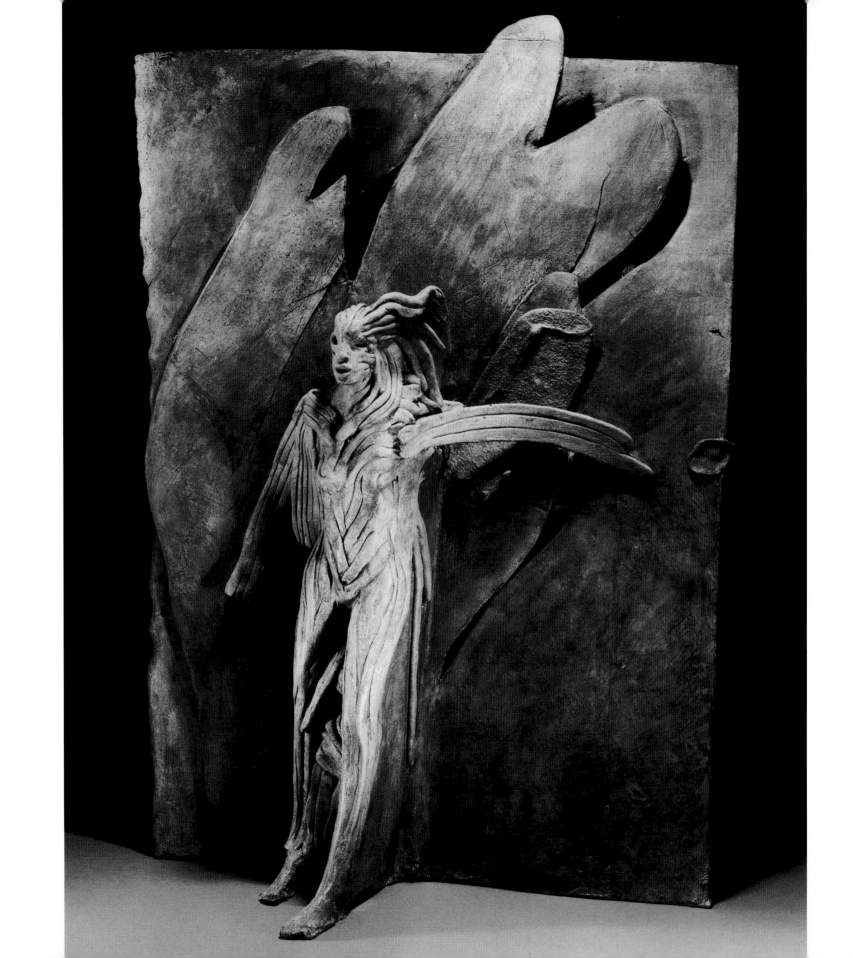

In the second half of the 1980s, with a number of museum shows behind her and a large following of devoted patrons, Mary has been able to afford to have several large clay sculptures cast (for example, her 1985 *Persephone* was cast in bronze in 1988). One of the most spectacular bronzes is a large head of a woman from 1985–86 entitled *Presence.* The story of its making has the improvisational quality that typifies Mary's approach to art. When she closed up the Lake Hill house and returned to New York in the fall of 1985, she left a large clay head drying in her studio. The temperature dropped below freezing, causing cracks to open on the sculpture's cheeks and forehead. When she returned the following spring, she watched the cracks lengthen and move toward the woman's eyes and mouth. "They had their own beauty," Mary recalls, "but I knew I would have to destroy the piece. One day the sculptor Alan Siegel dropped by and suggested that I cast it. So I did. I never would have thought of it myself." Head tilted back, eyes closed, lips open, the woman, like *Persephone*, offers herself to and imbibes the world around her. For all her fleshy substance, the vivid blue patina makes her seem a concretization of air. Inspired perhaps by the blue patina in this and several other recently cast bronzes, and prompted by her obsession with color, Mary painted two ceramic sculptures, *Ethiopian* and *Woman in Wave, Spring*, both 1986–87, in various shades of blue.

Another medium to which Mary returned in the 1980s is plaster, which she carved in relief and into which she stuck fragments of painted glass and sometimes small clay sculptures. In a plaster relief from 1982 entitled *The Grammar of Regret*, she managed to bring together such disparate images as a female head (taken from Botticelli's *Birth of Venus*), a horse and rider (painted on glass), and a large plaster fish whose tail juts beyond the relief's right edge. Sometimes the images and objects that she inserts into the plaster reliefs seem arbitrarily thrown together, and the negative space of the white plaster that surrounds them does not come across as an imaginative "place" where these images and objects can reside. But when the plaster reliefs "work," they have tremendous vigor.

During the second half of the 1980s, Mary began to feel that clay sculpture no longer engaged her deepest energies. "When I choose a medium," Mary says, the decision comes out of a certain urgency. The medium I've been using no longer works for me." Her fascination with color grew, and her monoprints took on the richness and complexity of oil paintings. Then in 1986 she stopped making sculpture for two years. Instead she painted on plaster, glass, metal, paper, and canvas. Perhaps her mother's death in that year removed some of what Mary called the "overwhelming" pressure attached to painting.

In spite of the fact that she is a painter's daughter, Mary feels she has "no painting background." She is battling to reinvent pictorial procedures, to use color with feeling, and to make forms live within the flat illusory space of paper or canvas. Propped

Ethiopian. 1986–87
Ceramic with paint, 27½ × 20 × 14"
Collection Jane and Raphael Bernstein

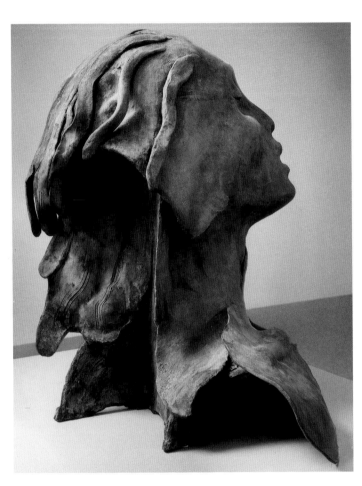
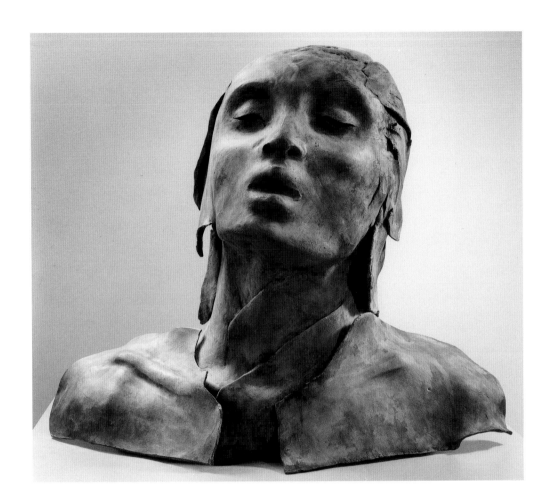

Presence (two views). 1985–86
Bronze, from an edition of four;
28 × 34 × 22″
Graduate School of Business Administration,
Harvard University

The Grammar of Regret. 1982
Plaster, painted glass,
23 × 31 × 4¾″
Private Collection

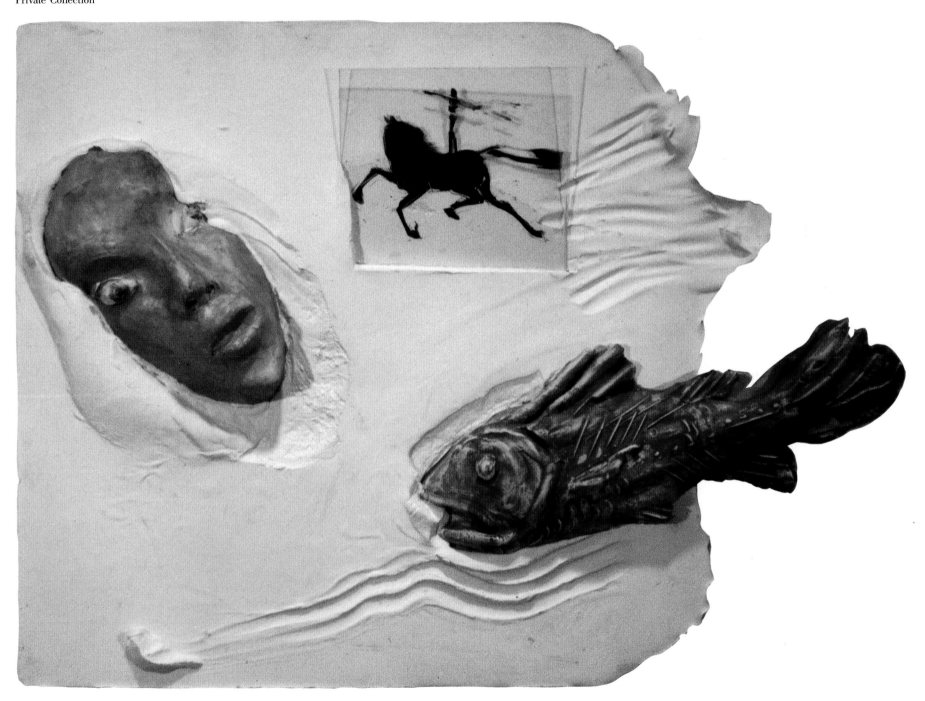

against her studio wall and piled on tables are numerous paintings about which she feels uncertain—some she will continue to work on, others she will throw away. For the moment she needs them not as works of art but as markers indicating the ground she has covered and the direction of her search.

Mary's paintings on metal began as monoprint plates. Instead of cleaning and reusing them, she keeps them, sometimes changing them slightly. The plates have the fascination of palimpsests—they are layered with a history of inking, wiping, stenciling, and reinking. "I began looking at the plates," Mary recalls, "and I decided that the plate was more interesting than the print. Sometimes I throw the print away. I love the color of the metal coming through the paint." The light that glows from behind forms is in perfect accord with the subjects depicted—mostly nudes, birds, horses, flowers, all floating in an ether as volatile as the feeling of air around the body of a person in love.

Mary also discovered that plaster is a wonderful surface on which to paint. In *Passage* (p. 3), for example, the pinks, peaches, and summer greens have a smooth, fresco-like luminosity that suits the pastoral landscape through which horses roam. In *Poppies*, also 1986, a nude woman lies beneath blossoms so enormous they must be her dream; in this melding of body and landscape, petals, together with the spaces between them, have absorbed the texture and tone of flesh.

In the summer of 1988 Mary began to explore a medium she had touched upon earlier in her plaster reliefs. She made paintings of near-abstract landscapes and flowers on glass that could be viewed from either side. Sometimes she reused old glass palettes upon which she had heaped pigment for use in monoprints. She left certain colors and scraped others away: as with the monoprint plates, she delighted in the history and layering. Seen from the back side, through the glass, the painted strokes' underbellies look almost as tactile as clay. Seen from the front, the strokes are sometimes so thick the painting becomes a relief. Most recently Mary has combined drawing in charcoal, pastel, or ink with painting on a sheet of glass set in front of the drawing. The disjunction between the mediums augments the imagery's tension in several drawings of a skeleton (in charcoal) moving out of a lush flower garden (painted in oil).

Some of Mary's paintings are close to abstraction, yet the gestures that form them always appear to be prompted by a direct response to a visual stimulus. In this they recall the speed and passion with which Fauve painters seized and reinvented what they saw. But Mary's semiabstract paintings also come close to the freedom and energy of New York School painting of the 1950s, especially to De Kooning's abstract landscapes.

Turning to painting may have been a way to revitalize her creative process. Like drawing in a darkened theater, the new medium forced her to push beyond her own habits of vision. Because she is still finding her way as a painter, her paintings are uneven and highly varied in style. All of them have an infectious energy and sensuousness, and there is something gallant about a successful artist in her midfifties struggling to learn a new medium when it would be so easy to continue in known paths.

Floating Figures I. 1985–86
Oil on metal plate, 47¼ × 36″
Private Collection, New York

OPPOSITE:
Waterfall. 1988
Oil on glass, 28 × 12″
Collection the artist

Expulsion. 1989
Oil on glass over charcoal,
30 × 24″
Collection the artist

Homage to Henri Rousseau. 1989
Oil on glass, 26 × 34″
Collection the artist

Poster for Human Rights Watch. 1989
29¾ × 19″. Image:
Head with Hand. 1988
Ceramic, 12 × 4½ × 3″
Collection the artist

OPPOSITE:
Vietnam Piece. 1974
Ceramic, 13 × 6 × 5″
Private Collection

All of Mary Frank's art, whether celebratory or mournful, proclaims her reverence for life; yet, with the exception of the Holocaust series, her expressions of outrage at humanity's disregard for life have generally been oblique. "It is difficult," she says, "to work with these concerns—to make a piece about the Vietnam War, for example, and to have it feel authentic, not like rhetoric." Her notebooks contain drawings of the tiger cages in which Vietnamese placed their prisoners. "I tried a lot to do work related to the Vietnam War," Mary recalls. "I did a lot of drawings, not much sculpture, and most of my things were complete failures in terms of what I was trying to do."

In response to her horror at the Vietnam War, Mary made several sculptures of women holding either dead children or a folded cloth that suggests a winding sheet. One of these, *Vietnam Piece*, 1974, is a particularly powerful image of grief. The Madonna/mother sits with the granite rigidity of an Egyptian tomb statue. The dead child lies collapsed across her knees, which have been transformed into a throne or a sepulcher. She neither embraces her son nor looks at him. Her face splits open to reveal three masks of mourning. The two halves of the outer face are deadened by grief. The inner face is fixed in a grimace of despair. The only indication that this pietà is a protest is the skeletal corpse of a military eagle impressed on the mother's belly with a seal.

In what appears to be another political sculpture, a cadaverous figure, perhaps the sole surviver of a holocaust, stands on top of what is left of the world. More recently Mary produced a poster for Human Rights Watch's tenth anniversary. Beneath the words "celebrate human rights and those who protect them" is a photograph of a sculpture Mary made of a hand that holds a head in its palm. The hand is raised in gentle supplication, not in protest, and the head—neither white nor black, old nor young, male nor female—is the unknown victim.

In Mary's view, an artist living today must be affected by political and social ills such as the environment, AIDS, the threat of nuclear disaster. "You can't help but use these things in art. If your eyes are open only to your work and closed to life around you, the work will suffocate."

She is particularly passionate about environmental issues. In a 1978 notebook she wrote: "I feel caught in an idea, and it is that we are the last (meaning in evolution) of different forms of life . . . will there be nothing after us and does anyone care if there

is? Are we so advanced that there are no more inventions, mutations, possibilities?" Two years later she added a note to this entry: "1980: On reading this I realize it was just the beginning of an idea—if we are the last, are we not responsible for the other beings—earth, substance, air? Or are we just victims of our nature that finds it so easy to destroy and so difficult to save and nurture what we have?"

In a sculpture entitled *Crouching Woman with Two Faces*, 1981, a woman holds a plant as protectively as if it were the last two leaves on earth or a newborn child. One of her faces stares out at us. This face, like the woman's squatting posture, has the innocence of a primitive being. Another face yearns upward with the closed eyes of lament. The ferocity of maternal love is akin to that expressed in Mary's ceramic *Pietà* from the same year.

Exile, loss, and destruction are the themes of a series of some thirty prints entitled *The Storm Is Here* that Mary pulled in 1982 from several plates, in some parts of which she combined drypoint etching with the monoprint process. A pageant of creatures coming and going across the monoprint stage tells the story of life's evolution and decline. The title comes from Peter Schumann's Bread and Puppet Theater, of which Mary is a passionate devotee. "When I began *The Storm Is Here* I had no idea it would become such a huge series, with all the same elements constantly changing like deaths and entrances, disappearing, reappearing. I began to see the connection to themes that Schumann had dealt with in a different way—a wonder and horror about what's being done to and on the earth."

The print series' cast of characters includes a profile of a man's head inside of which a walking woman is sometimes inscribed. In some prints the walking woman appears by herself. Sometimes she is winged, and sometimes her rear leg is defined by an extra red line that looks like a ribbon of blood and that speeds her forward motion. Also among the dramatis personae are a running man (taken from the large plaster *Running Man* of 1981); a skeleton from some extinct reptile, probably a dinosaur; and a primordial horse that occasionally has two heads and that in one print transforms itself into a fish and in another bursts into flame. Elsewhere, a bird swoops down to attack a fish inscribed with the profile of a woman; elephants burn; a bull wheels around to stem the inexorable flow of creatures toward destruction. Another recurring image is a crowd of human beings fleeing from some unseen horror. They huddle together so that their bodies dissolve into a rocklike mass. Whatever the storm is that drives them, that storm is, Mary tells us, here. Just as *The Time Is Now* is an invitation to live more fully in the present, *The Storm Is Here* is a warning that we may not have a future.

Chimera, 1984–86, is another kind of omen. A chimera, Mary says, has no substance except in the imagination. Part lion, part antelope, part serpent, this fabulous monster is made out of papier-mâché. The lightness and fragility of this material suits the subject as does the process by which strips of paper are bandaged onto the armature so that the chimera looks like a mummy. In addition, the idea of flimsy paper turning into solid form parallels the idea of chimeric mutability.

The *Chimera* recalls the lion-women that Mary modeled in wax in the late 1950s. It has another source as well. "When I was a child," Mary wrote in a 1986 notebook,

Crouching Woman with Two Faces. 1981
Ceramic, 29 × 24 × 16"
Collection Richard Ekstract

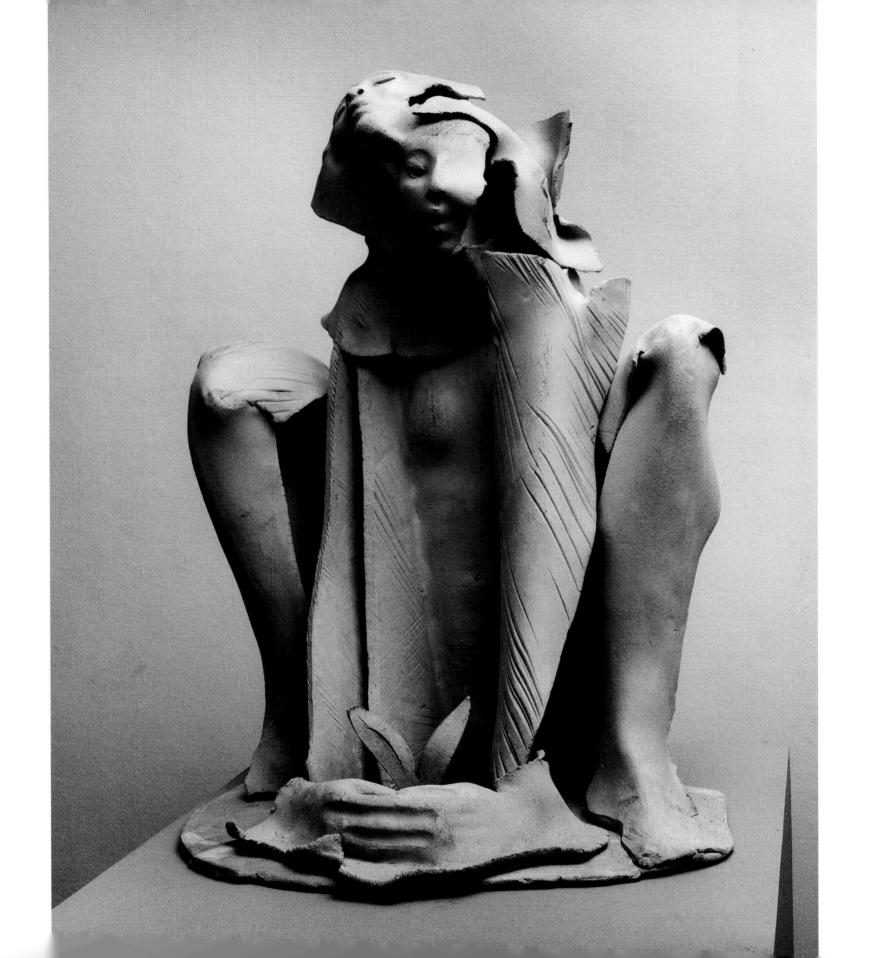

The Storm Is Here (five versions). 1982
Monoprint and drypoint, each 25 × 35″
Private Collections

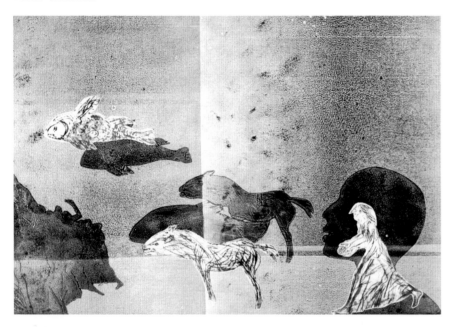

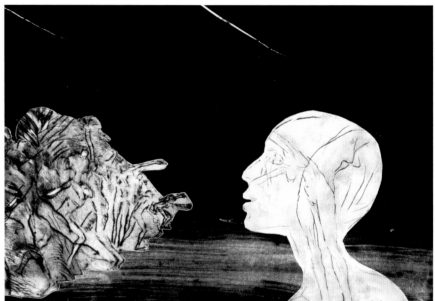

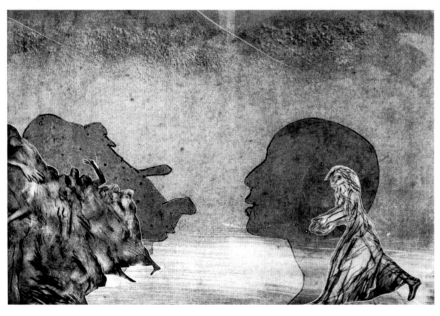

Chimera. 1986
Charcoal, 29¾ × 42″
Collection Karl K. Ichida,
Honolulu, Hawaii

Chimera. 1984–86
Papier-mâché, 34 × 60 × 24″
Collection the artist

"my mother had a book of Etruscan sculpture. There were many things that haunted me of clay, stone, bronze—women with joy in their faces, sudden ibexes, warriors pared down to bones, and a most amazing figure called Chimera. A lion bronze, in seeming pain; from his side an ibex, neck and head arched. [From] his lashing tail comes a snake monster head which attacks the ibex, biting his horn. I did not love this piece, but I never forgot it. From 82 to 86 I worked from time to time on different versions of this idea in clay, small and large, and in papier-mâché, finally [in] monoprints."

Forty years after seeing the Etruscan chimera in her mother's book, Mary saw the actual piece in Florence. "It was more terrifying, but it was even more amazing." She covered her own *Chimera*'s armature with a skin made out of old rice-paper monoprints that she tore up because she thought they were no good. The way the prints "composted into the sculpture" pleased her. Using the "discards from one medium to feed another" is, she said, "like gardening." Most of the chimera is gray, like the monoprints. The antelope's head is bright red. "Though the antelope is the tender aspect, I did not want to give it a humble color."[50]

The roaring chimera sprouting an antelope head and brandishing a serpent tail that bites the antelope's horns, stands for nature's cycles of life and death. "It became for me," Mary wrote, "an image of much of life on earth, now the spiraling circle that doesn't get broken, the denial of the tender creature, the destruction of the earth itself."

For two years the *Chimera* had no tail. "I couldn't bring myself to finish the tail, to make the serpent's head," Mary explained. "I found it so depressing, so terrible, so I just left it blank."[51] Finally she finished it "in one fell swoop," adding the serpent, the agent of the Fall from grace, so that the *Chimera* became a kind of Expulsion from Eden for the nuclear age.

It was after she made the *Chimera* that Mary stopped making sculpture. When she returned to it in 1988 she made a similarly terrifying papier-mâché creature inspired by Henri Rousseau's maddened horse in *War*. The expressive force with which *Trajectories*' papery surface is painted burnt sienna, black, and white reflects the artist's recent engagement with painting.

Like *Horse and Rider*, 1982 (or like the horse in *The Storm Is Here*), the horse in *Trajectories* is a two-headed creature and an omen of destruction. Once again the rider is falling. Indeed, he seems to want to fall; otherwise he will be propelled to his ruin. The situation is all the more precarious because the horse does not have solid ground to support his charge. He is, like the horses in so many of the monoprints, flying through air in some kind of apocalypse.

Beneath him is a small island of water; it is as if the earth had been used up and there were no place left to stand. "Originally the water was much larger. I kept carving it away during the year I worked on this piece." Upon this vestigial world, and much smaller in scale than the horse, floats a primitive boat, an image that appears in several paintings and monoprints from 1989 and that brings to mind Egyptian death barks (and Mary's lunar barks of the 1950s). The water around the boat turns from

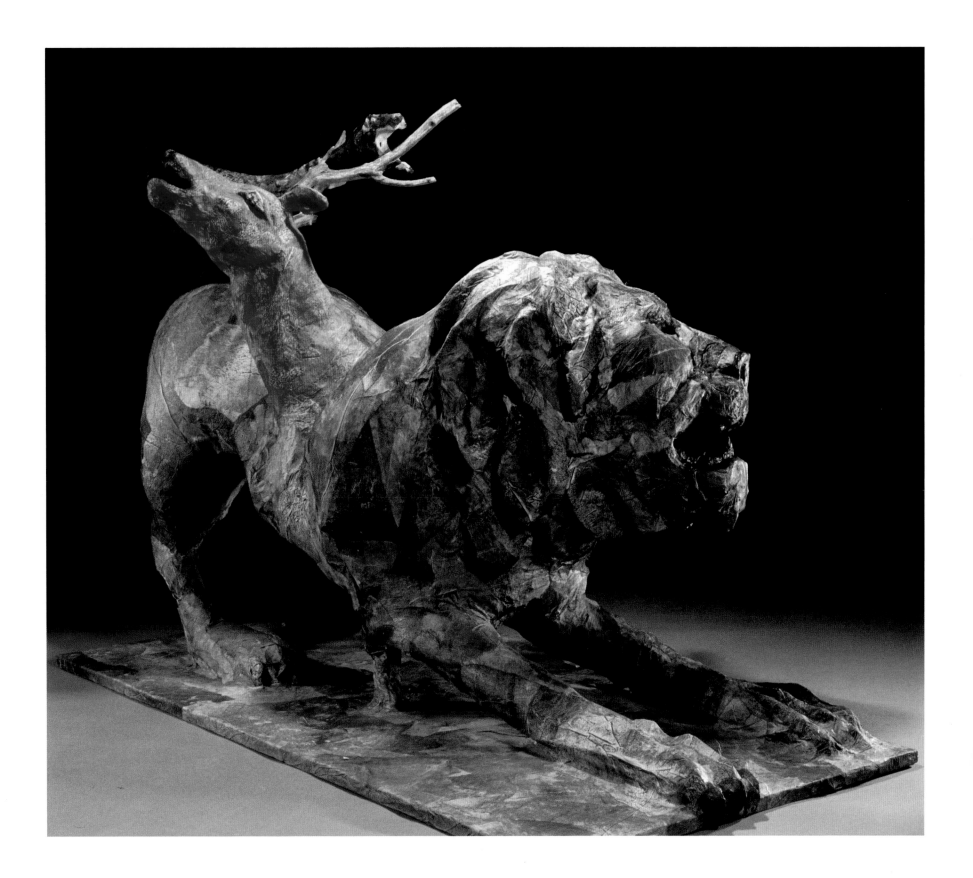

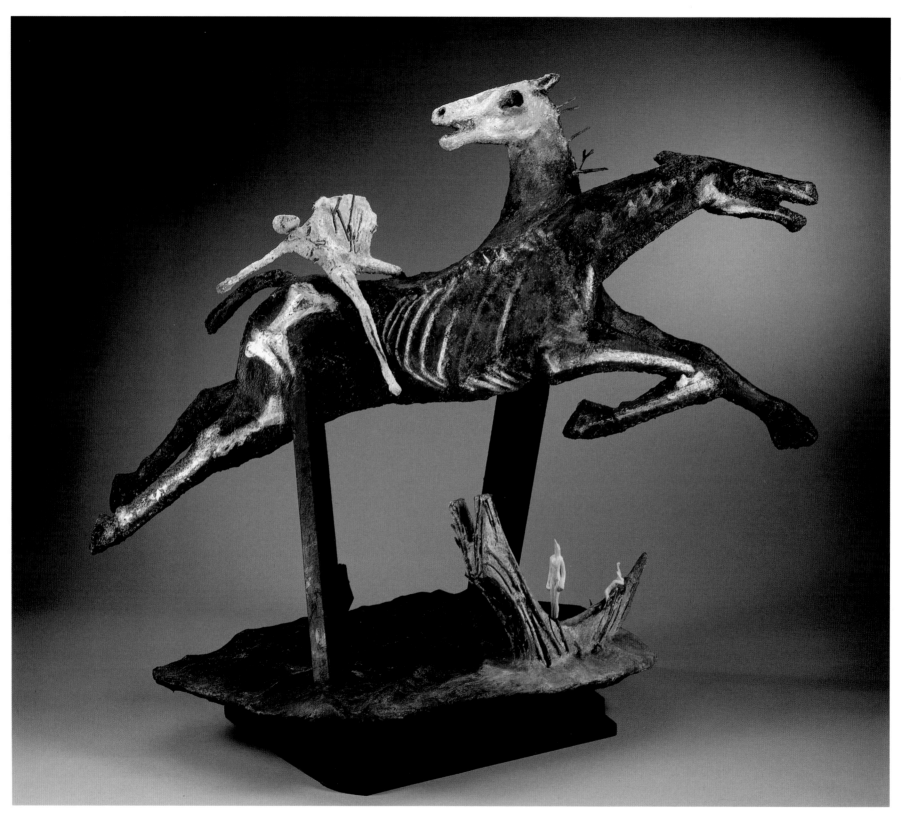

Trajectories. 1988–89
Papier-mâché, 38½ × 53 × 35″
Collection the artist

Barque. 1989
Oil on metal, 36 × 47¼″
Collection the artist

black to a fleshy russet-rose—a piercingly tender color like the red of the ibex in *Chimera*.

On board are two small figures whittled in wood. One is a bird-headed man that harks back to Mary's early sculptures. Standing facing the prow, seeming to accept his fate, he is Egyptian in his immobility, yet he sniffs the air as if he were an animal alert to danger. The other figure struggles to pole the boat out of the quagmire. Holding no pole, his raised arms could also be a gesture of despair.

The contrast between the boat's stillness and the horse's dash, and between the whirling, falling rider and the standing man, is poignant. Although differences in scale and direction make the horse and boat, the rider and the boatsmen seem to exist in different moments in time, the pinwheel motion of the sculpture's multiple trajectories brings disparate parts together. Indeed, much of the sculpture's mystery and meaning come from the tug of opposing directions. The figures' paths will never converge, destinations will not be reached, and the upheaval will go on forever.

Although she insists on adventure, Mary has always had a sure sense of what she wants her art to be. Often her work falls short of her ideal. In notebook entries she complains that it is too "lyrical," too "tight," or too "soft." Or it needs "more risk, more edge." Again and again she despairs at her scatteredness. "I am like one of the dogs who bark up many *wrong* trees, it seems whole forests. Somewhere when the work is good, I know that the inner feeling connects through my hand to the work and maybe beyond—when the feeling is strong enough and clear."

In a moment in the early 1980s when she felt dispersed and unconnected, Mary wrote: "Working is based on faith. When that's chinked away (it's so fragile) pure will can't work. . . . My subjects are gone." But they are never gone for long. Mary is a survivor, and the part of herself that she protects most fiercely is her creative drive: without that everything else collapses. "For me," she says, "making art seems to be just the normal thing. I can't imagine not working unless I were crazy or dying."

Mary Frank is an extraordinarily productive artist who is almost constantly obsessed with the fear that she is not working enough. "Sometimes I sense that it would be some kind of salvation if I could work much more," she said in 1973. "Often I'm on the outside, distracted, distracting myself. I know I could go much further."[52] Since then she has gone much further. Still, she is discontent. She nags at herself when she is not productive, and when she is, she acts as if her ability to make art were a momentary gift.

In a notebook entry from the 1970s Mary drew a hand, a heart, and an eye next to the words, "Where is one working from? The observing heart. There is *no* way to make art. I can only make palpable experience." She never looks for absolutes or finalities: she offers glimpses that take hold gently and then slowly unfold in the viewer's mind. Because making art for Mary is synonymous with being alive, its processes are more important to her than its products. "Working with substances," she wrote, "may be a way of staying in touch with the heart—the heart of the matter." In her sculptures, drawings, prints, and paintings, Mary Frank moves straight to the heart of the matter; she puts feeling into matter so that matter is transformed into heart.

Recognition. 1989
Oil on metal, 36 × 47½″
Collection the artist

notes

1. All quotations, unless otherwise noted, come from interviews with Mary Frank by the author on June 23, 1977, at Lake Hill, N.Y.; on October 12, 1979, November 1980, and September 28 and 29, 1987, in New York; and on August 9, 1988, in Cape Cod.
2. Paul Cummings, "Interview: Mary Frank Talks with Paul Cummings," *Drawing* (May/June 1981): 12.
3. *Mary Frank: Persephone Studies*, exhibition catalogue, The Brooklyn Museum, 1987, n.p.
4. Margaret Staats and Lucas Matthiessen, "The Genetics of Arts," part II, *Quest* (July/August 1977): 40.
5. Conversation with Leo Treitler, May 1989.
6. Margaret Moorman, "In a Timeless World," *ARTnews* (May 1987): 97.
7. Margaret Moorman, op. cit., p. 97.
8. Eleanor Munro, "Mary Frank," in *Originals: American Women Artists* (New York: Simon and Schuster, 1979): 296.
9. Conversation with Henrietta Mantooth, July 1989.
10. Eleanor Munro, op. cit., p. 296.
11. Ibid., pp. 296–297.
12. Conversation with Emily Mason, January 17, 1989.
13. Margaret Moorman, op. cit., p. 95.
14. Eleanor Munro, op. cit., p. 294.
15. Margaret Moorman, op. cit., p. 95.
16. Ibid., p. 95.
17. *Robert Frank: New York to Nova Scotia*, exhibition catalogue, The Museum of Fine Arts, Houston, 1986, p. 28.
18. Staats and Matthiessen, op. cit., p. 40.
19. Margaret Moorman, op. cit., p. 95.
20. Margaret Moorman, op. cit., p. 96.
21. Hilton Kramer, "The Possibilities of Mary Frank," *Arts* (March 1963): 52, 55.
22. S. B. in *ARTnews* (May 1966), quoted in Eleanor Munro, op. cit., p. 301.
23. April Kingsley, "Mary Frank: A Sense of Timelessness," *ARTnews* (Summer 1973): 67.
24. Margaret Moorman, op. cit., p. 94.
25. April Kingsley, op. cit., p. 67.
26. Eleanor Munro, op. cit., p. 300.
27. Ibid., p. 302.
28. April Kingsley, op. cit., p. 67.
29. Bill Marrel, "A Modern Way with Clay," *Horizon* (September 1978): 45.
30. Eleanor Munro, op. cit., p. 302.
31. On a 1979 trip to London Mary drew the Elgin Marbles in the British Museum, and in the 1980s she drew and sculpted the head of one of the wind figures from Botticelli's *Primavera*.
32. Fleur Weymouth, "An Interview with Mary Frank," *Helicon Nine: The Journal of Women's Arts & Letters*, no. 9 (1983): 31.
33. Hilton Kramer, op. cit., pp. 54–55.
34. Paul Cummings, op. cit., p. 14.
35. Ibid., p. 11.
36. *Mary Frank: Persephone Studies*, op. cit., n.p.
37. Paul Cummings, op. cit., p. 11.
38. April Kingsley, op. cit., p. 66.
39. *Zabriskie Newsletter* 4 (Spring 1981): 1.
40. Fleur Weymouth, op. cit., p. 24.
41. Paul Cummings, op. cit., p. 12.
42. Margaret Moorman, op. cit., p. 92.
43. Paul Cummings, op. cit., p. 13.
44. Eleanor Munro, op. cit., p. 290.
45. Alfred H. Barr, Jr., *Matisse: His Art and His Public* (Salem, N.H.: Ayer Co. Pubs.): 274.
46. Lawrence Campbell, "The Monotype," *ARTnews* (January 1972).
47. Margaret Moorman, op. cit., p. 93.
48. Ibid., p. 92.
49. *Mary Frank: Sculpture and Works on Paper*, exhibition catalogue, Zabriskie Gallery, New York, 1986, n.p.
50. Ibid.
51. Margaret Moorman, op. cit., p. 94.
52. April Kingsley, op. cit., p. 66.

Horse. 1989
Oil and charcoal, 36 × 48″
Collection the artist

chronology

Mary Frank in her Lake Hill studio, 1977

Note: Biographical material revised and updated from the versions in Hayden Herrera, *Mary Frank: Sculpture/ Drawings/Prints* (Neuberger Museum, 1978); and *Natural Histories: Mary Frank's Sculpture, Prints, and Drawings* (DeCordova and Dana Museum and Park, 1988).

1933
Born February 4 in London, England, to Eleanore and Edward Lockspeiser.

1939
Evacuated from London to a series of country boarding schools.

1940
Moves to the United States with mother. Lives with maternal grandparents in Brooklyn for five years. During the 1940s attends various public and private schools, including Friends School, the High School for Music and Art, and the Professional Children's School.

c. 1945–50
Studies modern dance, principally with Martha Graham, also with José Limon, Jerome Weidman, Hanya Holm, and others; abandons dance training in 1950. Also trains for one year (c. 1948) to become a circus performer.

1950
Begins wood carving in studio of Alfred van Loen. Graduates from the Professional Children's School. Marries Robert Frank. The Franks live at 53 East 11th Street in New York. Studies drawing with Max Beckmann at the American Art School in New York.

1951
On February 7 son Pablo is born. Works intermittently at wood carving and plaster. Studies life drawing with Hans Hofmann; begins lifetime commitment to drawing. With Pablo travels to Zurich, then to Paris, where they are joined by Robert Frank during the summer.

1952
In the summer the Franks travel to Spain and are based in Valencia. In October they return to Zurich and in December travel to London.

1953
In March the Franks travel to Caerau, Wales, for nine days before returning to New York on March 17. Begins to visit Provincetown, Massachusetts, on Cape Cod, in summers.

1954
On April 21 daughter Andrea is born. Returns to Hans Hofmann's drawing class. Meets Jan Müller, Robert Beauchamp, Robert Grillo, Miles Forst, and Lester Johnson. Continues carving small wood pieces and working in plaster.

Mid-1950s
Participates in several group exhibitions at the cooperative Tanager Gallery in New York.

1955
In October Mary and children join Robert Frank, who, supported by a Guggenheim Fellowship, is taking photographs for *The Americans*, published in 1958. The family travels across southern Texas to Santa Fe, New Mexico, and across Arizona and Nevada to Los Angeles. Mary and the children return to New York.

1956
Moves to 34 Third Avenue, near Tenth Street.

1958
Exhibition (with Paul Harris) at Poindexter Gallery, New York. Shows wood sculptures, small bronzes cast from wax originals, and drawings.

1961
First solo exhibition, at Stephen Radich Gallery, New York. Shows wood sculptures and drawings. Travels to Europe with Robert and children. In Venice meets friends Red Grooms, Mimi Gross, and K. K. Keene and travels for a week from Venice to Ravenna in a horse and cart. Receives Ingram Merril Foundation Grant.

1962
Moves to Sixth Avenue and Spring Street. Receives Longview Foundation Grant (and again in 1963 and 1964).

1964
Moves to 201 West 86th Street.

1965–70
Teaches drawing at the New School for Social Research.

1967
Gives up carving in wood to concentrate on modeling in plaster. Begins making monoprints. For two months travels with Robert and children in Mexico.

1968
First of a series of exhibitions at Zabriskie Gallery, New York. Exhibits plaster and bronze sculpture. Illustrates children's book *Enchanted, An Incredible Tale*, by Elizabeth Coatsworth. Receives National Council of the Arts Award.

1969
Separates from, and later divorces, Robert Frank. Moves to Westbeth soon after the separation. Begins to concentrate on ceramic sculpture. Illustrates children's book *Buddha*, by Joan Cohen.

1970
Teaches drawing and sculpture at Queens College Graduate School through 1975. During this time works with students to create handmade posters to be used in anti–Vietnam War protests. Illustrates children's book *Son of a Mile-Long Mother*, by Alonzo Gibbs.

1972
Included in *10 Independents* exhibition at the Solomon R. Guggenheim Museum, New York. Receives American Academy and Institute of Arts and Letters Award in Art. Travels to Mexico.

1973
Buys summer house in Lake Hill, New York, and builds first kiln. Receives New York State Creative Artists Public Service Grant and a Guggenheim Fellowship for Graphics.

1974
On December 28 daughter Andrea dies in airplane crash in Guatemala.

1975
Travels to Greece and France.

1976
Visiting artist, Skowhegan School of Painting and Sculpture, Maine. Solo exhibition at The Arts Club of Chicago.

1977
Travels to Paris for exhibition of her monoprints at Zabriskie's Paris gallery. Receives Brandeis University Creative Arts Award. Visits Morocco.

1978
Included in *8 Artists* exhibition at the Philadelphia Museum of Art. Retrospective exhibition, *Mary Frank: Sculpture/Drawings/Prints*, at the Neuberger Museum, State University of New York at Purchase. *Mary Frank: Works on Paper* exhibition organized by the Gallery Association of New York State, Hamilton, N.Y.; travels for two years.

1980
Included in *The Painterly Print* exhibition at The Metropolitan Museum of Art, New York, which travels to the Museum of Fine Arts, Boston.

1981
Attends weekend workshops at the Bread and Puppet Theater, Glover, Vermont

1983
Receives Guggenheim Award for Sculpture.

1984
Elected to the American Academy and Institute of Arts and Letters. Meets Leo Treitler. Travels to Japan.

1985
Designs sets for the production *Big Mouth*, by Talking Band, performed at La MaMa, New York.

1986
Lectures in *Artists' Visions* program at the 92nd Street Y, New York. Designs sets for the Bertolt Brecht/Kurt Weill production *Little Mahagonny*, performed at the 92nd Street Y. Travels to Israel with Leo Treitler.

1987
Persephone Studies exhibition at The Brooklyn Museum. Commencement speaker at the School of the Museum of Fine Arts, Boston.

1988
Retrospective exhibition, *Natural Histories: Mary Frank's Sculpture, Prints, and Drawings*, originates at the DeCordova and Dana Museum and Park, Lincoln, Massachusetts, and travels.

1990
Publication of *Mary Frank*, by Hayden Herrera (Abrams). Collaborates with nature writer Peter Matthiessen on a book combining his essays with her drawings of African animals. Begins work on a traveling exhibition for the Drawing Society.

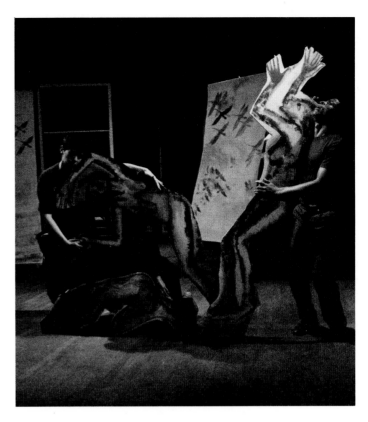

Sets and masks for the Talking Band production *Big Mouth*, performed at La MaMa, New York, 1985

Mary Frank and Leo Treitler, Hawaii, 1989

exhibition history

See Selected Bibliography for major catalogue essays.

solo exhibitions

1961, 1963, 1966
Stephen Radich Gallery, New York.

1964
Drawing Shop Gallery, New York.

1965, 1967
Boris Mirski Gallery, Boston.

1968
Donald Morris Gallery, Detroit.
Zabriskie Gallery, New York, *Mary Frank.*

1969
Richard Gray Gallery, Chicago, *Mary Frank/ Drawing.*

1970
Zabriskie Gallery, New York, *Mary Frank.*

1971
Zabriskie Gallery, New York, *Mary Frank: Drawings.*

1973
Zabriskie Gallery, New York, *Mary Frank: Sculpture and Monoprints.*

1974
Proctor Art Center, Bard College, Annandale-on-Hudson, N.Y.

1975
Jorgensen Auditorium Gallery, University of Connecticut, Storrs, *Mary Frank: Sculpture, Drawings, Prints.*
Zabriskie Gallery, New York, *Mary Frank: Large Ceramic Sculpture.*

1976
The Arts Club of Chicago, *Mary Frank: Sculpture, Drawings, and Monoprints.*
Harcus Krakow Rosen Sonnabend Gallery, Boston, *Mary Frank: Recent Sculpture.*
Hobart College, Geneva, N.Y.
Manwaring Gallery, Cummings Art Center, Connecticut College, New London, *Mary Frank: Sculpture and Drawing.*
Alice Simsar Gallery, Ann Arbor, Mich., *Mary Frank: Drawings and Ceramic Sculpture.*
University of Bridgeport, Conn., *Mary Frank: Exhibition of Sculpture and Drawings.*

1977
Zabriskie Gallery, Paris and New York, *Mary Frank.*

1978
Neuberger Museum, State University of New York at Purchase, *Mary Frank: Sculpture/Drawings/ Prints.*
Neuberger Museum, State University of New York at Purchase, *Mary Frank: Works on Paper.* Exhibition organized by the Gallery Association of New York State, Hamilton, N.Y. Traveled throughout the state for two years.
Zabriskie Gallery, New York, *Mary Frank: Shadow Papers.*

1979
Zabriskie Gallery, New York, *Mary Frank: Sculpture and Monoprints.*

1981
Zabriskie Gallery, New York, *Mary Frank: 1980–81.*

1981–82
Zabriskie Gallery, New York, *Mary Frank: Sculpture and Monotypes.*

1982
Makler Gallery, Philadelphia.

1984
Quay Gallery, San Francisco, *Mary Frank: Sculpture and Monotypes.*
Zabriskie Gallery, New York, *Mary Frank: Monotypes and Sculpture.*

1985
Marsha Mateyka Gallery, Washington, D.C., *Mary Frank: Monoprints.*

1986
Zabriskie Gallery, New York, *Mary Frank: Sculpture and Works on Paper.*

1987
The Brooklyn Museum, *Mary Frank: Persephone Studies.*

1988
Dalsheimer Gallery, Baltimore, Md.
DeCordova and Dana Museum and Park, Lincoln, Mass., *Natural Histories: Mary Frank's Sculpture, Prints, and Drawings.* Traveled to Everson Museum of Art, Syracuse, N.Y., and Pennsylvania Academy of the Fine Arts, Philadelphia.
Neilsen Gallery, Boston, *Mary Frank: Works on Paper 1970–87.*

1989
Everson Museum of Art, Syracuse, N.Y., *Natural Histories.*
Pennsylvania Academy of the Fine Arts, Philadelphia, *Natural Histories.*
Zabriskie Gallery, New York, *Mary Frank: Recent Work.*

group exhibitions

1958
Poindexter Gallery, New York (with Paul Harris).

1972
Gedok, Hamburg, West Germany, *American Women Artists' Show.*
The Solomon R. Guggenheim Museum, New York, *10 Independents.*
Whitney Museum of American Art, New York, *Whitney Sculpture Annual.*

1973
Whitney Museum of American Art, New York, Whitney Biennial.

1975
New York Cultural Center, *Three Centuries of the American Nude.* Traveled to Minneapolis Institute of Arts and University of Houston Fine Arts Center.
Portland Art Museum, *Masterworks in Wood.*

1976

Marion Koogler NcNay Art Institute, San Antonio, Tex. *American Artists '76*.

Philadelphia College of Art, *Private Notations: Artists' Sketchbooks*.

1977

The Art Institute of Chicago, *Drawings of the 70's*.

The Brooklyn Museum, *Contemporary Women: Consciousness and Content*.

Whitney Museum of American Art, New York, *Small Objects*.

1978

Albright College, Reading, Pa., *Perspective '78: Works by Women*.

Philadelphia Museum of Art, *8 Artists*.

Wave Hill, Riverdale, N.Y., *Figure in the Landscape*.

1979

The Queens Museum, Flushing, N.Y., *By the Sea: 20th Century Americans at the Shore*.

Whitney Museum of American Art, New York, *Whitney Biennial*.

1980

The Aldrich Museum of Contemporary Art, Ridgefield, Conn., *Mysterious and Magical Realism*.

Hayden Gallery, Massachusetts Institute of Technology, Cambridge, *The Narrative Impulse*.

Institute of Contemporary Art, Virginia Museum of Fine Arts, Richmond, *On Paper*.

The Metropolitan Museum of Art, New York, *The Painterly Print*. Traveled to the Museum of Fine Arts, Boston.

Pratt Institute, New York, *Sculpture in the 70's— The Figure*.

Whitney Museum of American Art, New York, *The Figurative Tradition*.

1981

American Craft Museum, New York, *The Clay Figure*.

Grey Art Gallery, New York University, *Tracking the Marvelous*.

The Maryland Institute, College of Art, Baltimore, *The Human Form: Interpretations*.

1983

The Brooklyn Museum, *American Printmaker's Show*.

The New Britain Museum of American Art, Conn., *Fragmentations*.

Wave Hill, Riverdale, N.Y., *Bronze Sculpture in the Landscape*.

1985

The Chrysler Museum, Norfolk, Va., *Contemporary American Monotypes*.

Contemporary Arts Center, Cincinnati, *Body and Soul: Recent Figurative Sculpture*.

Dayton Art Institute, Ohio, *Clay*.

De Saisset Museum, Santa Clara, Calif., *Contemporary Monotypes: Six Masters*.

1986

The Brooklyn Museum, *Public and Private: American Prints Today*.

Contemporary Arts Center, Cincinnati, *Disarming Images*. Traveled throughout the U.S. during 1986.

Marilyn Pearl Gallery, New York, *Tenth Anniversary Exhibition*.

Whitney Museum of American Art, Equitable Center, New York, *Figure as Subject: The Last Decade*.

1987

Associated American Artists, New York, *Recent Figurative Prints*.

Grace Borgenicht Gallery, New York, *Pastel Anthology II*.

Contemporary Arts Center, Cincinnati, *Standing Ground: Sculpture by American Women*.

Everson Museum of Art, Syracuse, N.Y., *American Ceramics Now*. Traveled throughout the U.S.

Philbrook Art Center, Tulsa, Okla., *The Eloquent Object*. Traveled throughout the U.S. during 1988–89.

The Queens Museum, Flushing, N.Y., *Sculpture of the Eighties*.

Anne Weber Gallery, Georgetown, Me.

1988

The Jewish Museum, New York, *The Jewish Museum Collects*.

The Museum of Modern Art, New York, *Committed to Print*.

1989

Salander-O'Reilly Galleries, New York, *Barnard Collects: The Educated Eye*.

University of Maine Museum of Art, Orono, *Monoprints/Monotypes*.

1990

The National Gallery of Art, Washington, D.C., *The 1980s: Prints from the Collection of Joshua P. Smith*.

public collections

Akron Art Museum, Ohio

Arnot Art Museum, Elmira, N.Y.

The Art Institute of Chicago

Bank of Chicago

The Brooklyn Museum

Brown University, Providence, R.I.

Centro Cultural del Arte Contemporáneo, Polanco, Mexico

Crocker Bank, Chicago

Des Moines Art Center, Iowa

Everson Museum of Art of Syracuse and Onondaga County, New York

Graduate School of Business Administration, Harvard University, Cambridge

Hirshhorn Museum and Sculpture Garden, Washington, D.C.

Kalamazoo Institute of Art, Michigan

Library of Congress, Washington, D.C.

The Metropolitan Museum of Art, New York

Museum of Fine Arts, Boston

The Museum of Modern Art, New York

Neuberger Museum, State University of New York at Purchase

The Pennsylvania Academy of the Fine Arts, Philadelphia

Michael C. Rockefeller Arts Center Gallery, Fredonia, N.Y.

Southern Illinois University, Carbondale

Storm King Art Center, Mountainville, N.Y.

University of Massachusetts, Boston

University of New Mexico, Albuquerque

University of North Carolina at Chapel Hill

Virginia Museum of Fine Arts, Richmond

Whitney Museum of American Art, New York

Worcester Art Museum, Massachusetts

Yale University Art Gallery, New Haven, Conn.

selected bibliography

1963

Kramer, Hilton. "The Possibilities of Mary Frank." *Arts* (March 1963): 50–55.

Peterson, Valerie. "Mary Frank: Sculptures a Bridge for Ideas." *ARTnews* (January 1963): 34–35.

1968

Coatsworth, Elizabeth. *Enchanted, An Incredible Tale.* Illustrated by Mary Frank. New York: Pantheon Books, 1968.

Mellow, James R. "Keeping the Figure Vital." *The New York Times* (September 15, 1968): IV, 33.

1969

Cohen, Joan. *Buddha.* Illustrated by Mary Frank. New York: Delacorte Press, 1969.

1970

Gibbs, Alonzo. *Son of a Mile-Long Mother.* Illustrated by Mary Frank. New York: Bobbs Merril, 1970.

Kramer, Hilton. "The Sculpture of Mary Frank: Poetical, Metaphorical, Interior." *The New York Times* (February 22, 1970): II, 27.

1971

Henry, Gerrit. "The Clay Landscapes of Mary Frank." *Crafts Horizon* (December 1971): 18–21.

1973

Kingsley, April. "Mary Frank: A Sense of Timelessness." *ARTnews* (Summer 1973): 65–67.

Mellow, James R. "About Woman as a Sexual Being." *The New York Times* (April 22, 1973): II, 19.

1975

Herrera, Hayden. "Mary Frank at Zabriskie Gallery." *ARTnews* (March 1975): 96–97.

Kramer, Hilton. "Art, Sensual Serene Sculpture." *The New York Times* (January 25, 1975): 23.

Mellow, James R. "Mary Frank Explores Women's Erotic Fantasies." *The New York Times* (January 19, 1975): II, 23.

1976

Kay, Jane Holtz. "Mythic Fragments." *ARTnews* (Summer 1976): 137.

1977

Sawin, Marticia. "The Sculpture of Mary Frank." *Arts* (March 1977): 130–32.

Thompson, Jerry, photographer. *The Sculpture of Mary Frank.* With essay by Hilton Kramer. New York: The Eakins Press Foundation, 1977.

1978

Herrera, Hayden. *Mary Frank: Sculpture/ Drawings/Prints.* Exhibition catalogue. Purchase, N.Y.: Neuberger Museum, State University of New York, 1978.

———. *Mary Frank: Works on Paper.* Exhibition catalogue. Hamilton, N.Y.: Gallery Association of New York State, 1978.

———. "Myth and Metamorphosis: The Work of Mary Frank." *Arts Canada* (April–May 1978): 15–26.

Hughes, Robert. "Images of Metamorphosis." *Time* (July 10, 1978): 76.

Ratcliff, Carter. "Mary Frank's Monotypes." *The Print Collector's Newsletter* (November– December 1978): 151–54.

Raynor, Vivien. "Sculptural Marvels of Mary Frank." *The New York Times* (June 16, 1978): III, 1.

1979

Clark, Garth. *A Century of Ceramics.* New York: E. P. Dutton, 1979.

Friedman, Jon R. "Mary Frank." *Arts Magazine* (September 1979): 12.

Harrison, Helen A. "A Sensual and Enigmatic World." *The New York Times* (December 23, 1979).

Munro, Eleanor. "Mary Frank." In *Originals: American Women Artists*, pp. 289–308. New York: Simon and Schuster, 1979.

1980

Kramer, Hilton. "Art: *World of the Monotype* Inaugurates a Corner at Met." *The New York Times* (October 24, 1980): III, 1.

1981

Cummings, Paul. "Interview: Mary Frank Talks with Paul Cummings." *Drawing Magazine* (May–June 1981): 11–14.

Glueck, Grace. "The Clay Figure at the Craft Museum." *The New York Times* (February 20, 1981): III, 21.

Goodman, Calvin. "Monotype: A Singular Art Form." *American Artist* (January 1981): 58–63.

Hess, Elizabeth. "Female Parts." *The Village Voice* (May 6–12, 1981).

Kramer, Hilton. "Mary Frank." *The New York Times* (May 15, 1981): III, 21.

Upshaw, Regan. "Mary Frank at Zabriskie." *Art in America* (October 1981): 140.

1982

Herrera, Hayden. *Mary Frank.* Exhibition catalogue. New York: Zabriskie Gallery, 1982.

1983

Fort, Ilene Susan. "Mary Frank." *Arts Magazine* (May 1983): 62.

Henry, Gerrit. "Mary Frank." *ARTnews* (May 1983): 160.

Weymouth, Fleur. "An Interview with Mary Frank." *Helicon Nine: The Journal of Women's Arts and Letters*, no. 9 (1983): 22–36.

1984

Brenson, Michael. "Mary Frank." *The New York Times* (November 30, 1984): III, 23.

Lauter, Estella. *Women as Mythmakers: Poetry and Visual Art by Twentieth-Century Women*, pp. 144–46. Bloomington: Indiana University Press, 1984.

Munro, Eleanor. "Mary Frank." In *Mary Frank: Monotypes and Sculpture.* Exhibition catalogue. New York: Zabriskie Gallery, 1984.

1986

Frank, Mary. Artist's Statement. In *Mary Frank: Sculpture and Works on Paper.* Exhibition catalogue. New York: Zabriskie Gallery, 1986.

Moore, John McDonald. "The Drawings of Mary Frank." *Drawing* (January–February 1986): 97–101.

Zimmer, William. Review of 10th Anniversary Exhibition at Marilyn Pearl Gallery. *The New York Times* (October 24, 1986): III, 28.

1987

Campbell, Lawrence. "Mary Frank." *Art in America* (March 1987): 139–40.

Kramer, Linda Konheim. "Mary Frank: Persephone Studies." *American Ceramics* (Fall 1987): 17–21.

Moorman, Margaret. "In a Timeless World." *ARTnews* (May 1987): 90–98.

Raynor, Vivien. "Persephone Studies at the Brooklyn Museum." *The New York Times* (March 27, 1987): III. 25.

1988

Dorsey, John. "Frank's Figures Bend with Forces of Time." *Baltimore Sun* (May 6, 1988).

Gill, Michael. *The Image of the Body: Aspects of the Nude*. New York: Doubleday and Company, 1988.

Herrera, Hayden. "Mary Frank's Natural Histories." In *Natural Histories: Mary Frank's Sculpture, Prints, and Drawings*, pp. 7–22. Exhibition catalogue. Lincoln, Mass.: DeCordova and Dana Museum and Park, 1988.

Koslow, Francine. "Mary Frank: [Exhibitions at] DeCordova Museum, Nielsen Gallery." *Artforum* (September 1988).

Kramrisch, Stella. "Clay Sculptures by Mary Frank." In *Natural Histories: Mary Frank's Sculpture, Prints, and Drawings*, pp. 23–26. Lincoln, Mass.: DeCordova and Dana Museum and Park, 1988.

Tarlow, Lois. "Profile: Mary Frank." *Art New England* (February 8, 1988): 6–7.

1989

Gadon, Eleanor. *The Once and Future Goddess: A Symbol of Our Time*. New York: Harper and Row, 1989.

1990

Herrera, Hayden. *Mary Frank*. New York: Abrams, 1990.

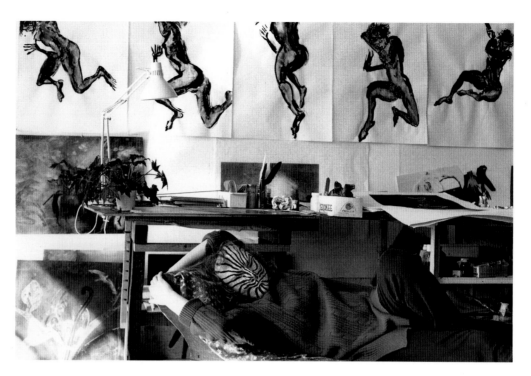

Mary Frank wearing handmade mask
in her West 19th Street studio, 1987

index

Page numbers are in roman type. Page numbers on which illustrations appear are in *italic* type. All works are by Mary Frank unless otherwise noted.

photograph credits

The author and publisher wish to thank the museums, galleries, and private collectors named in the illustration captions—and especially Zabriskie Gallery and the artist—for supplying the necessary photographs. Other photograph credits are listed below.

Burstein, Barney: 32 right.

Fatheree, Lee: 103.

Ferrari, John A.: 1, 9 below, 29, 39, 46 above right, 53, 54, 55, 60, 83, 89 below, 92, 93, 94, 104, 109; courtesy former Stephen Radich Gallery, New York: 38; courtesy Zabriskie Gallery, New York: 102.

Gabriner, Ralph: 7, 10, 30 left, 31 right, 58, 59, 71, 73, 74, 75, 96, 116, 117, 118, 121, 124, 125, 133, 134, 135, 137, 138; reproduced with permission from *Mary Frank: Persephone Series*, copyright The Brooklyn Museum: 84; courtesy Whitney Museum of American Art, New York: 70; courtesy Zabriskie Gallery, New York: 6, 67, 76, 77, 80, 100, 111, 132.

Michals, Duane: 145.

Photograph reproduced with permission from *Mary Frank Sculpture/Drawings/Prints*, copyright Neuberger Museum, State University of New York at Purchase: 45, 46, 89 above, 127.

Pollitzer, Eric, courtesy former Stephen Radich Gallery, New York: 31 left.

Schiff, John D.: 8.

Strong, Jim: 44 below right.

Suttle, William: 39, 44 above right, 46 below right, 65, 81 above; courtesy Zabriskie Gallery, New York: 49, 62, 68, 69.

Thompson, Jerry L.: endpapers, 12, 14, 40, 59, 78, 79 left and right, 77 below, 106, 140.

Vasquez, George: 112–13.

Vezzuso, Gerard: 141 above.

Wells, Sarah, courtesy Zabriskie Gallery, New York: 120, 123.

Weymouth, Fleur: 141 below; courtesy Zabriskie Gallery, New York: 129.